John Varley

1778–1842

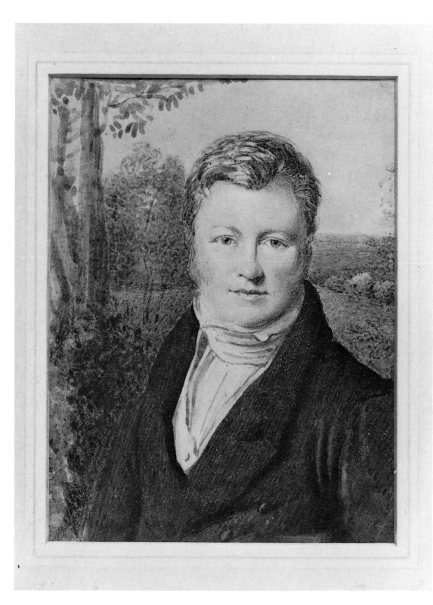

C.M. KAUFFMANN

John Varley

1778–1842

B.T. BATSFORD LTD · LONDON
IN ASSOCIATION WITH THE
VICTORIA & ALBERT MUSEUM

ISBN *0 7134 3402 3 (cased)*
0 7134 3403 1 (limp)

Typeset and printed by Butler & Tanner Ltd,
Frome and London
for the publishers
B.T. Batsford Ltd
4 Fitzhardinge Street
London W1H 0AH

FIG. 1 (Frontispiece) John Linnell (1792–1884), portrait of John Varley (1778–1842) in his early thirties
Watercolour, $4\frac{3}{4} \times 3\frac{5}{8}$, V & A (P. 14–1937)

Contents

Black-and-white

Colour plates *between pages 84 and 85*

Foreword

With the publication in 1981 of the *Concise Catalogue of British Watercolours in the V & A* by Lionel Lambourne and Jean Hamilton and the accompanying microfiche, the national collection became more widely accessible, yet it has long been felt that these important holdings should be catalogued in greater depth. Consequently a series of publications was planned that would combine a detailed catalogue of the Museum's holdings on individual artists with an up-to-date monograph on the artist concerned. Some of the leading painters, such as Cozens, Girtin, Turner, Cotman, Cox and de Wint have been the subject of recent exhibitions or monographs, and these have not been included in this series. Instead, the first six artists to be treated in this way are Rooker, Varley, Bonington and his followers, Prout, Sandby and J.F. Lewis, and an exhibition of each is planned to coincide with the publication of the book. The series is edited by John Murdoch, Deputy Keeper of the Department of Paintings.

In compiling the John Varley catalogue, I should like to acknowledge help freely given by members of the Varley family, above all Joan Varley and Netta Guillan; Joan Linnell Burton; the Linnell Trust which gave permission to quote from the Linnell archives, and Evelyn Joll who allowed access to Messrs Agnew's photographic archive. Librarians and archivists, particularly at the Witt Library, Courtauld Institute, and Hackney Borough Archive were unfailingly helpful, as were the curators of public and private collections who freely allowed access. I have benefited greatly from discussions with numerous friends and colleagues, in particular Martin Butlin, Ronald Lightbown, Marcia Pointon, Christopher Titterington, John Wagstaff of the Museum's Conservation Department, Andrew Wilton and, above all, John Murdoch. Anne Lyles offered much help and generously allowed me to read a draft of her article on Varley's early work. Sam Carr, formerly Chairman of Messrs Batsford, was a source of encouragement from the start and this publication has been carried through by Timothy Auger. Colour photography was the work of Sally Chappell of the Museum's Photographic Service. Thanks are also due to private owners and public galleries for permission to reproduce their paintings, and to Messrs Spink for a print of fig. 19. The exhibition has been strengthened by generous loans from the Museum of London, Miss Scott-Elliot, Mrs Basil Taylor and an anonymous lender, and mounted with the support of Sarah Postgate. Jennifer Blain typed impeccably from a barely legible manuscript and, as always, my wife ironed out endless infelicities in the text.

Numerals printed in **bold** type in the introductory chapters are references to items in the catalogue.

I Early years 1778-1802

John Varley was born at the Old Blue Post Tavern, Hackney, on 17 August 1778, 18 degrees 56 minutes, Sagittarius ascending.[1] The astrological precision, no mere pedantry, was, as we shall see, of fundamental importance to him. One of a family of five, three boys and two girls, his early childhood was spent in easy circumstances in their large house, the site of the tavern on Mare Street, Hackney, next to the churchyard. His father, Richard Varley, born at Epworth in Lincolnshire, had settled in London after the death of his first wife in Yorkshire. We have no knowledge of his profession. Redgrave had called him 'a man of very scientific attainments ... tutor to Lord Stanhope's son', but, as Roget pointed out, this description applies to his elder brother Samuel Varley, manufacturer of scientific instruments, from whom John's brother, Cornelius, derived his scientific interests.[2]

All that is certain of Richard is that he was not a painter, for when John wished to follow his natural bent, his father forebade it, saying that 'Limning or drawing is a bad trade'. Nevertheless, all his sons became artists: both Cornelius (b. 1781) and William Fleetwood (b. 1785) followed in John's footsteps, while their sister Elizabeth, also a painter, married William Mulready. But for the moment his father's interdict meant that at the age of 13 John was apprenticed to a silversmith.

Richard Varley died in November 1791, apparently leaving his widow and five children inadequately provided for. The large house at Hackney was vacated and the family moved into what John's friend J.P. Neale described as an 'obscure court, opposite St Luke's Hospital, in Old Street'. John was placed with a law stationer but, as Cornelius tells us, his heart was in his sketching. On one occasion he disappeared for three days, returning with sketches of Hampstead and Highgate, driven home by hunger. As Cornelius put it, 'Mrs Varley, who had more taste for the arts than her husband, regretted that her son's inclination had been so long opposed, and now encouraged him to draw and study, and gave him all the assistance her humble means permitted.'

For a brief time he was employed by a portrait painter in Holborn and then, at the age of 15 or 16, he went to a teacher by the name of Joseph Charles Barrow who had an evening drawing school twice a week at his house at 12 Furnival's Inn Court, Holborn. Varley was employed for odd jobs and errands, in return for which he was allowed to draw with the other pupils and to copy old master prints. François Louis Francia, later to become Bonington's teacher, was an an assistant there at the same time.

An eye witness for this period is John Preston Neale, topographical draughtsman and engraver whose reminiscences of John Varley, extensively quoted by Roget, are in the Jenkins papers at the Royal Society of Painters

in Water-Colours:

> It was early in March 1796 that I went one Sunday morning to Hornsey Wood to sketch and collect insects, when I met John Varley sketching likewise – we entered into conversation and commenced a friendly intercourse which only terminated with his life.

Thereafter the pair frequently 'sallied forth in search of the picturesque' in the villages around north-east London – Hoxton, Stoke Newington and Tottenham, and also projected a joint publication consisting of landscapes, beasts, birds, insects and flowers to be called the *Picturesque Cabinet of Nature*. Varley was to do the landscapes and Neale to draw the others and to do the etching. The first number, consisting of three prints of animals, was published on 1 September 1796, but there was no landscape by Varley and no second number.

Neale goes on,

> Poor Varley began the world with tattered clothes and shoes tied with string to keep them on. Yet nothing could damp the ardour of this determined, great man. He was ever with his pencil, either drawing from nature, or copying the works of distinguished masters. He rose early, drew till it was time to attend his situation, and set off with a large, ragged portfolio and a string over his shoulder, attached to it head first, at a full trot until he arrived at his master's. ... So great an enthusiast I never, in the whole of my long practice, beheld.

There is no reason to doubt these stories, coming as they do from Varley's brother and from a close friend, but it is worth noting how similar they are to ancient biographical tradition of the artist as hero. From the time of Pliny's account of Lysippus, the great sculptor of Alexander's time, we hear of men who became artists after being forced into other occupations; they are frequently self-taught and turn to Nature as most worthy of imitation.[3] Of course, such accounts are often true; other children may have similar experiences but if they do not become well known artists their lives are not recounted. But these stories do fulfil a social and psychological need to provide a heroic origin for artistic creativity.

Perhaps the best example of such a traditional tale of the discovery of artistic talent as applied to Varley is the one told by a Miss Smith, an old friend of the family. The young Varley was, for a time, engaged by a stockbroker named Trower to clean and sweep out the office.

> This Mr Trower was in the habit of sketching on scraps of paper, and throwing them on the ground. Young Varley took to copying some of these. By some chance a copy came to the sight of his employer who told the boy it was so well done, that he had better take to drawing.[4]

It was J.C. Barrow who took Varley on a sketching tour to Peterborough from which he emerged as a professional painter. For in 1798 he exhibited a sketch of Peterborough Cathedral at the Royal Academy which, according to Cornelius, 'gained him so much credit that Barrow was lost sight of'. Unfortunately, this work is no longer extant, but it is reasonable to assume that its style is reflected in the Herefordshire and Welsh town views of 1801-2 (**4**, **5**). At any rate he was now a regular exhibitor at the Royal Academy until the foundation of the Water-Colour Society in 1805.

In 1798 or 1799 he made his first tour to Wales in company with the landscape painter George Arnald (later ARA) and, 'either together or separately', in the words of Cornelius, with the drawing master, Baynes. This Welsh tour laid the foundations of Varley's art in providing him with inspiration and with subject matter which he was to draw upon throughout his career. The evidence for a second tour in 1800 is inconclusive, though it is boldly asserted by the Redgraves and appears in most of the standard biographies. Cornelius at any rate was unsure on this point.[5]

Varley's route in north Wales is not recorded, but it is likely that he followed the principal tour proposed in the current guide books. This followed the road from Chirk and Llangollen to Capel Curig, with its view of Snowdon, on to Bangor and along the coast to Conway; then back to Llanrwst and Capel Curig, on foot through the Pass of Llanberis to Caernarvon, south to Beddgelert, Harlech, Barmouth and Dolgelly, to ascend Cader Idris, Tal-y-llyn, back to Dolgelly, Bala and the border. There were variations to this itinerary, as the guide books put it: 'Of course the plan of these Tours may be reversed but the tourist is recommended to follow the route indicated, as it exhibits the scenery in the most favourable manner.'[6] Most of the views depicted by Varley could be adduced to support this statement. In any case the places listed were all painted by him and remained a constant part of his repertoire.

At this time Varley became acquainted with Dr Thomas Monro (1759-1833), physician, collector, amateur artist and one of the most remarkable patrons of art in England (**34**). As principal physician to Bethlem Hospital, he had taken charge of J.R. Cozens during his final years of mental illness, 1794-7, and the evening drawing sessions at his house on Adelphi Terrace, the 'Monro Academy', became the principal route by which Cozens's watercolours were assimilated by the younger generation of artists, headed by Girtin and Turner. Varley formed part of this circle and is recorded as visiting Dr Monro at the Adelphi and at his country home, Fetcham Cottage, near Leatherhead, from 1800 until 1820.[7] Cornelius's statement that in 1800 'Dr Monro took him to his house at Fetcham in Surrey to

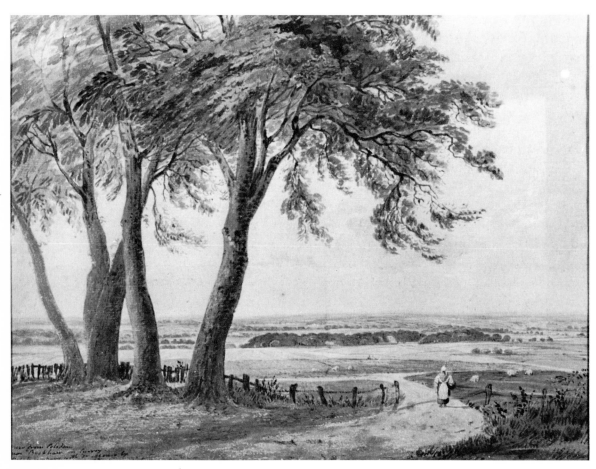

FIG. 2 Varley, *View of Polesden, Surrey*, October 1800
Watercolour, 16 × 21. Laing Art Gallery, Newcastle

make coloured sketches in the neighbourhood particularly about Boxhill', is supported by the inscription on a watercolour in the Laing Art Gallery, Newcastle: *View from Polesden near Bookham made in company with Dr. Monro by J. Varley Oct. 1800. 'Study from Nature'* (fig. 2).

On Dr Monro's advice Varley left Hoxton and moved to the artists' quarter in the West End, living at first with Cornelius in Charles Street, Covent Garden. It was here that he was visited and patronized not only by Dr Monro but also by the Earl of Essex, patron and amateur artist, and by Edward Lascelles, for whom he was commissioned to make drawings of Harewood House.[8] Cornelius provides a vivid description of how Dr Monro 'would stand while my Brother was drawing and dictate the tints he should use'.

In 1801 he moved to 2 Harris Place, Pantheon, Oxford Street, and it was at this time, at the age of 23, that he is first recorded as taking pupils. Cornelius mentions two pupils, the Misses Schutz, whose mother invited them to her house at Gillingham, Norfolk, 'where I remained and my brother went to the Earl of Essex at Hampton Court, Herts.' Together, they visited north Wales in 1802 accompanied by Thomas Webster, the architect. There they met Joshua Cristall and William Havell, and Cornelius describes meeting at Dolgelly a large party of Londoners who were making a geological tour through north Wales. It is significant that the area was attracting Londoners for its geological interest as much as for the appeal of its Sublime and Picturesque mountain scenery to large numbers of artists. For Varley it was significant in other ways, as it appears to have been his last visit. Although he was to paint Welsh views for the next 40 years, there is no evidence of his ever returning to the source of his youthful inspiration.

It was in 1802, also, that Varley became a member of the Sketching Society originally founded in 1799 to establish a school of history painting by joining together to draw original designs for 'poetick passages'.[9] After Girtin's departure for Paris and subsequent death, Cotman became the leading spirit, and Varley is first recorded at one of the Society's meetings on 5 June 1802 along with William Alexander, P.S. Munn, T.R. Underwood and Cotman himself.[10] The Society's rules are set out in a letter dated 24 February 1803 from P.S. Munn to J.S. Hayward, who was about to become a member:

1. The meetings shall be held on every succeeding Wednesday at the house of each Member alternately.
2. The Member at whose house the meeting is held, shall be the President for that eveng. & shall provide the materials for the drawings.

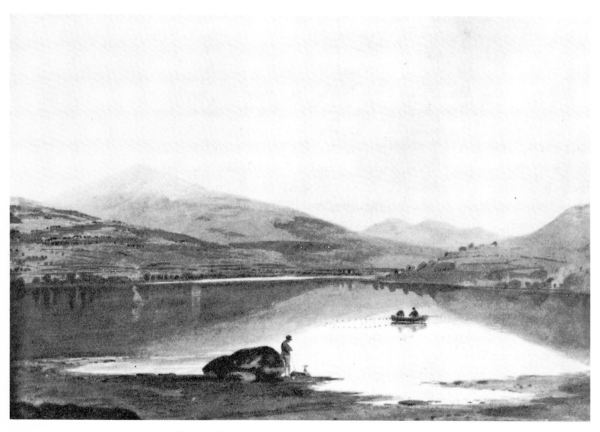

FIG. 3 Thomas Girtin (1775–1802), *Bala Lake*
Watercolour. Whereabouts unknown
Copied by Varley; compare (**12**)

3. The subject shall be selected by the Prest. & by him given out at seven o clock precisely & at ten, the several drawings shall be presented to him – After which Bread & cheese and beer shall be introduced – & the meeting shall break up at eleven . . .[11]

Among the subjects tackled by Varley during these evening sessions were *The death of Milo, Pale Melancholy* from William Collins's *Ode to the Passions*, William Falconer's *Shipwreck* and *The crowded mart* from Charles Lloyd's poem *London* (**6–10**). Varley himself was never at his best in figure drawing, but the sketches of the Society, preserved in the V & A and elsewhere, show a generation of English artists coming to terms with grand themes of literary illustration at a time when history painting was very low in public esteem.

While Cornelius and Cristall returned to Wales in the following year, John toured Yorkshire, as his drawing of Kirkstall Abbey dated 1803 (Stoke on Trent Art Gallery) clearly testifies.[12] However, Cornelius's statement that he went to Northumberland on the same trip cannot be substantiated and, indeed, from the available evidence it seems unlikely that Varley toured Northumberland before 1808, the date of his Northumbrian sketchbook in the V & A (**25**).

The year 1803 also saw his marriage to Esther Gisborne (d. 1824), one of whose sisters married Copley Fielding. It was not a happy marriage. Indeed, according to his friend, the painter John Linnell, Varley was unaware of the fact that his wife had an infant son when he married her,

And what led to his failure in life afterwards, for failures there were too often, and with a better woman for a helpmeet he might have risen to great things, for even as it was he succeeded even under great pressure from bad management in his house . . .[13]

From Linnell also, we can obtain a picture of his heavy build and imposing physique, 'bull like in strength and figure', marred by his ungainliness. On a boat on the Thames, he tells us,

Varley could never acquire the skill [of rowing], he broke the skull the first attempt by dipping in too deep in the water and pulling with all his might which was considerable for he was very *strong* but could never learn how to use his strength.[14]

All witnesses agree on his great kindness and generosity. 'John Varley was a man of the most generous impulses . . . but deficient in sagacity and most easily imposed upon by the crafty.'[15] Even this failing indicates an attractive character. His interest in astrology, which led him to ask for the date of birth of anyone he met to enable him to cast their horoscope, was

already gaining him a reputation for mild eccentricity. In 1803, at the age of 24, he was acknowledged as a young artist of great promise, if of slightly eccentric habits. Joseph Farington, gossip and diarist as well as artist, wrote in his diary for 2 November 1802 (see also 2 July 1803): 'dined at Dr Monro's with J.F. Daniell, Edridge, Hearne and Baker. Much was said about the singularities of Varley, an ingenious young man who had been making drawings in Wales.'[16]

NOTES

1. Inscription on Blake's drawing of Varley (NPG no. 1194), see Butlin, 1981, cat. 689, pl. 906. A fuller inscription including the place of birth but giving the state of the sky as 18d 54m was formerly on the mount of the watercolour of the *Demolition of Hackney Church* in the Hackney Public Library, Archives Dept. Can Varley have been in doubt about these two minutes?

2. Information concerning Varley's family and early years is taken from Roget, 1891, I, chapter IV, pp. 165–73, supplemented by direct reference to Roget's source, the manuscript of J.J. Jenkins, secretary of the OWCS 1854–64, which has recently been rediscovered at the Bankside Gallery, London, current home of the OWCS. The principal MSS consist of a short *Memoir of John Varley* by his brother Cornelius, dated 10 December 1842 and *Reminiscences of John Varley* by J.P. Neale, which covers the years 1796–7. Roget quotes extensively from both.

3. E. Kris and O. Kurz, *Legend, Myth and Magic in the Image of the Artist*, new ed., Yale U.P., 1979, pp. 13 ff.

4. Jenkins MS, summarized by Roget, 1891, p. 167. This was apparently William Trower, stockbroker at Clapton whose death was recorded in the *European Magazine*, 23, 1793, p. 80. He should not be confused with John

Trower of Findon, Sussex, patron of Anthony Devis.

5. Redgrave 1866 (1947 ed., p. 200); Jenkins MS, 'Cornelius Varley, Memoir', fol. 1.

6. Leigh's *Guide to Wales and Monmouthshire*, 2nd ed., 1833, p. 29. Several earlier authors began their tour in south Wales and hence proceeded north from Dolgelly to Snowdonia, e.g. Wyndham, 1781.

7. V & A Museum, *Dr Thomas Monro and the Monro Academy*, 1976, introduction by F.J.G. Jefferiss. I am grateful to Dr Jefferiss for checking the MS Journal of E.T. Monro, eldest son of Thomas Monro; Farington, 2 November 1802; Linnell, MS *Journal*, 3 February 1820.

8. Bury, 1946, pls. 18–19.

9. Hamilton, 1971.

10. Barnes MS.

11. Ibid.

12. Bury, 1946, pl. 24. There is a closely similar drawing by Mulready in the British Museum which suggests that the two artists made the trip together (Heleniak, 1981, pp. 37 ff.).

13. Linnell, *Autobiography*, MS p. 10; passages quoted by Story, 1892.

14. Ibid., p. 8.

15. Ibid., p. 10.

16. Farington, 2 November 1802.

II Early work 1800 - 1805

'John Varley and myself sallied forth in search of the picturesque,' J.P. Neale had written concerning their youthful sketching tours in the outlying areas of north London, such as Hoxton and Tottenham.[1] In general parlance the picturesque means merely 'suitable for a picture', but in early nineteenth-century England the term had greatly elaborated connotations sufficiently widely recognized to be worthy of the heavy satire of Rowlandson's illustrations to the *Tour of Dr Syntax in Search of the Picturesque* and the gentler humour of Jane Austen in *Northanger Abbey*.[2]

The peculiarly English obsession with the term may be traced both in the literature of the landscape garden, with its stress on irregularity, from the early eighteenth century, and with the habit of poets, particularly Thomson in *Seasons*, of describing nature in terms of great landscape paintings.[3] It was fed by Edmund Burke's attempt to establish a philosophically rigorous theory of taste in his *Philosophical Enquiry into the Origin of our Ideas of the Sublime and the Beautiful* (1757).[4] The Sublime was defined as arousing sensations of terror, obscurity and vastness, while Beauty was identified with qualities of smoothness and softness, in fact akin to prettiness.

Under the influence of both Burke and the poets, William Gilpin coined the confusing term 'Picturesque beauty'. He was no master of aesthetic speculation, but he travelled extensively in the countryside of England and Wales from 1768 to 1776 and his published descriptions of Picturesque scenery gained wide currency. The qualities that made a landscape Picturesque were roughness of texture, singularity, variety and irregularity: deep recesses of shade on distant mountains and lakes (in the middle distance), and a foreground with broken ground, a rough road or rocks with a fractured surface. An artist, Gilpin admitted, cannot exactly improve on nature, but he can use 'a little practice in the rules of picturesque composition' – a sentiment frequently echoed by Varley and the other teachers in the early nineteenth century.

The other principal authorities on the Picturesque were more precise in their analysis, but none equalled the influence of Gilpin whose *Observation on the River Wye*, published in 1782, had run to a fifth edition by 1809. Uvedale Price's *Essay on the Picturesque* (1794) established Picturesque as a third category, distinct from the Sublime and the Beautiful. It was based on the requirement of irregularity – 'men grow weary of uniform perfection' – and extended beyond landscape to include peasants, beggars, gypsies and shaggy animals.[5] It was left to the Scot, Archibald Alison, to counter the pure sensationism of these theories by proposing that objects were only picturesque in so far as they aroused associations in the viewer's mind.[6] This interest in the aesthetic power of association was taken up by Richard

Payne Knight, squire of Downton in Herefordshire, collector and connois-
seur. In doing so, he criticized Uvedale Price for his sensationist system
and stressed the importance of the viewer's subjective experience: 'our
pleasure in viewing a painting arises from our associating other ideas with
those immediately excited by them.'[7] Yet in spite of the controversy be-
tween Payne Knight and Price the tendency to isolate visual art from all
other values – symbolic, moral or religious – unites most apologists of the
Picturesque. With Wordsworth's and Turner's appeal to moral or religious
interpretations, experienced with emotional intensity, we move once again
to the Sublime or, to use a more current term, into the Romantic period.

Varley's early work has been conveniently divided by subject matter into
three groups: the topographical views of English and Welsh towns, the
Welsh landscapes, and the more informal 'studies from nature',[8] and these
groups are imbued, to varying degrees, with the principles of Picturesque
aesthetics. The topographical views, mostly of Hereford, Leominster, Ches-
ter and Conway (**4, 5**), tend to conform to a pattern of rows of houses on
a central receding street. They are reminiscent of Thomas Hearne's town
views which Varley would have had the chance to see at Dr Monro's, for
Hearne was one of Monro's closest friends and his work was used as a
model at the Monro Academy. Picturesque irregularity is embodied in
half-timbered houses, peeling paintwork and crumbling masonry emphas-
ized by the deepening shadows of the evening sun.

The second group, the Welsh mountain views, form the bulk of his
output in these early years and, indeed, they continue to do so throughout
his career. But it is in this period that they are closest to his original
experience and most convincingly portray the awe-inspiring character of
mountain scenery. Varley's *View of Cader Idris across Lake Bala* (**12**) is a
direct copy of Girtin, and both in technique and in composition many of
Varley's Welsh views owe a prime debt to Girtin. Behind Girtin's influence
lies that of J.R. Cozens and, above all, of Richard Wilson whose *Snowdon
from Llyn Nantle* is the progenitor of these Welsh compositions (fig. 4).[9] It
was Wilson who first applied the principles of Claude's arcadian landscapes
to Welsh scenery, but Claude's work was widely known to English artists
at this period not only through the presence in England of so many of his
paintings but more importantly through Earlom's engravings after
Claude's drawings for the *Liber Veritatis*, which themselves belonged to
Payne Knight.

However, at this early period Varley's views are more naturalistic, closer
to those of Girtin than to the more formal compositions of Claude and
Wilson which he adopted as a direct model in the following decades. Varley

FIG. 4 Richard Wilson (1713–82), *Snowdon from Llyn Nantle, c.* 1765–6
Oil on canvas. Walker Art Gallery, Liverpool

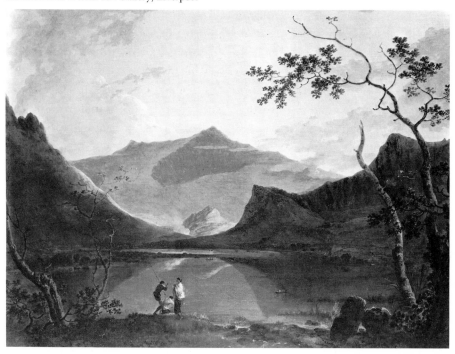

FIG. 5 Claude Lorrain (1600–82), *Landscape: the marriage of Isaac and Rebekah,* 1648
Oil on canvas. National Gallery. Compare, for example, Varley's composition (**36**)

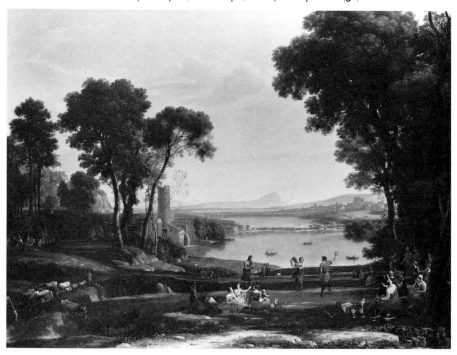

himself had visited all these places during his Welsh sketching tours of 1798–1802 and, on the whole, the views are represented with regard for topographical accuracy. Nevertheless, Gilpin's warning that nature needs some help in matters of composition has been heeded: distant mountains are brought nearer to form the focal point – 'emphasis must always be on the principal subject' as Varley put it – and rivers given a more pronounced curve in order to balance a composition (compare **19** and **15** with figs. 6 and 7).

From the beginning, indeed, Varley was intent on formulating and following principles both of composition and of tonality. These were not actually published until he produced his *Treatise on the Principles of Landscape Design* in 1816, but we can see that he was already following these rules in at least some of his early work. Taking the compositions in depth where 'the subject is principally in the distance' which are the staple of his Welsh views, for example the Bala Lake (**12**) and Moel Hebog (**15**) of 1804, the tonality follows in detail the rules he published a dozen years later. Objects in the foreground should be in shadow; this shadow should be succeeded by a mass of light in the next distance, and that light succeeded by and contrasting with the middle tone in the further distance. In this way the mind and eye are directed on to the subject, aided by the few figures in the foreground which should generally be in a reclining position and appearing unconscious of the spectator. Apart from the addition of diagonal shadows on the waters of Lake Bala, which further serve to direct the eye on to the subject, the rules laid down in the *Treatise* could be used verbatim to describe the disposition of tones in this group of early watercolours.

In essence there was nothing new about this stress on chiaroscuro, with its emphasis on the importance of tonal contrast in the structure of a composition. It was discussed at length in early manuals of painting, for example by the Frenchman Roger de Piles in his *Art of Painting* (English translation 1706), and applied to landscape, not only by theorists of the Picturesque but by Varley's immediate predecessors such as Edward Dayes, who stressed the need for broad and simple shadows to help 'conduct the eye' to the principal subject of the composition.[10] Varley's text differs in the extreme formalism of the rules proposed, and this formalism lies at the root of much of his art throughout his career. Nevertheless, the best of these early Welsh watercolours are much more spontaneous, and it is only with his later work that these formulae give the appearance of mechanical application.

In selecting his viewpoints, Varley and his contemporaries followed pic-

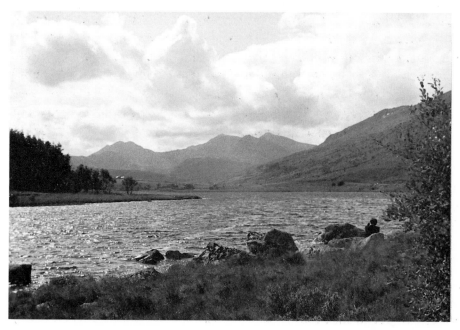

FIG. 6 *View of Snowdon from Capel Curig*
Compare Varley's view (**19**)

FIG. 7 *View of Moel Hebog from Llyn Dinas*
Compare Varley's view (**15**)

torial models in the work of earlier watercolour painters and illustrators of travel literature, as much as the Picturesque theory which tended to follow from rather than determine artistic trends. The eighteenth century was the first great age of British tourism and this newly awakened interest in the country led to a rapid growth of both antiquarian and topographical travel books, often illustrated with engravings.[11] The brothers Samuel and Nathaniel Buck were among the first in the field with engravings dating from the 1720s, though their three volumes of *Buck's Antiquities...* were only published in 1774. Meanwhile, with the improvement of roads and the extension of the stage-coach, the trickle of guide books published in the 1760s with titles like *England Illustrated, or a compendium ... of England and Wales* (1764) and *A Description of England and Wales* (1769) turned into a steady stream in the last quarter of the century and into a veritable flood after 1800. The Wye Valley, north Wales, the Lake District and the Northumberland coast were the main centres attracting travellers in search of the Picturesque. Most of the splendid volumes describing either antiquities, such as Francis Grose, *The Antiquities of England and Wales* (1797) or travels, such as Thomas Pennant's *Journey to Snowdon* (1781) with etchings after Moses Griffith, were fully illustrated. In choosing his subject matter or angle of vision, Varley followed the pictorial tradition pioneered by the illustrators of the eighteenth-century antiquarian and travel books. Time and again the study of his watercolours in the V & A leads to a source in an engraving in one or other of these books. Even when the pictorial language changed, in the period of Turner and Girtin, the choice of viewpoint remains remarkably static. Examples could be chosen from views in Northumberland or York (fig. 9) as readily as in north Wales, but perhaps the most persistent tradition was the view of Snowdon from Capel Curig (**19**). Varley chose the same viewpoint as de Loutherbourg, Moses Griffith and Colt Hoare before him (fig. 10) and, such is the continuity of this particular pictorial tradition, that the identical view appears in a photograph of *c.* 1950 by W.A. Poucher, the doyen of contemporary mountaineers.[12]

'Study from nature' describes the third category of Varley's early watercolours: these are the informal studies of English landscape, several of them inscribed with this rubric and all clearly based on direct observation. *Polesden near Bookham*, dated October 1800 and painted in the company of Dr Monro, is an early example (fig. 2) and the V & A *Near Handborough* of 1804 (**16**) belongs to this group. These are horizontal compositions with soft naturalistic colours, greens and browns, and the extensive views they portray may have been influenced by the painted panoramas which had

FIG. 8 *Beddgelert Bridge*
Engraving in Thomas Pennant, *Journey to Snowdon*, 1781
Compare Varley's view (**20**)

FIG. 9 *Porch of St Margaret's, York*
Engraving in Francis Drake,
History and Antiquities of the City of York, 1736
Compare Varley's view (**22**)

FIG. 10 *Snowdon from Capel Curig*
Engraving in Richard Colt Hoare, *A Collection of forty-eight Views . . . in North and South Wales*, 1792
Compare Varley's view (**19**)

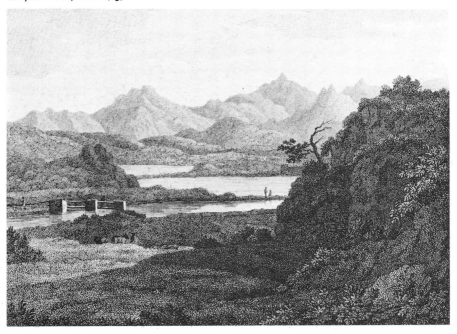

just come into vogue as a form of popular entertainment. Varley was not alone in painting directly from nature at this period – the fashion is usually traced back to Thomas Jones's oil sketches of the 1790s – and his 1801 *View of Bodenham and the Malvern Hills* (fig. 11) is clearly comparable to Constable's panoramic views of the valley of the Stour painted for Lucy Hurlock in 1800 (V & A, P.25/27-1970; Whitworth Art Gallery, Manchester). It is in these watercolours that John Varley comes closest to the work of his brother Cornelius. Yet, even though they must be seen as part of a broader development, his studies from nature, coupled with the fact that his pupils, who included Mulready and Linnell, were, in Linnell's words 'constantly drawing from nature', give Varley an important place in the short-lived fashion for *plein air* painting in early nineteenth-century England.

The freshness of these studies contrasts with his strict adherence to rules of composition and tonality in his more formal compositions, but it has been demonstrated that these early sketches from nature underlie some of his more inventive Welsh compositions. Most strikingly similar is the *View in the Vale of Clwyd* (1804),[13] which shares the low horizon, horizontal composition and subdued tones of *Near Handborough* (**16**). *Sunrise from the top of Cader Idris* (fig. 12, cf. **17**) is inscribed *View of sunrise from the top of Cader Idris, N. Wales with Bala Lake in the distance, at Half Past 3 in the Morning . . .*

FIG. 11 Varley, *View of Bodenham and the Malvern Hills*, 1801
Watercolour, $12\frac{1}{4} \times 20\frac{1}{2}$. Tate Gallery

FIG. 12 Varley, *Sunrise from the top of Cader Idris*, 1804
Watercolour, $11\frac{1}{4} \times 19\frac{1}{4}$. Miss Scott-Elliot, CVO

and although it is in the pictorial tradition of Cozens and the Sublime, it is suffused with more naturalistic tendencies. The inscription alone indicates a strong interest in the depiction of transient natural phenomena and leaves little doubt that Varley was there to see that particular sunrise from the top of the mountain.[14]

It was in 1804, also, that he developed his landscapes dominated by the unbroken, unmodulated layers of wash with sharply defined edges for which he was to become famous. *Harlech Castle and Tygwyn Ferry* (Yale) dated 1804 is an early example of this style[15] and it is closely comparable with Cotman's work of the same period. This has given rise to partisan views as to the priority of one or other artist as the progenitor of the broad wash style.[16] However, as they had worked together in the Sketching Society from 1802 and were sharing a common interest in the effects of very broad shadows in 1803 (for example, Varley's *Kirkstall Abbey*, Stoke on Trent Art Gallery, and Cotman's *Rievaulx*[17]), it is likely that the two artists were experimenting concurrently on similar lines. And although Cotman and Varley both developed unmodulated, flat washes at the same time, Cotman always remained more firmly tied to the natural phenomena he was depicting. Varley's most famous work in this style, *Mountainous landscape: afterglow c.* 1805 (**18**), is a more conceptual construction, dominated by rules of balance, than anything Cotman painted. It represents the most complete rendering of Varley's principle of simplicity, of emphasizing the main subject and cutting out all inessentials. Indeed, in omitting Picturesque irregularity and using his newly developed broad wash in a sombre dark blue colour to emphasize the awe-inspiring monumentality of the mountains at twilight, he has moved firmly from the complexities of the Picturesque to the Sublime.

Notes

1. J.P. Neale in Jenkins MS; Roget, 1891, I, p. 168.
2. William Combe, *Dr Syntax in Search of the Picturesque*, 1812; see John Hayes, *Rowlandson, Watercolours and Drawings*, 1972, pp. 52, 199, pl. 135; *Northanger Abbey*, chapter 14.
3. N. Pevsner, 'The Genesis of the Picturesque', *Studies in Art, Architecture and Design*, I, 1968, pp. 78–101. The two best general introductions remain E.W. Manwaring, *Italian Landscape in 18th Century England*, 1925; Christopher Hussey, *The Picturesque*, 1927. For a more detailed analysis of the literary aspects, see W.J. Hipple, *The Beautiful, the Sublime and the Picturesque in 18th Century British Aesthetic Theory*, 1957; Martin Price, 'The Picturesque Moment', in F.W. Hilles and H. Bloom, ed., *From Sensibility to Romanticism, Essays presented to Frederick A. Pottle*, New York, 1965, pp. 259–92.
4. Edited, with an illuminating introduction, by J.T. Boulton, 1958.
5. See especially W. Gilpin *Observations on ... the Mountains and Lakes of Cumberland and Westmorland relative chiefly to Picturesque Beauty made in the year 1772*, 1786, I. pp. 87 ff; C.P. Barbier, *William Gilpin*, Oxford, 1963; Uvedale Price, *Essay*, 2nd ed., 1796, pp. 71–6.
6. Archibald Alison, *Essays on the Nature and Principles of Taste*, 1790, Essay I.
7. Richard Payne Knight, *Analytical Enquiry into the Principles of Taste*, 2nd ed., 1805, p. 145. On Payne Knight, see Pevsner, op. cit., pp. 109–25; M. Clarke and N. Penny, *The*

Arrogant Connoisseur: Richard Payne Knight, 1751–1824, Whitworth Art Gallery, Manchester, 1982.
8. Lyles, 1984.
9. Walker Art Gallery, Liverpool; Solkin, 1982, no. 117A.
10. *The Works of the Late Edward Dayes*, 1805, Cornmarket Press reprint, ed. R.W. Lightbown, 1971, p. 292.
11. Esther Moir, *The Discovery of Britain: The English Tourists, 1540–1840*, 1964; Clarke, 1981, ch. 2; see also the full bibliography by M.I. Wilson, *Early British Topography*, V & A Museum, 1977, and Ronald Russell, *Guide to British Topographical Prints*, 1979; and, for the Welsh revival, Solkin, 1982, pp. 86–103.
12. Original print in the Bryn Tyrch Hotel, Capel Curig.
13. Lyles, 1984; Agnew, *111th Annual Exhibition of Watercolours and Drawings*, 1984, no. 90.
14. Bicknell, 1981, no. 123, repr.
15. Bayard, 1981, no. 34, repr.
16. Hardie, 1967, II. p. 104, and Pidgley, 1975, p. 56 argued for Varley's primacy.
17. Rajnai, 1982, no. 14.

III Years of success 1805–12: teacher & astrologer

On 30 November 1804, at an informal meeting at Samuel Shelley's house in George Street, Hanover Square, a group of watercolour painters, including Robert Hills, W.H. Pyne, W.F. Wells, John Varley, John Glover and Sawrey Gilpin decided to establish a Water Colour Society for the purpose of holding annual exhibitions of watercolours, exclusively the works of the members who were limited to 24. The first exhibition, which opened in April 1805 at 20 Lower Brook Street, heralded a new era in the history of English art.[1]

For some years the watercolour painters had felt themselves at a disadvantage on the walls of the Royal Academy where their work was confined to one small room and was in every way overshadowed by the oil paintings. Underlying their grievance was a change in the status of watercolour, brought about by changes in technique and the existence of a growing number of specialist practitioners called into being by an expanding market. Some of these developments were described with admirable clarity in a series of articles entitled 'Observations on the rise and progress of paintings in watercolours' published in Ackermann's *Repository of Arts* in 1812–13.[2] Although painting in watercolour was an ancient tradition, it was argued, the contemporary British school 'may be almost considered as a new art'. The old masters had produced sketches in watercolour, consisting of lightly tinted pen outlines 'a custom that is entirely at variance with nature'. The new British school, by contrast, had pigments prepared with gum to achieve greater depth of tone, and painted finished works rather than sketches. Contributing to these changes in technique were the products of two ingenious manufacturers, William Reeves, whose cakes of pigments were strong and fast and saved artists the time-consuming task of preparing their own colours, and James Whatman, the Kent paper manufacturer, whose new 'vellum paper' (wove paper) 'at once superseded all other fabrics'. Its surface was unbroken by the wire marks of traditional laid paper and it was far easier to spread washes on the new paper than on the old.

The technical development of the watercolour was more fully discussed in a well known essay by W.H. Pyne in the *Somerset House Gazette* in 1823.[3] The basic change was attributed to Turner and Girtin in the 1790s. They made watercolours 'on the same principles which had hitherto been confined to painting in oil, namely laying in the object upon his paper with local colour and shadowing the same with the individual tint of its own shadow'. This was indeed a fundamental change, but it was an earlier generation, Towne, Pars and especially Cozens who, from about 1780, first used pure washes modelled by darker tints of the same colour, effectively

to model with colour rather than line. This technique was passed on in the Monro school to the younger generation which went on to use other means to obtain depth and varieties of texture, including sponging, scraping, rubbing with bread crumbs and cutting. A.T. Story describes Varley using these techniques to such an extent that he would 'moisten and rub the paper clean away' in order to obtain his brilliant highlights. He almost invariably used a paper prepared by himself; a thin white or cream wove laid on good Whatman paper and laminated to several other sheets.[4]

Finally, to complete the emulation of oil paintings, exhibition watercolours were framed in gilt, without mounts or with gilt slip frames which served to enhance the mellow tones of the watercolours. Much, therefore, was done to give watercolours the power and richness of oil paintings, yet in his *Treatise* Varley was at pains to emphasize the special qualities of his chosen medium. Watercolour had a transparency, enhanced by the whiteness of the paper, which matched the growing interest in atmosphere and changing qualities of light, and these could be 'more readily explored in watercolour than in oil'.[5] It is paradoxical that typically the watercolour artist increasingly turned his back on these innate qualities in order to emulate oil paintings, while Constable and other practitioners of the oil sketch made brilliant use of the oil medium to achieve the rapidity and instantaneousness for which Varley demonstrated the superiority of watercolour.[6]

Changing technique was not the only factor in the growing popularity of the watercolour. The unknown author of the 1812 essay, probably W.H. Pyne, went on to identify 'the greatest encouragement to landscape drawing' as the love of exploring 'the beautiful scenery of our island'.[7] Gilpin had made landscape drawing of the English and Welsh countryside respectable for connoisseurs, and the case was most strongly emphasized in J.H. Pott's *Essay on Landscape Painting* (1782): 'The English park and forest afford an infinite variety of character in its trees, an endless choice of foliage. We have also a great advantage over Italy itself in the great variety and beauty of our northern skies...'.[8] And, by 1800, such sentiments were shared by the painters as much as by their patrons who would, in all likelihood, have made the same tours in England and Wales.[9]

Meanwhile, the selling exhibition was, to some extent, replacing more traditional forms of patronage by direct commission and the watercolour artists were in the vanguard of the new trend. The Water-Colour Society's first exhibition was a great success, attracting 12,000 visitors at 1s od a time in its six-week run. Its success continued for several years, the exhibition of 1809 receiving glowing reviews and as many as 23,000 paying visitors, even

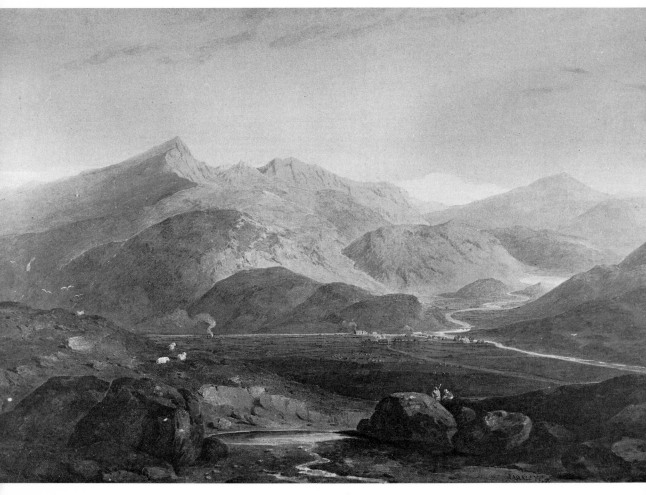

FIG. 13 Varley, *Snowdon from Moel Hebog*, 1805
Watercolour, $21\frac{1}{4} \times 31\frac{1}{4}$. Private collection
Bought for 10 gns at the OWCS exhibition, 1805

after a rival group had established the New Society of Painters in Miniature and Water Colours, later the Associated Artists, in 1807.[10]

Varley took a leading part in the Water-Colour Society in its early years and enjoyed a considerable personal success in its exhibitions. In 1805 he contributed 42 watercolours out of a total of 275, of which 30 were sold for £139 13s od. He continued to be the most prolific exhibitor, with an average of 44 works in the exhibitions of 1805-12 and, despite his modest prices, he usually managed to earn over £150 at these shows, reaching a peak of £213 10s 6d in 1808.[11] Looking back on those early years of the Society in 1855, Varley's pupil Francis Oliver Finch described their difficulties in gathering sufficient exhibits for an approaching show:

> At those times several of the Members set to work to supply as many pictures as possible. Fielding, Robson and Varley made up about the two thirds of the whole exhibition. Varley used to go home at night and invariably bring down to the gallery a bundle of fresh drawings in the morning – these were called by the Members – 'Varley's Hot Rolls'.[12]

Varley's prices ranged from $1\frac{1}{2}$ to 10 guineas at the 1805 exhibition and from 2 to 21 gns. in the following years. This was about average; considerably less than Glover, for example, who asked for and obtained 30 and even 50 gns., but more than his brother, Cornelius, an artist whose very considerable talents went unrecognized and whose work remained unsold. Prices, then as now, were governed by size. Two of the watercolours bought by William Ord of Whitfield in Northumberland at the 1805 exhibition can still be identified in a private collection: no. 111, *Snowdon from Moel Hebog* sold for £10 10s od and no. 168 *Llanberis Lake with Dolbadarn Castle* for £8 8s od (figs. 13, 14). Both are exceptionally large and imposing works, the first measures $21\frac{1}{4} \times 31\frac{1}{4}$ in., the second $15\frac{3}{4} \times 21$ in. For Varley's more routine output Mr Ord paid a mere £1 11s 6d (nos. 199, 200) and £2 12s 6d (no. 198).

The increase in the number of exhibitions and the number of artists exhibiting was a phenomenon not limited to England in the early nineteenth century. The Paris Salon had 282 exhibitors in 1800, rising to 786 in 1824 and 1212 in 1831, at which date the complaint was commonly voiced that 'works of art had become a merchandise and the Salon a bazaar'.[13] Given the relatively low prices of the watercolours exhibited and their emphasis on the countryside of England and Wales it is tempting to see the success of the Water-Colour Society as evidence for the growing patronage of the middle classes. However, the fact remains that Varley's principal patrons at these exhibitions in the years 1805-10 belonged to the traditional connoisseurs among the aristocracy and landed gentry. Most of

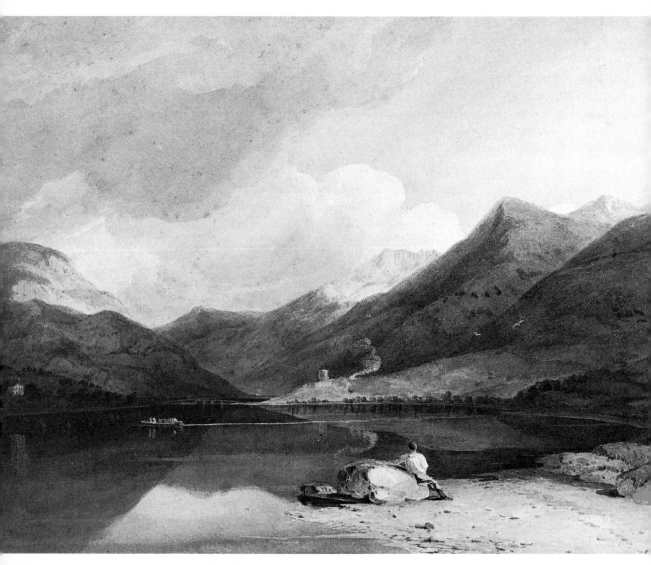

FIG. 14 Varley, *Llanberis Lake with Dolbadarn Castle*, 1804
Watercolour, $15\frac{3}{4} \times 21$. Private collection
Bought for 8 gns at the OWCS exhibition, 1805

them, indeed, were well known names among the principal patrons of the arts of the period: Sir Henry Englefield, FSA, antiquary; Lord Essex, amateur artist; Thomas Hope, patron of neo-classicism; Lord Ossulston; William Ord; Lord Cawdor; Sir John Swinburne; Walter Fawkes, Turner's patron; Edward Lascelles, later Earl of Harewood; Lord Manson; Sir Thomas Gage; and the Duc d'Avaray. A few 'new men' may be inserted in the list, but they tended to be city grandees like George Hibbert (1757–1837), a West India merchant and alderman of London from 1798 to 1803 and patron of the arts on a large scale, who bought Varley's watercolours at the OWCS in 1808, 1822 and 1827. There was a sprinkling of barristers, clergymen and military officers, but only occasionally is it possible to iden-tify a possibly new entrant to the patronage class. Mr J. Brogden, who bought two $1\frac{1}{2}$ guinea watercolours in 1805, appears to have been a gold-smith and jeweller at 16 Bridgewater Square.[14]

Varley exhibited much less after 1812, but the social background of his patrons, and indeed, those of his colleagues, remained the same. In the 1820s the principal buyers of his work at exhibitions were Lord Northwick and Lord Charles Townshend, and it was not until about 1830 that a change was discernible in the OWCS buyers' lists with a clear decline in the part played by aristocratic patrons. When Varley again exhibited on a large scale in 1840–42 there was hardly a title amongst his many pur-chasers, though those that can be readily identified belonged to the profes-sional rather than the industrial classes.[15] But by that time the dealer was replacing not only the country house but also the exhibition itself as the main channel of patronage. Inevitably, the social complexion of artistic patronage mirrors the rapid developments in English society during Var-ley's working life. When he began to exhibit his work in 1800 the popula-tion was 8·7 million and essentially agrarian; at the time of his death it was over 15 million, partially industrialized, and with a thriving middle class in the towns. And the shift of balance from upper- to middle-class patron-age, may be pinpointed at the very time when pressure was mounting for a reform of the franchise that led to the Great Reform Act of 1832.

But this is to anticipate. In 1805–12 Varley's principal patrons were largely identified with those whose sisters or daughters he taught, either in their country seats or their London residences. Typical of these was the Earl of Tankerville, one of a group of Northumbrian patrons, with whom Varley stayed at Chillingham, perhaps in 1808, and whose sister Mary, later Lady Mary Monck, was his pupil. They acquired many of his draw-ings, some of which have remained in the family; others are in the Laing Art Gallery, Newcastle.

FIG. 15 William Turner 'of Oxford' (1789–1862), *Trees on a river bank, c.* 1806
Black and white chalk on blue paper, 6½ × 11, V & A (E.253–1984)

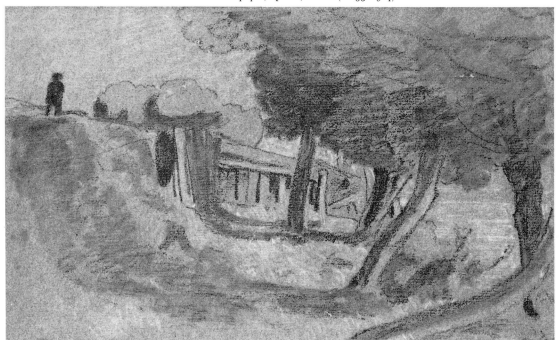

It was indeed as a teacher of both professional artists and well-born amateurs that Varley came into prominence, as much as for his leading role in the foundation of the Water-Colour Society. According to W.H. Pyne, Varley's reputation as a teacher was second to none: 'As a preceptor we know of no one to prefer to Mr Varley ... for no artist has ever studied his department with more abstract reasoning upon cause and effect.'[16] Mulready became his friend and pupil in 1803 when, at the age of 17, he married his elder sister Elizabeth Varley.[17] By about 1805–6 the whole of the rising generation of watercolour artists were his pupils. John Linnell, aged 13; W.H. Hunt, aged 15; William Turner 'of Oxford', aged 16; and Copley Fielding, aged 18, all lived at his house at about this time. Linnell describes how John Varley 'prognosticated that I might some day earn 400 a year', whereupon his father was persuaded to pay 'a sum about £100 I believe for me to live with J. Varley and proceed with my artistic education under his direction'.[18] Linnell went on to describe the liveliness of the Varley household and, in particular, the boxing matches at which Mulready's skill invariably defeated Varley's lumbering weight. All this is echoed in the autobiography of Francis Oliver Finch who became Varley's pupil a decade later, by which time the price had risen to £200 per annum.[19] Not all these pupils were apprenticed in this way: Cox and de

Wint, for example, took just a few lessons at this period, but they were both in their early 20s.[20] In any case, Varley's popularity as a teacher was still at its height in 1810 when the young Newcastle architect, John Dobson, later best known as the architect of Newcastle station, came to London. According to Dobson's daughter:

> Before commencing his profession, however, he resolved to seek the instruction of John Varley, the father of English water color drawing, and with this view proceeded to London. On his arrival, he found the realisation of his wishes attended with greater difficulty than he anticipated. Varley declined to be troubled with young pupils, and at first declared that he could not spare even half-an-hour. Observing, however, the intense disappointment of the youth, he at last consented to give him lessons at five in the morning, his time during the day being fully occupied.[21]

Varley's success as a teacher is substantiated beyond doubt, but there is something of a paradox in the reasons discernible for it. On the one hand he was a firm believer in principles of composition according to which nature was to be adjusted, and he came to publish these *Principles* in 1816. Indeed, his published work was, as we shall see, more dogmatic on the principles of good composition than that of any of his contemporaries and one could imagine that Varley's strength lay in the fact that he drilled his pupils in this discipline.

Paradoxically, however, the evidence of the pupils themselves points in the opposite direction. Far from having demanded slavish imitation and adherence to theoretical principles, Varley is constantly praised for encouraging his pupils to draw from nature and offering only the most general supervision. 'Copying drawings,' Linnell wrote, 'formed no part of the pupils' employment; they were constantly drawing from nature or trying to compose.'[22] Linnell goes on to describe Varley's pupils drawing studies at Millbank and, in 1805–6, on the Thames at Twickenham where Varley had rented a summer house. 'Hunt and I were always out when weather permitted painting in oil on millboard from nature.' Some of his pupils' work of this kind has survived, both oil sketches and drawings by Mulready, Linnell, Hunt and Turner of Oxford, and they are direct studies from nature, most typically close-up views of trees on an embankment (fig. 15), similar to Varley's own studies (**24**) and quite untrammelled by the formalism which characterized most of his exhibited work.

From this evidence, Varley has been accorded recognition as father figure of *plein air* painting in early nineteenth-century England,[23] but unfortunately only a handful of his London scenes of this period survive. Typical, perhaps, are the chalk studies of willows on the river bank (**24**)

and also two recently exhibited watercolours of the Thames at Chelsea which are similar in style to the *Handborough, Oxon.* of 1804 (**16**), though less uniform in colouring and probably a few years later.[24] There is apparently nothing extant by Varley comparable to the studies of suburban subjects made by Mulready and Linnell in Bayswater in 1811–12. His earliest dated watercolour studies of Lambeth and Millbank are 1816, though, as we shall see, there is evidence that he was painting such scenes as early as 1809.

From Varley, his pupils learnt the principles of composition and the importance of making direct studies from nature. They must also have been taught the importance of simplification and of the flat wash which dominated his own work at this period. An early sketch by David Cox in Wales demonstrates this influence;[25] at least it shows the artist experimenting with washes unstructured by pencil underdrawing, and de Wint also remained a master of this technique throughout his career. However, it is a matter of surprise how little of Varley's style is visible in the work of his professional pupils. Quite the contrary: his strength lay in encouraging them and infecting them with his enthusiasm, without forcing them to accept his stylistic modes. As Cornelius put it: 'he gained credit for these because they distinguished themselves without showing any likeness to their Master.'[26]

Varley's principal importance as a teacher lay in the fact that he taught a whole generation of English artists coming to maturity in the years 1805–10. But more beneficial financially and for the development of his own career was the part he played in the booming profession of drawing master to amateurs, mainly well-born ladies. At a guinea an hour[27] these lessons provided him with a reasonable income, but, perhaps more vitally, they also gave him entry to households well placed to provide him with patronage for his watercolours. Not many works by his amateur pupils survive, but those that do, such as Lady Mary Monck's sketches of a tour in Scotland, 1826, recently acquired by the Laing Art Gallery, Newcastle, show the unmistakable imprint of Varley's style and compositional methods. In spite of Linnell's specific statement that 'copying his drawings formed no part of his pupils' employment', it clearly did play a part in the teaching of amateurs, perhaps increasingly so in later years. The three drawings in the collection apparently made for pupils to copy date from about 1810 (**17, 21, 26**) and for the importance of this method we have the evidence of Elizabeth Turner, daughter of the Yarmouth banker Dawson Turner, who took lessons from Varley when he visited them in October 1822 (see **34**).

All this week we have been much and most delightfully employed in listening to and observing Mr Varley, the water-colour artist, who has stayed with us while Papa was at Holkham. It is not enough to tell you that we have been delighted with this most singular man: I must try to describe his character a little, it is so rare and extraordinary. Far from feeling any jealousy for himself in his art, Mr Varley possesses so high an opinion of its excellence and so true a desire for its extension, that, as Moses – solely earnest for the honour of his God – wished all the people might be prophets, so he would make everyone an artist, and as good a one as himself. Not only has he, with most unwearied diligence, sought to show us every way of copying his drawings, he has also tried to make us compose, and explained to us all those principles of composition, which after many years of hard fagging, he discovered himself. But alas! All his endeavours are vain! We can copy, and that is all. Mr Varley's kind efforts have only served to prove to us the strong line of demarcation which separates the artist from the draughtsman; the one who, with a principle of beauty firmly impressed on his mind, goes out and arranges the materials Nature affords according to his pre-conceived idea, and the other who draws for ever without ever making a picture, or raising any feeling in the spectator. But it is not Mr Varley's fault if we are not now all Michael Angelos.[28]

All this is a far cry from the young teacher who took his pupils for sketching trips on the banks of the Thames in 1805-6. But before leaving Elizabeth Turner, it is worth considering the rest of her acute appreciation of her drawing master:

I have not however yet mentioned the strangest part of Mr Varley's character, and that which makes mere casual observers esteem him mad. With all his nobility of mind he unites a more than childish simplicity and credulity, and he entirely believes in astrology, palmistry, raising of ghosts and seeing of visions. All the errors which have been detected and exposed ages since, he chooses to revive. And this part of his character lies open at first sight, for he dashes at once into astrology and was not happy until he had cast all our nativities. Yet he is quite sane in mind, even on this insane topic.

This view represents the general consensus on Varley's astrological activities; it demonstrates his own obsessive interest in astrology and also the contempt this earned him in genteel society, where astrology had not been held in high esteem since the seventeenth century. The ancient science of astrology, going back to Babylonian times, postulated a single system in which the seven moving stars or planets shift their position in relation to the earth and each other against a fixed backcloth of the twelve signs of the zodiac. No one doubted that these heavenly bodies affected life on earth and the nature of the influence depended on their position in the sky. Accordingly, by drawing a map of the heavens – a horoscope – the astrologer could analyse the situation and assess its implications. Indeed, if he

FIG. 16 *Astrological diagrams* Plate 2 in Varley's
Treatise on Zodiacal Physiognomy, 1828

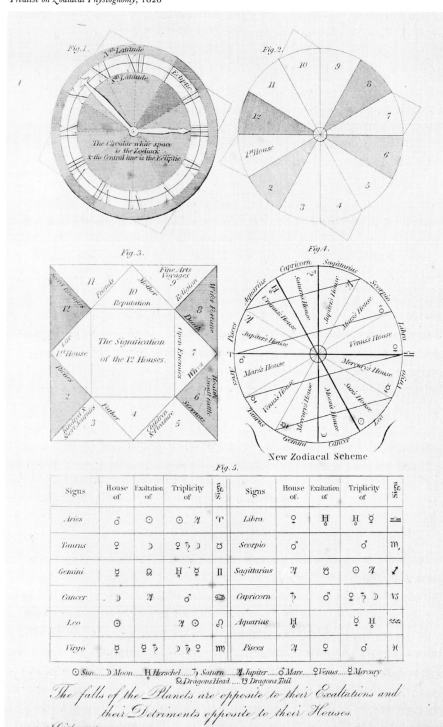

was equipped with sufficient professional knowledge, he could construct a horoscope for a future point of time and enter the field of prognostication.

A central feature of astrological belief was that the stars transmitted to individuals different quantities of the four physiological qualities of heat, cold, dryness and moisture, which underlay the four humours, and hence the study of astrology was seen to be important for medicine, botany, psychology and, as Varley was to point out, for an understanding of physical appearance. Indeed, as late as the sixteenth and seventeenth centuries, astrology, far from being the occupation of a handful of eccentrics, has been characterized as 'an essential aspect of the intellectual framework in which men were educated'.[29] Even in the second half of the seventeenth century, successful astrologers like William Lilly and Nicholas Culpeper counted the most elevated ranks of society among their clientele, and Elias Ashmole was frequently asked to cast horoscopes to assess the auspices of Charles II's position in Parliamentary politics between 1669 and the 1680s.[30]

However, the ancient Ptolemaic world picture could not survive the astronomical discoveries of the period from Copernicus (1473-1543) to Newton (1642-1727) and it is these which ultimately drove astrology to the margins of obsolete belief. It survived mainly among the less sophisticated who provided a consistent readership for the ever popular almanacs. John Varley, therefore, was looked upon as an eccentric in the circles in which he moved. He cast his own horoscope each morning, and, according to one of his friends, 'Varley rarely was introduced to anyone that he did not in a short time ask them for the day and hour of their birth; his pockets were always crammed with old almanacks.'[31] His clients included the socially grand, such as Lady Blessington, as well as fellow artists like William Bell Scott, and there are countless stories of his prognostications.[32] He was said to have foretold the fire that burnt down his house in 1825, the marriage of the painter A.W. Calcott at the age of 48 and, on more than one occasion, the death of William Collins.

Although astrology was unfashionable in Varley's circles, his interest must be considered against the background of popular millenarianism which was at its height in the early years of the nineteenth century. Older generations of artists, such as de Loutherbourg and Fuseli, had followed the mystical teaching of Swedenborg with its emphasis on the second coming and the new Jerusalem, but it was with the visionaries of the 1790s, Robert Brothers and Joanna Southcott, that millenarianism became a popular belief.[33] Joanna Southcott (c. 1750-1814), self-styled prophetess, had a large following after she came to London from Exeter in 1801, which

rose to an estimated 20,000 by 1814. She believed in a direct relationship between the visible and invisible worlds and that certain persons were favoured with a special knowledge of this relationship which enabled them to prophesy the future. She was to give birth to the saviour in 1814 at the age of 64, but she died instead. Her followers were mainly in London and the northern industrial towns and most numerous among artisans, shop keepers and small farmers, and the millenary beliefs of the time must be seen as a response to the social upheaval of industrialization from the insecure or oppressed sections of society.[34]

John Varley had no direct links with movements of this kind, but there was at least one point at which visionary millenarianism impinged on his interests in astrology and the occult and that was his friendship with William Blake. It was Linnell who introduced Varley to Blake in September 1818[35] and thereafter they remained firm friends until Blake's death nine years later. The friendship is recorded in Linnell's pencil drawing of Blake in conversation with John Varley, 1821 (Fitzwilliam Museum) which shows an enthusiastic Varley holding forth to a somewhat amused Blake.[36] Indeed, Linnell recounts that Varley could make no headway in inducing Blake towards astrology, but on the other hand

> it was Varley who excited Blake to see or fancy the portraits of historical personages ... Varley believed in the reality of Blake's visions more than even Blake himself, that is in a more literal and positive sense that did not admit of the explanations by which Blake reconciled his assertions with known truth.[37]

During their evening sessions at Varley's house in Great Titchfield Street in 1819–25, Blake drew the figures he saw in his visions, some of them in one of Varley's sketchbooks which he had ready for the purpose.[38] They included biblical and historical figures, such as Socrates, Boadicea, Mahomet, Canute and Wat Tyler as well as more humorous or abstract concepts like the *head of the ghost of a flea* and the *man who taught Blake painting in his dreams*. How seriously Blake himself took these visions is open to dispute. Certainly Varley's credulity was greater than Blake's, but Martin Butlin's complete scepticism has been fiercely contested by a modern authority on the occult,[39] and it has been suggested that they were eidetic or optical perceptual images, the result of auto-suggestion.[40] Such an explanation does not exclude the likelihood of Blake borrowing from other sources and there can be little doubt of the direct influence of Lavater's theories of physiognomy.[41]

Johann Caspar Lavater, a Zwinglian minister at Zurich, set out to demonstrate that man's innate moral and intellectual powers determine his outward appearance and that an observer can ascertain the character of a

FIG. 17 *Facial types determined by astrological factors* Plate 4 in Varley's *Treatise on Zodiacal Physiognomy*, 1828, Linnell's engraving after Varley

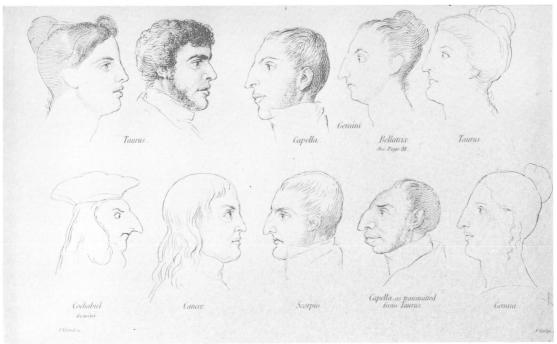

person by carefully studying his features. Ultimately, he argued, the improvement of man's spiritual qualities would make the body more beautiful. His *magnum opus* was translated into English under the sponsorship of his friend Fuseli and published as *Essays in Physiognomy Designed to Promote the Knowledge and Love of Mankind*, 1789–98, in five volumes lavishly illustrated with more than 800 engravings. From Lavater's *Physiognomy*, his followers Franz Joseph Gall and Johann Caspar Spurzheim developed phrenology, or the study of the cranium. Spurzheim was in London from 1808 expounding his theories that the shape of the skull manifests the development of the organs of the brain, and his views gained widespread currency when he published *The Physiognomical System of Drs Gall and Spurzheim* in 1815.

Blake, who had contributed four illustrations to Lavater's text in 1789, was fully conversant with physiognomical and phrenological concepts, and it is very likely that these theories played some part in the formulation of his visionary heads. Varley shared these interests and he copied some of Blake's heads probably with the aid of the Patent Graphic Telescope, not only for their intrinsic appeal but for their link with his own project, *A Treatise on Zodiacal Physiognomy*, of which the first and only part was published in 1828.

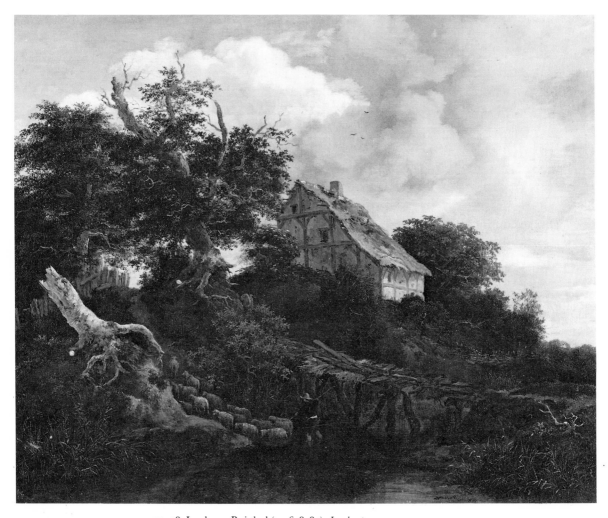

FIG. 18 Jacob van Ruisdael (*c.* 1628–82), *Landscape
with a cottage, bridge and sheep*
Oil on canvas. Glasgow Art Gallery and Museum
Compare Varley's cottage scenes (**29, 30**)

Varley's *Treatise* takes note of the work of Lavater and Spurzheim, but he finds the mainspring of human physiognomy in the basic astrological belief that the influence of the heavens at the moment of birth accounts for the differing physical characteristics, abilities and temperaments of mankind. His introduction to physiognomy echoes Lavater: 'every quality of the mind, temper and disposition is correctly expressed by the features of the face',[42] but as the stars govern the four humours, so by extension they leave their indelible mark on our features. For example, the principal physiognomical indications of the dominion of Mars in Aries 'are observable in the well formed chin, ample but not in excess, squareness of jawbone, and in the nose the martial style ...'. His descriptions are illustrated by a series of profiles and frontal heads engraved by Linnell mainly from Varley's drawings (fig. 17). Five sheets of the original drawings are still extant, including the complete page layouts for plates 3 and 4, as well as some freer sketches.[43] Two of the illustrations, the *head of the ghost of a flea*, and the *reverse of the coin of Nebuchadnezzar* are derived from Blake's visionary heads. In general terms these illustrations are in the tradition of Lavater's. *Essays on Physiognomy*, and yet there is no doubt that it is in this consideration of physical appearance as governed by the stars that Varley's activities as artist and astrologer are most closely intertwined.

At all these points – the survival of astrology and popular messianism, the friendship with Blake, and the theories of Lavater – Varley's life and interests illuminate trends in early nineteenth-century English society, but the sad truth is that these interests hardly impinged on his watercolours. Varley himself took it for granted that there was a fundamental connection between his position as an acclaimed teacher of art and his authority as an astrologer. He was, indeed, known at *Vates* (prophet or seer) by his pupils. Astrology was not just an eccentric hobby, as seen by his contemporaries and biographers. The trouble remains that his view of himself as an authority on the mysteries of life and art far outran his own abilities as a practising artist. The fact that Varley was an astrologer adds a dimension to his personality and is of interest in considering the artist's role as a seer, but it does not affect the form of his own work.

Meanwhile, to return to more mundane matters, Varley made a tour of Northumberland in 1808, visiting his Northumbrian patrons, William Ord of Whitfield, Sir John Swinburne of Capheaton, and the Countess of Tankerville, and sketching the coastal castles at Warkworth, Dunstanborough, Bamburgh and Lindisfarne (**25**). Henceforth, Northumberland, like Wales, provided a repertoire of subjects upon which he was to draw for the rest of his career. His best Northumbrian views of the period 1808-12 are essen-

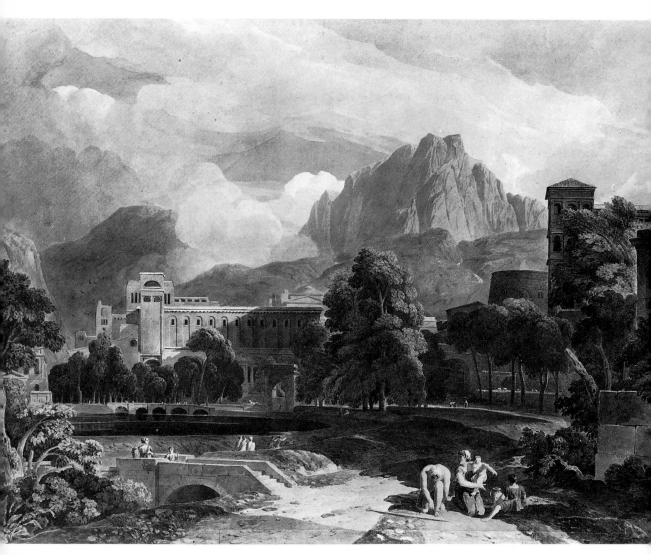

FIG. 19 Varley, *Suburbs of an ancient city*, 1808
Watercolour, 27⅞ × 37. Mrs Basil Taylor

tially in his broad wash style, but with modifications (**26-8**). There is a
return to some modelling of mountains and the sea is characterized by an
orderly progression of precisely defined scraped out white waves contrasting
with the darker tones of the water. Increasingly from about 1810 Varley
favoured a long and narrow panoramic format for the Welsh (**32**) and
Northumbrian views.

This is the period also of his cottage scenes (**29, 30**) of which there are
prints dating from 1805 and 1815. The cottage, with its timbered structure,
irregularly crumbling infill and thatched roof was a favourite subject of
picturesque landscape. 'Cottages, mills, outhouses and hovels,' wrote Uve-
dale Price, 'many of which are in their entire state extremely picturesque
and almost all become so in decay'.[44] Varley himself expanded on these
sentiments concerning

> cottages, which form the principal subject of the picture, it is not to those newly
> formed to which we attach the pleasures of association, but from such objects
> as seem to have existed for generations; from the aged tree, and seat, under
> which the peasant and his forefathers have enjoyed the society of their families
> and friends . . .[45]

The idea of an ancient rustic calm was an ideal for town dwellers, like
Varley, in a time of rapid social change, and one that was highly acceptable
to his well-born patrons.[46] But far from being, as was believed, the home
of the medieval peasant, the great majority of these cottages belonged to
well-off yeomen and were constructed during the rebuilding of rural Eng-
land in the two centuries c. 1570-1770.[47] As a pictorial subject, they were
favoured by the Dutch school in the seventeenth century as is pointed out
in the text to one of Varley's plates in Francis Stevens's *Views of Cottages*
(1815): 'Those who feel desirous of acquiring the principle of colouring this
class of subject should observe the pictures of the Dutch and Flemish
masters.' But even a cursory comparison with the expressive intensity of a
cottage landscape by Jacob van Ruisdael (fig. 18) will demonstrate how
much the subject lost by the conventions of Augustan pastoralism and
English Picturesque theory and practice.

Although the simplifications of the flat wash style continued to dominate
Varley's work until about 1812, he had already begun to introduce more
strictly classical motifs, derived from seventeenth-century epic and pastoral
landscape. As early as 1808 he had exhibited the large and imposing *Suburbs
of an ancient city* (fig. 19) at the Water Colour Society where it was bought
for the unprecedented sum of £42 by Thomas Hope, well known as a
patron, connoisseur and historian of neo-classicism.[48] The ancient build-
ings, bridges and fragments accompanied by a pool in the foreground are

precisely as he described classical landscape in his *Treatise on the Principles of Landscape Drawing* eight years later. And although the mountain background depends on Varley's reminiscences of Wales, the classical buildings and the grandiose, symmetrical composition are modelled on Poussin. Varley's aim, to recall the grandeur of a long vanished classical past, was not in itself unusual, but in terms of watercolour this was, for its time, a highly ambitious work. A perceptive contemporary review described its strength and its weaknesses in the following terms:

> If this picture has faults, they arise out of the redundance of its merits, or rather we should say, proceed from the excess of those principles which have guided the artist in its production. The solidity of the shadows is perhaps carried to an extreme that may border on heaviness; and the long horizontal lines which prevail in the lower part, and form a firm basis for Mr Varley's towers and mountains, may be rather too obviously opposed to forms which are broken, pyramidal, upright, or irregular.[49]

Scenes dominated by ancient buildings and ruins remain a feature in his subsequent career (**39, 57, 67-8**), but much more common was his fusion of ideal Claudean composition, meticulously finished, with Welsh landscape scenery. An early example of this kind is the *Snowdon from Capel Curig* dated 1810 in the Birmingham Art Gallery. Forerunner of what was to become a common type (e.g. **36**), it emulates in the clarity and detail of its finish and its carefully balanced composition, the style of a Claudean oil painting.

NOTES

1. Roget, 1891, pp. 175 ff., 201 ff.
2. Ackermann's *Repository*, VIII, 1812, pp. 257, 324; IX, 1813, pp. 23, 91, 146, 219.
3. Vol. I, 1823, p. 67. Ephraim Hardcastle, editor of the *Somerset House Gazette*, was the pen name of W.H. Pyne, one of the founders of the OWCS. For recent discussions of the technical developments, see Gage, 1969, pp. 27 ff.; Wilton, 1979, pp. 58 ff.; Clarke, 1981, pp. 12 ff.; Bayard, 1981, pp. 15 ff.
4. Story, 1894, pp. 284 ff.
5. Varley, *Treatise*, 1816, Introduction.
6. On the use of oil sketches at this period see Gage, 1969-70; *Painting from Nature: The Tradition of Open-Air Oil Sketching from the 17th to the 19th Century*, Arts Council 1980-81.
7. *Somerset House Gazette*, IX, 1813, p. 146.
8. J.H. Pott, *Essay on Landscape Painting*, 1782.
9. See chapter 2, note 11.
10. Roget, 1891, I, pp. 203, 233 ff.
11. OWCS price books.
12. Jenkins MS.
13. N. Hadjinicoloau, 'Studies in the status of the artist in France . . .', summary of a lecture, *Bulletin of the Association of Art Historians*, 17, December 1983, 9. i.
14. *The Post Office Annual Directory*, 1807, p. 38.
15. Of the buyers at the 1841 OWCS exhibition, Samuel Angell was an architect and Benjamin Austen a solicitor.
16. *Somerset House Gazette*, I, 1824, p. 13.
17. Heleniak, 1981, pp. 7 ff., 37 ff.
18. Linnell, *Autobiography* MS, p. 5; Story, 1892, p. 24.
19. Finch, 1865, p. 14.
20. Wildman, Lockett and Murdoch, 1983, p. 35; Scrase, 1979, p. x.
21. Margaret Jane Dobson, *Memoir of John Dobson*, 1885, p. 13.
22. Linnell, *Autobiography* MS, p. 7.
23. Gage, 1969-70, p. 12. For early, naturalistic works by his pupils, see also Crouan, 1982, nos. 1-4; John Witt, *W.H. Hunt*, 1982, p. 32, pl. 2.
24. Michael Bryan, *In Cheyne Walk and Thereabout*, exh. at Alpine Gallery, 1984, nos. 10-11.

25. Wildman, Lockett and Murdoch, 1983, no. 2.
26. Jenkins MS, fol. 3.
27. Roget, 1891, I, p. 314.
28. Quoted by Kitson, 1932–3, p. 74.
29. Keith Thomas, *Religion and the Decline of Magic*, Peregrine ed., 1982, p. 338. This section is much indebted to Chapters 10 and 11 of Thomas's stimulating book.
30. *Elias Ashmole and his World*, exh. at Ashmolean Museum, 1983, no. 18.
31. Mrs Ward in Jenkins MS.
32. Hardie, II, 1967, p. 102 (Lady Blessington); *Autobiographical Notes of the Life of W.B. Scott*, ed. W. Minto, I, 1892, p. 118; individual incidents are recounted by Story, 1892, pp. 23 ff., 1894 pp. 242 ff. and Bury, 1946, chapter III, who based his account on an article by John Varley jun., 'Some astrological predictions of the late John Varley', in the *Occult Review*.
33. J.F.C. Harrison, *The Second Coming: Popular Millenarianism 1780–1850*, 1979.
34. *Ibid.*, chapter 5.
35. Linnell, *Journal* MS, 18 September 1812: 'To Mr Blake with Mr Varley evening'.
36. Butlin, *William Blake*, Tate Gallery exhibition, 1978, no. 280, repr.
37. Linnell, *Autobiography* MS p. 59, quoted by Butlin. On the Blake–Varley friendship, see Cunningham, 1830, II, pp. 167 ff.; Gilchrist, 1863 (revised ed. 1942), pp. 262 ff.
38. Butlin, 1969; 1973; 1981, pp. 495–531, contains a catalogue of the Visionary Heads.
39. Gettings, 1978, pp. 109–25.
40. Joseph Burke, 'The eidetic and the borrowed image: an interpretation of Blake's theory and practice of art', in F. Philipp and J. Stewart, *In Honour of Daryl Lindsay, Essays and Studies*, Oxford, 1964, pp. 110–27.
41. Anne K. Mellor, 'Physiognomy, phrenology and Blake's visionary heads', in R.N. Essick and D. Pearce, *Blake and His Time*, 1978, pp. 53–74.
42. Varley, 1828, p. 56. For Varley's followers in this field see M.C. Cowling, 'The artist as anthropologist in mid-Victorian England', *Art History*, 6, 1983, pp. 461–77. For Töpffer's attack on phrenologists in 1845, see E.H. Gombrich, *Art and Illusion*, chap. X.
43. Christie's, 20 March 1984, lot 28.
44. Uvedale Price, *Essays*, II, 1798, p. 302.
45. Varley, *Treatise*, 1816, General Observations.
46. This interpretation of cottage scenes is most fully explored by J. Barrell, *The Dark Side of Landscape: The Rural Poor in English Painting, 1730–1840*, 1980.
47. C.H. Knowles, *Landscape History*, Historical Association, 1983, pp. 13 ff., with bibliography; E. Mercer, *English Vernacular Houses: A study of Traditional Farmhouses and Cottages*, 1975.
48. Bayard, 1981, no. 36.
49. *The Review of Publications of Art*, II, June 1808, p. 193. I owe this reference to Christopher Titterington.

IV The watercolour in retreat 1813-20

The boom in watercolours, inaugurated in 1805, was short-lived. By 1812 dwindling sales forced the members of the Water-Colour Society to swallow the bitter pill of allowing oil paintings to hang in their exhibitions. From 1813 until 1820 the Society's name was changed to include 'Painters in oil and water colours'.[1] Varley's case was typical: the peak sales of 39 works in 1809 dropped to 15 at the exhibition of 1812. It is tempting to see this decline as due to the cost of the Napoleonic wars and the ensuing financial strain on the rich,[2] but in fact the war years were a boom period for both agriculture and industry. The agricultural depression and ensuing social unrest followed the defeat of Napoleon in 1814–15 and the rapid fall in the price of corn. The depression clearly had its effect on the art market, but it can hardly explain the plight of the OWCS as early as 1812.

A review in Ackermann's *Repository* in 1810 suggests another reason for the decline in patronage of the watercolour: boredom at the monotony of the diet on offer.

> The first thing that strikes an observer ... is the overwhelming proportion of landscapes: a proportion almost as unreasonable as that of the portraits at Somerset House. In passing round the rooms the spectator experiences sensations somewhat similar to those of an outside passenger on a mail-coach making a picturesque and picturizing journey to the north. Mountains and cataracts, rivers, lakes and woods, deep romantic glens and sublime sweeps of country, engage his eye in endless and ever-varying succession. For a while he is delighted, but as he proceeds the pleasure gradually fades: he feels that even in variety there may be sameness, and would freely exchange a dozen leagues of charming landscape for a scene among 'the busy haunts of men'.

The reviewer went on to complain of the 'multitude of pieces that do not rise above mediocrity', and such criticism, combined with a contracting market, led to a decline in the lively experimentation in both *plein air* and sublime landscape. Varley was not alone in retreating to meticulously produced exhibition pieces in the manner of Claude's oil paintings. De Wint painted similar works from the 1820s,[3] and Cotman's immersion in antiquarian illustration provides another parallel. Yet Varley's rapid decline from a position of central importance in the Water-Colour Society must be seen as a personal one as much as part of a general decline in the importance of the watercolour. His average of 44 works at the OWCS exhibitions of 1805–12 dwindled to a mere eight in the years 1816–21. And as far as one can see from the scarcity of dated drawings of this period, this decline in exhibited works mirrors a general reduction in his output. In order to extend the scope of his subjects he took to painting Scottish and Irish landscapes from about 1812, adding Spanish and, occasionally,

French views from 1814, though he never actually visited any of these places. Instead, he copied available drawings superimposing the compositional schemata he had developed for his depiction of north Wales.

Although these were particularly lean years in terms of exhibited watercolours, Varley's name was kept before the public eye with the publication of his *Treatise on the Principles of Landscape Drawing* in 1816-18. It presents the distillation of his teaching methods and yet it is misleading to consider it in isolation. For the early nineteenth century saw a rapid growth in the literature of art which is most clearly discernible in the production of teaching manuals, particularly for amateurs of watercolour.[4] William Marshall Craig's *An Essay on the Study of Nature in Drawing Landscape*, 1793, was the first English teaching manual of this period and it was followed in rapid succession by a series of volumes directed at the student of watercolour: J.C. Ibbetson, *Process of Tinted Drawing* (1794); Edward Dayes, *Instructions for Drawing and Colouring Landscapes* (1805); John Heaviside Clark, *A Practical Essay on the Art of Colouring* (1807); and John Hassell, *Speculum* (1808). The last two in particular, with their stress on the need for approximations to nature and on the particular effects of brushwork in watercolour, have a modernity which mirrors the rapid development in the technique and status of watercolour painting in the years after 1800. And among Varley's own peers, both Samuel Prout (*Rudiments of Landscape in Progressive Studies*, 1813) and David Cox (*Treatise on Landscape Painting, and Effect in Watercolours*, 1813-14) preceded him in the production of lavishly illustrated teaching manuals.

Varley set the tone for his own work in his *Introduction*. The painter should represent the generally known aspects of nature rather than the accidental or particular and he should conceal or omit all that is inconsistent with the ideal. Inessentials must be omitted to bring out 'the great general truth of the objects delineated'. He goes on to illustrate the *Principles of light and shade* which demonstrate that a structure of contrasting tones underlie his compositions; that chiaroscuro, and not colour, is the basis of landscape watercolours. Subsequent plates outline the *Principles of objects reflected in water* and distinguish *Epic* – nearly always distant – from *Pastoral* landscape 'more close and retired'; treat a *River scene* and the *Ouse Bridge York* and the effects of the weather and the time of day: *Sunshine*, *Twilight*, and *Principles of skies in fine or stormy weather*.

In the first place, it is worth stressing how much Varley derived from his predecessors. The comparison of epic and pastoral landscape was probably conceived under the influence of Turner's *Liber Studiorum*. Claude and Gaspard Poussin are his main models – as they had been for generations of

FIG. 20 Varley, *Boat building*, 1806
Watercolour, $13\frac{1}{2} \times 21\frac{1}{2}$. Yale Center for British Art

English writers on art. The emphasis on chiaroscuro originates in an older aesthetic tradition of contrasts, summarized by Roger de Piles in his *Art of Painting* (English translation, 1706),[5] but now combined with Picturesque theories of variety and intricacy. And the central theme, that 'emphasis must always be on the principal subject', most widely recorded in his saying 'every picture must have a look there', may be traced in several of the manuals discussed above. Dayes, for example, stressed that 'every picture should have a principal feature' which should occupy the centre of the picture and that 'every art should be used to conduct the eye to it'.[6]

What distinguishes Varley from his predecessors is his extreme formalism. His basic rules are defined under the *Principles of skies*:

> the true exercise of Art consists in contrasting the round with the square, the light with the dark, the hard with the soft, the far with the near, the local and distinct with the general and indefinite . . .

Examples of such contrasts occur throughout the treatise. In the depiction of water (plate C), for instance, 'it has ever been a beauty of the highest class, to introduce the reflection of a warmish cloud in the midst of a cold mass of water'. Each shadow sets a foil to a particular highlight of middle tint, and their relationship with each other and with the principal objects delineated structures the composition according to strict and unvarying internal rules.

Varley's *Treatise on the Principles of Landscape Design* is his fullest work in this field but it was not the only one. His *Practical Treatise on the Art of Drawing in Perspective* (1815–20) contains eight pages of text and two plates of diagrams illustrating the rules of perspective. There are also three shorter works: *A Practical Treatise on the Art of Drawing* (c. 1815–20), *Precepts of Landscape Drawing . . . Instructions to Young Artists* (c. 1818) and *Studies of Trees* (1818–19). But these are short and rudimentary in comparison to his principal treatise. More interesting is *John Varley's List of Colours* (1816). Nineteen colours are listed, showing Varley's use of a very full colour range that contrasts with the more muted palette of his brother Cornelius. These are cobalt blue, Prussian blue, indigo, lake, gamboge, burnt Sienna, yellow ochre, Venetian red, vermilion, burnt umber, warm grey, purple grey, neutral tint, dark warm green, warm green, olive green, orange, Roman ochre, sepia. With each sample there are a few words of advice: indigo, for example, should be used 'for twilight and evening skies, but not sufficiently bright for skies in clear days'.

The year 1816 embodies the central paradox of Varley's career. It saw the publication of his *Treatise*, preaching the most uncompromising applica-

FIG. 21 Varley, *Millbank Penitentiary, c.* 1816
Watercolour, 10¾ × 16⅛. Museum of London

tion of formal rules of composition, but also the earliest dated examples of
his direct, informal views of Lambeth and Millbank which are in striking
contrast to the classicizing compositions of Welsh mountain scenery that
formed his staple output at this period.

Millbank – named after the Westminster Abbey mill which once stood
on the site – was a rural area lying between the ancient City of Westminster
and the urbanized village of Chelsea. Its marshy land, essentially a swamp
in winter, was used for growing vegetables in summer.[7] Some building
work was in progress at this time; the penitentiary, the present site of the
Tate Gallery, was completed in 1816, but it remained a rural suburb until
Thomas Cubitt's reclamation schemes led to rapid urban development in
the 1840s. Varley's depiction of Millbank was equivalent to the choice of
Bayswater by Mulready and Linnell; both were still essentially rural areas
on the verge of development. There is a comparable naturalism in these
drawings even though, unlike Linnell in his *Kensington gravel pits* (1813,
Tate Gallery), Varley does not appear to have painted scenes of manual
work or industrial activity after his early *Boat building* (1806; Yale) (fig.
20).[8] These scenes of Millbank (fig. 21), of the old Horse Ferry, Lambeth,

Vauxhall Bridge and Tothill Fields (**37**) form a coherent stylistic group. Although they still concentrate on the crumbling masonry of ancient cottages so dear to Picturesque theory, they are imbued with a much greater degree of naturalism. Their oblique views of unspectacular corners differentiate them from the formal eighteenth-century town views of the kind to which Varley's *Cheyne Walk* (**31**) still belonged. There is also a new informality in the relationship between figures and buildings which links these town views with urban genre painting, currently pioneered by Wilkie and Mulready. The tonality is lighter than in much of Varley's work and the luminosity and directness of such scenes suggest that they might well have been drawn from nature, though it is only some of the later ones that are actually inscribed *Study from nature*.[9]

Only three of this group of eight Millbank watercolours are dated (see under no. **37**) and as their dates are 1816 and 1817, it is reasonable to place the others in about the same period.[10] However, there is one piece of evidence to prove that Varley was painting such views at least as early as 1809. A quarto sheet dated 1 January 1810 and headed *Description of Drawings at present unsold and Numbered as follows* contains 37 thumbnail sketches in pen and ink of his compositions, possibly for use as a sample sheet for potential customers (Cyril Fry collection). Among the numerous views of Wales, Northumberland and Yorkshire, and a few of Home Counties locations like Eton and Watford, there is one inscribed *Millbank* and another *Lambeth Walk*. Although we cannot know how close these were to those of 1816-17, the pattern sheet supports the hypothesis that John Varley was making drawings of Millbank as early as Cornelius (e.g. Tate Gallery, no. T.1712, *c.* 1805) in a style comparable to the surviving works of the later period of 1816.

Notes

1. Roget, 1891, I, pp. 266 ff.
2. This was Roget's explanation, *loc. cit.*
3. For example, Scrase, 1979, nos. 45-6.
4. For a full discussion of these teaching manuals, see Dobai, 1977, chapter 6. They are listed in Hardie, III, 1968, pp. 284-88.
5. R. de Piles, *The Art of Painting and the Lives of the Painters*, 1706, p. 5.
6. 'Instructions for drawing and colouring landscapes', in *The Works of the late Edward Dayes*, 1805, Cornmarket Press, ed. R.W. Lightbown, p. 292.
7. Hugh Phillips, *Mid Georgian London*, 1964, pp. 13 ff.
8. Hawes, 1982, p. 182, no. V.9, pl. 156.
9. For example *Hackney Church*, 1830, British Museum.
10. There are also similar views of London dated 1817, e.g. Coldharbour Lane, Brixton, Agnew's *111th Annual Exhibition of Watercolours*, 1984, no. 79 (not repr.).

V Lean years 1820s and '30s: revival & death 1840-42

The main insights into Varley's life at this period come from Linnell's unpublished *Autobiography* and *Journal* and it is a gloomy picture that emerges. Linnell describes Varley often helping his friends at the expense of his own interests. 'All his acquaintances benefited by his generous activity to serve them and no one more perhaps than myself.' Varley 'acquired a large and valuable professional connection among the nobility and others and how ready he was to recommend to their notice and employment his brother artists'.[1] And clearly some of his pupils had at this stage far outstripped him in public recognition and commercial success. Linnell goes on: 'Most of my best connections and friends came through Varley – many whom he only gave a few lessons employed me largely – from Col Dumaresque who took lessons of Varley I had an introduction to Lady Torrens ... in 1818,' and he describes how both families patronized him as a portrait painter.

Varley, meanwhile, exhibiting only a handful of watercolours each year in the period 1816-22, supporting eight children and an improvident wife who despised him, and totally without control of his finances, had run deep into debt. From 1819 Linnell was inundated with requests for loans of sums varying from £15 10s to 3s 0d; the most pathetic note dated 7 February 1820 reports, 'I am *quite* without money can you find some as we have not even a bit of bread in the house...'.[2] In April 1820 he was declared bankrupt, owing his creditors £4140 2s 4d, and gaoled. It was, apparently, on this occasion that he wrote to Linnell, 'I have found that it was not the Person I thought of, it is an apothecary who has done it and if I cannot get 15 to twenty pounds I must remain here 30 days and then go to the fleet...'.[3]

The years 1823-6 saw a temporary revival in the number of his exhibits at the OWCS, reaching an average of 23, and he also built a 'gallery for the display of his works' at his house in Great Titchfield Street.[4] Nevertheless, Linnell had to stand bail for him again in 1830 when there was another seizure for debt.[5] Varley was still able to call upon the help of a few wealthy patrons but his affairs were in such a state that he saw very little of the money offered to him. Jeremiah Harman, for example, Governor of the Bank of England, whose home, Higham House at Woodford, Varley painted in 1820, lent him £1000.[6] He placed the money with Varley's brother-in-law for John's benefit, but his brother-in-law kept £800 which Varley owed him and handed over only £200. His insolvency appears to have been constant in the 1820s and early 1830s even though he was again exhibiting over 20 works a year at the OWCS and the Royal Academy in 1823-6.

By the 1820s, however, traditional picturesque landscapes, which, as we have seen, were already subject to criticism in 1810, had fallen out of favour. Under the influence of the Romantic poets, there was now a growing insistence on moral content or literary illustration, preferably in combination. Walter Scott became the author most favoured by artists, and the 1820s and 1830s saw a veritable Scott craze.[7] This development favoured the figure painters, but Varley did make some attempt to fall in with the prevailing taste. His illustrations to Byron's *Bride of Abydos* (**39**) was a prize winner in 1821 and he continued to exhibit at least one illustration to the Bible, or to Homer, Milton, Collins, Goldsmith, Byron or Scott at the OWCS in subsequent years. Such subjects are not well represented in the Museum's collection. The small versions of the *Castle of Chillon* and the *Burial of Saul* (**49, 57**) form, together with the *Bride of Abydos*, only a token representation of this aspect of Varley's work.

His own lack of confidence in his ability as a figure painter doubtless inhibited him in his attempts to enter the field of literary illustration. Even so, it comes as a surprise to learn from Linnell's *Journal* that Varley was in the habit of asking Linnell to paint the figures on to his landscapes. From 1817 until 1828 Linnell frequently records painting 'figures etc. in a small landscape by J. Varley'. In December 1819, for example, he painted on Varley's watercolours of Lake Killarney, Battersea and Eton. Linnell would charge varying sums ranging from one to five guineas for this work. At least he noted these amounts in his account books, though he must have realized that he was unlikely to collect from his insolvent friend who was constantly appealing to him for loans.

Considering the very minor part played by figures in Varley's landscapes the story becomes even more curious. It was not uncommon in times of artistic specialization, particularly in the Dutch and Flemish schools, for figure painters to work on other artists' landscapes or urban scenes. Frans Francken and his followers, for example, added figures to the church interiors of Pieter Neeffs, and Cornelis van Poelenburgh did the same for the landscapes of Jan Both.[8] But in such cases the figures played a prominent part in the composition, very much more so than in Varley's landscapes. Furthermore, his early figure studies in the British Museum show him to have been at least reasonably competent in this field and, indeed, the small distinctive squat figures that people his landscapes and urban views appear perfectly adequate for the part they are called upon to play. One cannot discount the possibility of a genuine crisis of confidence in these years leading Varley to seek Linnell's help in this way. However, it is likely that the cooperation was at least as much a part of an artistic friendship. For at

the very time that Linnell was painting figures on Varley's landscapes he was himself using them as a source for his own work. In June 1819, for instance, there are three entries in his *Journal* recording such activity: 'Began a small Painting from a drawing of J Varley of a view at Eton College.' Perhaps Varley no more needed Linnell to paint his figures than Linnell needed Varley to copy his compositions, but both activities become explicable as an expression of a close personal and artistic friendship.

Esther Varley died in 1824 and in the following year Varley married Delvalle Lowry, daughter of his old friend the engraver Wilson Lowry, whom he had known as a girl and whose portrait he drew when she was in her teens (**34**). She was about 25 to his 47, and the marriage appears to have been a happy one; at any rate his friends, who had been highly critical of Esther, have nothing negative to say of Delvalle. She had two children, bringing Varley's total up to ten. In September 1830 they moved from Great Titchfield Street to rent Linnell's house in Bayswater. After living in the neighbourhood of Oxford Street since 1802, Varley was now to remain in Bayswater until his death, moving to 2 Bayswater Terrace in 1833.

Neither the content nor the style of his output changed very much during these years. There were endless repetitions of his classicizing views of the landscape of Wales and elsewhere: the catalogue entries for *Beddgelert Bridge* (**20**), *Chiswick* (**47**), and *Harlech Castle* (**36, 55-6**) give an idea how often these compositions were repeated. Yet the views of London retain their directness, lightness and air of naturalism throughout his career (**37, 40, 45, 54**). It was in the 1830s that he turned increasingly to dealers for a market for his watercolours. In an undated letter to Linnell, probably *c.* 1830, he promises that if he can satisfy his creditors, 'I can then go home and see Mr Woodburn who wishes to have some drawings of me'.[9] This was Samuel Woodburn (1785-1853) who dealt mainly in old master paintings. Towards the end of his life Varley turned more and more to William Vokins (1815-95), a carver and gilder as well as a dealer in English watercolours who became a close personal friend.

After the low ebb of his fortunes, as of his art, in the 1820s and '30s, there was a distinct revival of both in his last years. From the later 1830s he moved away from topographical subjects to concentrate on imaginary landscape compositions. This is the period of his small, postcard-size sketches, characterized by bold, rapid brush drawing in dark brown wash (**57-62**). In the more finished works, such as the *Harlech Castle* of 1837 (**55**) the late style is heralded by an increasing use of gum and a dominant orange tonality.

Picturesque colour theory, as expounded by Uvedale Price and Sawrey Gilpin, had stressed autumnal hues and mellow colouring, and the requirement of the whole picture to partake of a single key tone. With certain notable exceptions, such as his London scenes, most of Varley's work would fit this theoretical framework, but from the 1820s he was using varnish, as well as gum to make his watercolours more like oil paintings (**39**). This is described in the *Somerset House Gazette* for 25 September 1824: 'Mr John Varley we have lately seen, busily engaged in his study, on his new process of landscape in water-colours, heightened with white and varnished with copal ... on some of his designs in small, the style is so affective, that they approximate to the richness and depth of painting in oil.' Yet Varley retained the traditional mellow tones, whereas the 1820s saw the emergence of more brightly coloured watercolours pioneered by Turner and Bonington. Under their influence lighter tonality and brighter, more glittering colours became commonplace.[10] But when Varley finally began to change his palette in the late 1830s it was probably the glowing, mystical landscapes of Samuel Palmer that provided the inspiration.

Palmer had been closely associated with Linnell and Blake since 1824, and he married Linnell's daughter Hannah in 1837. During his stay at Shoreham he and his circle were known by the locals as 'Extollagers'[11] – presumably a corruption of astrologers – for their mysticism, and although Palmer never shared Varley's predeliction for horoscopes, they did have in common an interest in the occult. Varley never followed Palmer to his pictorial sources in German renaissance landscape, for Claude continued to dominate his composition. But both for its reddish tonality and for its intensity, his late work owes a considerable debt to Palmer, who had returned to London in 1832.[12] From about 1837, doubtless aware that his art had been rotating in the same groove for decades, Varley began to experiment with a variety of paper, the extensive use of gum and hot tonalities.

The revolution in his style was effected in two phases. The first, *c.* 1839-40, combined the sketchy, brown wash technique of his 1830s drawings with the introduction of dark red and purple colours and the use of coarse wove paper (**70-2**). In the second phase, 1841-2, he extended the use of hot tonalities with contrasting pink, purple and orange areas and his technical experiments led to an increasing use of gum, scraped down to reveal patches of paper ground (**73-8**). His glazed and scraped trees are reminiscent of Palmer's sombre, mystical landscapes, even though they were very different in technique, as Palmer achieved his effect by the use of heavy layers of body colour. Delvalle Varley, in conversation with J.J. Jenkins in

1852, described her husband's late work in this way:

> It was his custom to sit down of an evening and rattle off a number of sketches, from which he would the next day select those he liked best and complete them in colour. The sketches were commenced with sticks of cedar charcoal, which he made by burning in the candle as he used them. He then worked out the broad masses of light and shade with Cologne earth; and upon this preparation the colours were laid. One evening while he was thus sketching, he took up some thin whity-brown paper which chanced to lie on the table, and began to sketch upon that. Liking the tint of the paper, and always ready to try something new, he conceived the idea of laying it down upon white paper, as with an India proof and began to lay on his colour. With a stiff brush which he poked about in all directions, he proceeded to work up the light and texture in the drawing, and scraped down to the white paper for the brightest points. Sometimes he would pass a wash of thin paste over the paper which enabled him to get the lights out more readily; and enriched the dark with gum Arabic water.[13]

These late works, variations of which are described in the entries for nos. **69-78**, have been condemned by watercolour purists in the twentieth century,[14] but they were a great success at the OWCS exhibitions of 1840-43 and we can see in the best of them the renewed inspiration of a considerable artist. Some of the works, indeed, are of an expressive intensity not seen in Varley's output since the early years of the century. In 1841, for the first time in 20 years, he again exhibited 30 watercolours at the Water-Colour Society and sold 24 of them. The most expensive one, no. 176, *Composition evening*, was bought by Prince Albert for 35 gns.

The originality of these works was recognized in the *Art Union* (III, 1841, p. 81) review of the 1841 OWCS exhibition:

> The painter has a fertile and vigorous fancy; he will not please those who are content with prettiness but he will satisfy all who desire to see exercised the higher qualities of the mind. His work seems to have been executed in a 'new style' – as if he had hit upon some plan for producing a moral effect. This alone is highly creditable; by far too few of our painters ever study to invent, being for the most part satisfied to work as lawyers do by 'precedent' ...

In his last years Varley achieved the worldly success that had eluded him since his first decade as a professional artist. Even so, it was a success that came too late to save him from the financial disaster that dogged him for so much of his life. Copley Fielding, in a letter to Robert Hills, suggested opening a subscription in the Water-Colour Society for their sick friend.[15] The letter is dated 15 November 1842; two days later John Varley died in the house of William Vokins his dealer and friend, who had offered him his house during his final illness.[16]

NOTES

1. Linnell, *Autobiography* MS, pp. 60, 62.
2. Varley letters in Linnell op. cit. Several are printed in Story, 1892, pp. 164 ff.
3. Linnell, op. cit.
4. J. Elmes, *Annals of the Fine Arts*, 1817, p. 551.
5. Linnell, *Journal* MS, 24 Dec. 1830.
6. Jenkins MS. The two watercolours of Higham House ($8\frac{1}{2} \times 12$ in., dated 1820) have recently been acquired by the Vestry House Museum, Walthamstow. See also Bury, 1946, pl. 7.
7. C. Gordon, 'The illustration of Sir Walter Scott'. JWCI, 34, 1971, pp. 297–317.
8. For example, V & A, Neeffs, no. 854–1894; National Gallery, Both and Poelenburgh, no. 209.
9. Story, 1892, p. 165.
10. Gage, 1969, pp. 97 ff.; Bayard, 1981, p. 21.
11. Martin Hardie, 'Robert Hills "Extollager"', *OWCS Club Annual*, XXV, 1947, pp. 38–40.
12. On Palmer see, most recently, the catalogue of the exhibition at the Fitzwilliam Museum, Cambridge, 1984.
13. Jenkins MS; quoted by Bury, 1946, p. 46.
14. Bury, 1946, p. 46; Hardie, 1967, II, pp. 105 ff.
15. MS Pierpont Morgan Library, New York. I am grateful to Marcia Pointon for this reference.
16. Roget, 1891, II, pp. 28 ff.; Story, 1894, pp. 286 ff.

VI Varley's family & posthumous reputation

THE FAMILY

John Varley's younger brother Cornelius (1781–1873) was an artist as gifted as John himself, though his career as a painter was much shorter. After his father's death, he was looked after by his uncle Samuel Varley, a watch and instrument maker as well as an amateur scientist, from whom Cornelius derived his own scientific interests. Under John's influence he began to draw in about 1800, 'and by sketching from nature I taught my self and was soon engaged to teach others'.[1] He benefited from copying Cozens at Dr Monro's, but 'sketching out of doors all day long,' as A.T. Story put it, remained the keystone of his art.

In 1801 he was invited, together with John, by Mrs Schutz, whose daughters were John's pupils, to their house at Gillingham in Norfolk and in the following year he toured north Wales with his brother. He went back to Wales in 1803, with Cristall and Havell, and on his own in 1805, but apart from Wales and East Anglia his subjects were mainly of London and the home counties. Views of St Alban's (1804) and of the Thames, from Millbank to Richmond, as well as of Wales, are foremost in his work.

His drawings are characterized by a naturalism and lightness of palette which John Varley only emulated in his early 'Studies from nature' and in his Millbank scenes of 1816–17. Cornelius was concerned with direct perception of nature, unencumbered by John's rules of composition, and his informal views, often only partially tinted pencil drawings, have a freshness and flair which makes them more appealing to twentieth-century taste than some of John's heavily laboured compositions (fig. 22).

However, at the time Cornelius found it difficult to find a market for his drawings. A founder member of the OWCS, he managed to sell five of the 11 drawings he exhibited in 1805 for sums ranging from one to five guineas, but in subsequent years his sales were very few even though his prices were consistently low. From 1810 he exhibited only rarely, partly perhaps discouraged by this lack of success, but also because his interests turned increasingly to the invention and manufacture of scientific instruments. In 1811 he patented his Graphic Telescope (see **34**) and there are several landscape drawings by him showing its use. He continued to draw *plein air* sketches in the early 1820s, but the few extant examples of his later work, such as the watercolour of Regent's Canal in the Museum of London (1827), seem laboured and garish.

Cornelius Varley's distinction as a maker of optical instruments, principally microscopes, may be gauged by the display mounted by Varley and Sons at the Great Exhibition in 1851. They showed two air pumps, a portable Gregorian telescope, three microscopes, a Graphic Telescope and

a single reflecting camera, for which they won a prize medal.

Linnell provides evidence of Cornelius's life-long intellectual interests and his religious beliefs. In 1811 he records borrowing from him volumes of Plato, Gibbon's *Decline and Fall* and William Paley's *View of the Evidences of Christianity* and at the same time he was introduced by him to the Baptist Chapel in Keppel Street, of which Cornelius was a devout member. He never shared John's interest in astrology and he certainly managed his affairs better. Indeed, according to A.T. Story, Cornelius 'represented a striking contrast to his broad, bluff King Hal of a brother, being small, dapper, and as sharp as a needle'.[3]

In spite of Richard Varley's dictum 'limning or drawing is a bad trade', four of his five children became painters. John and Cornelius shared most of the talent, but Elizabeth (b. 1783) and William Fleetwood (1785-1856), the youngest of the family, were also painters. Elizabeth married Mulready in 1803 and when they separated soon afterwards one of the reasons given for the collapse of their marriage was that his wife was constantly finishing his pictures for him when his attention was distracted.[4] She continued to exhibit cottage scenes at the Royal Academy and OWCS from 1811 until 1819, though little of her work has been identified.

William Fleetwood Varley appears to have been taught by John, with whom he was still living at 2 Harris Place as late as 1804. There are 15 watercolours by him in the V & A and most of them bear out Linnell's judgement: 'William had no talent and was the butt of the family.' They reflect different aspects of John's style: broad wash simplification in his early years;[5] Claudean and more finished in a watercolour dated 1825 (P.2-1936). Only a few cloud studies differ from John's work. He exhibited at the Royal Academy from 1804 until 1818, but his main activity appears to have been teaching. From 1810 he taught drawing in Cornwall, then in Bath and Oxford. Indeed, he is said to have given up drawing after nearly losing his life from a fire caused by undergraduates at Oxford; if so this must have been after 1825, the date of the Museum's latest work by him.

Yet there is one piece of evidence to dispute Linnell's 'no talent' jibe: a manuscript entitled *Principles of Art by William Varley 1819* (VAM D.501-1907). Consisting of 14 folios of drawings with explanatory texts, it is in the tradition of early nineteenth-century artists' manuals, but considerably more direct and practical than many of them. Practical advice is given mainly on colouring and to some extent on composition, quite without the formalism of John's treatise. It begins with simple images, for example logs on folio 2: 'Lamp black & lake first' (first illustration); 'Dark brown then Bt. Sienna and P. Blue for moss the Timber shadowed with the grey colour

FIG. 22 Cornelius Varley (1781–1873), *Part of Cader Idris and Tal-y-Llyn*, 1803
Watercolour, 10 × 14½. V & A (139801924)

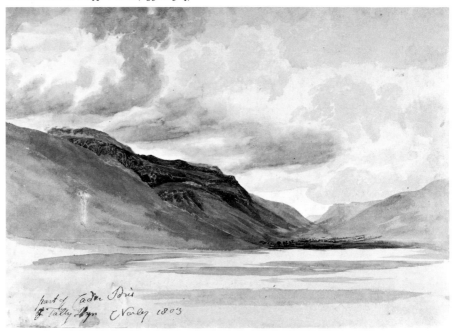

of the first Tint' (second illustration). Stone blocks and tree trunks are dealt with next, followed by complete landscapes with castles and cottages, contrasted with the broad sketch of a distant landscape. This manuscript provides an insight into current watercolour technique and secures William Varley's reputation as one of the more important teachers of his generation.

Of John Varley's ten children, two became professional painters, Albert Fleetwood (1804–1876) and Charles Smith (1811–1887). Albert, also a teacher of drawing, exhibited at the Royal Academy in 1838 and appears to have worked very much in his father's style (VAM D.1906–1889). Charles Smith exhibited at the Royal Academy from 1839 until 1856. His *Landscape with bridge* (1843) in the Museum (P.18–1952) is based on his father's late style.

Artistic talent was inherited by the next generation too: Edgar John (1839–1888), son of Charles Smith, exhibited in London in 1861–87 mainly watercolours, strongly coloured and somewhat pre-Raphaelite in style (VAM FA.672), and he was curator of the architectural museum, Westminster. A more widely known figure was John Varley, jun. (1850–1933), son of Albert Fleetwood. He travelled extensively in the East and his watercolours of Egypt, India and Japan, which he exhibited at the Royal Academy in 1876–95 were also the subject of one-man shows in London. From his grandfather he inherited an interest in astrology and the occult. He and his wife Isabella, née Pollexfen of Sligo, aunt of W.B. Yeats, were

early drawn to Theosophy and were of the Inner Circle who gathered round Madame Blavatsky in London in 1883–4. The Theosophist C.W. Leadbeater devoted a whole book to describing his 16 re-incarnations.[6] These interests were shared by W.B. Yeats and they formed a bond between the great poet and the Varleys, just as they had cemented the Blake–Varley friendship 70 years earlier.

Posthumous Reputation: Growth of the V & A Collection

The revival of Varley's reputation in his last years received an additional fillip after his death. Ten watercolours were exhibited as a memorial at the OWCS in 1843 and eight of them were sold. Queen Victoria bought a *View on the River Wharf* (exhibit no. 309) for ten guineas and Prince Albert a *Composition* (exhibit no. 5) for 20, a clear indication of royal awareness of the passing of one of the patriarchs of the English watercolour school. Other buyers at the exhibition included the Bishop of Winchester and Richard Ellison, the Museum's benefactor.

Varley's position was recognized in his obituaries: 'Few men are better known in our water-colour school of Art than Varley ...' and 'the genius of this celebrated water-colour painter was not enfeebled by years, for during the late period of his life "his lamp burnt on" and even more brightly than at any period of his career'.[7] The *Athenaeum* was equally complimentary but allowed itself some critical commentary, 'The range of his imagination was not very large, and oftentimes his treatment verged on mannerism ...', and drew attention to his enormous output:

> Unfortunately his circumstances obliged him to work much for the dealers, and therefore down to the low level of a certain class of purchasers. Noone was more prolific in what artists call 'bread-and-cheese' drawings, as all print-shop windows testify.[8]

Ruskin, writing at about the same time, absolved Varley from the lack of 'solemnity and definite purpose' apparent in contemporary artists, but added, 'if the aim be higher, as was the case with Barret and Varley, we are generally put off with stale repetitions of eternal composition'.[9] These commentaries summarize the essence of his reputation after his death as much as during the greater part of his lifetime. On the one hand there was the respect due to a serious landscape painter, one of the central founders of the Water-Colour Society, and on the other an awareness of the monotony of much of his vast output. Varley exhibited over 700 watercolours at the OWCS – itself only a relatively small proportion of his total output – and his reputation never survived the ensuing glut of his work. Prices of

his watercolours, recorded in Redford's *Art Sales* between 1861 and 1884, are, on the whole, very modest. The sum of £105 achieved for a view of Carisbrooke at the J.C. Robinson sale in 1865 was most unusual. The average price at sales in this period was about £30, appreciably less than the sums commanded by Cox and de Wint, though rather more than those of J.R. Cozens, whose reputation was not fully restored until the twentieth century. It is indicative also of Varley's modest status that his old friend William Vokins, who mounted a large loan exhibition of de Wint in 1884 and of Copley Fielding in 1886, never did so for Varley and nor did anyone else.

On the other hand, when the Royal Institute of Painters in Watercolours mounted an *Exhibition of Watercolour Drawings by Deceased Masters of the British School* in July 1886 they showed 23 works by Varley, more than by anyone else except David Cox. His watercolours continued to be used as examplars of landscape composition: for example, there are copies of his cottage scenes by Sir Henry Cole (1808–1882), probably made in the 1850s (VAM E.3729/30-1934). At the same time they began to be acquired by the national collections. The Harlech Castle of 1837 (**55**) was the very first of these, being the sole representative of Varley's work in John Sheepshanks's gift of 233 oil paintings and 289 watercolours, drawings and prints which was to establish a national gallery of British art at South Kensington in 1857. Two years later, the British Museum bought a dozen fine, mainly early, Varley watercolours at the sale of Dawson Turner, the Yarmouth banker, best known as Cotman's patron.[10] His connection with Varley is recorded in 1822 with the gift of Patent Graphic Telescope portraits and the drawing lessons received by his daughter Elizabeth (see p. 38ff. and **34**), but it is clear from his collection that he was buying Varley's watercolours from the first decade of the century. And because they have been much less exposed to the light levels of public display (in the days before the 50 lux maximum was enforced) these watercolours are in better condition than those at South Kensington – a point that was already noted in 1886.[11]

Meanwhile, the collectors of 1840-70 were buying mainly the late Varley watercolours of *c.* 1840 not surprisingly for a generation used to the hot colouring and mysticism of pre-Raphaelite landscapes. Such were the Varleys that entered the Museum in the large bequests of the Rev. C.H. Townshend in 1868[12] and of the Rev. Alexander Dyce in the following year.[13] English watercolours formed only a small part of these great collections: Townshend's of continental oil paintings and Dyce's of old master drawings and prints. More important as collectors of English watercolours

were Richard Ellison and William Smith whose benefactions form the core of the Museum's holdings.

Richard Ellison (d. 1860) of Sudbrooke Holme, Lincolnshire, best known as de Wint's principal patron, was buying watercolours at the OWCS from the 1830s, acquiring a season ticket to the exhibition in 1839.[14] He bought late watercolours by Varley from 1840 both at the OWCS and from Vokins. After his death in 1860, in accordance with his intentions, his wife Elizabeth made a gift to the Museum of 51 watercolours which was followed by a further 49 on her own death in 1873. The gift included one early drawing by Turner, but the weight of it lay with the stalwarts of the Water-Colour Society such as Varley (**53, 70, 77, 81**), Barret, Copley Fielding, W.H. Hunt and, above all, de Wint, and mid-century artists like John Frederick Lewis. In leaving them to the National Collection of Watercolour Paintings, 'always to be exhibited ... on the walls of South Kensington', she added the proviso 'but it is our desire that the exhibition thereof do not take place on a Sunday, thereby affording an inducement to persons to make that sacred day a time of amusement to the neglect of their religious duties'.

William Smith (1808–1876) was a successful print dealer who sold John Sheepshanks's Dutch and Flemish engravings to the British Museum in 1836 and who retired early from business to become deputy chairman of the National Portrait Gallery.[15] Through his friend Richard Redgrave, the Art Referee at South Kensington,[16] he made a gift of 86 watercolours in 1871 and left a further 136 on his death in 1876. His was a historical more than a contemporary collection and his benefaction accounts for the Museum's key holdings of Malton, Rooker, Dayes, Hearne and early Turner. William Smith's eight Varleys cover his career from 1802 to 1826 and include some of the best in the collection: *High Street Conway* (**4, 5**), *Llanberis Pass* (**11**), *Beddgelert* (**20**), *Holy Island* and *Frognal* (**26, 45**).

The benefactions of Dyce, Townshend, Ellison and Smith account for 40 of the Museum's watercolours by Varley and there are no gifts or bequests of major importance after 1876. Sir Edward Denny Bt (1796–1889) of County Kerry gave four Varley watercolours in 1882 along with a collection of family portraits and memorabilia. They are worth recording as they include all the literary and biblical illustrations in the Collection (**39, 49, 57**). Henry Ashbee's bequest of 1900 contained four good Varleys, including one of his rare oil paintings (**28, 36, 40, 42**), but meanwhile the collection was augmented by purchases ranging from *Handborough, Oxfordshire* (**16**) from Mrs Varley for 3 guineas in 1882 to *Cheyne Walk* (**31**) for 19 guineas from Agnew's. Varley's prices remained modest.

Not surprisingly, the watercolours bought in the twentieth century reflect a fundamental change in taste. The unfinished *Snowdon* (**19**), bought in 1924 for ten guineas and the *Mountainous landscape: afterglow* (**18**), acquired for £25 in 1930 and displayed as the Museum's *Masterpiece of the Week*, conformed to the taste of a generation reared on the bold simplifications and unrealistic colours of post-Impressionism. This was the period of the rediscovery of Alexander and J.R. Cozens and the Sublime watercolours of John Varley were honoured accordingly. In 1942, at the height of the war, the V & A Museum took the trouble to mount a small exhibition to mark the centenary of his death. The bicentenary of his birth in 1978 was celebrated by the Hackney Borough Council's exhibition; a loyal gesture but a modest one compared to the recent shows of Cozens and Girtin, Cotman, Cox and de Wint. Varley's vast, routine output will always count against him in terms of popularity and market value, but it is fair to say that his more outstanding work is now once again being accorded the recognition due to an artist who was the most complete *professional* of his generation.

NOTES

1. M. Pidgley, *Cornelius Varley*, P. and D. Colnaghi, 1973. On Cornelius see also Pidgley, 1972; B.S. Long, 'Cornelius Varley', *OWCS Club Volume* 14, 1936–7, p. 1 ff.; Story, 1892, p. 28; Story, 1894, p. 221 ff.
2. Story, 1894, p. 227.
3. Story, 1892, p. 28.
4. Story, 1894, p. 241. For a further account of the separation see Heleniak, 1981, pp. 8 ff.
5. A more impressive example was in Agnew's *111th Annual Exhibition of Water-colours*, 1984, no. 76. repr.
6. C.W. Leadbeater, *The Soul's Growth through Reincarnation. Lives of Erato and Spica*, Theosophical Publishing House, Madras, 1941.
7. *Art Union*, V, 1843, p. 9.
8. *Athenaeum*, 26 November 1842, p. 1015.
9. *Modern Painters*, Part II, in E.T. Cook and A. Wedderburn, *The Complete Works of John Ruskin*, 1903, III, pp. 275, 472, 529, 624.
10. Binyon, 1907, pp. 292 ff.
11. B. Webber, *James Orrock RI*, 1903, II, pp. 74 ff.; summarized by Clarke, 1981, pp. 125 ff.
12. On Townshend as a collector and literary figure see M. Haworth-Booth, *The Golden Age of British Photography, 1840–1914*, 1984.
13. *Catalogue of Paintings, Miniatures, Drawings ... bequeathed by the Rev. Alexander Dyce*, 1874.
14. OWCS, MS price book, 1839. On his patronage of de Wint see Smith, 1982, p. 85.
15. F. Boase, *Modern English Biography*, III, 1965, col. 649.
16. On Redgrave's importance, see L. Lambourne, 'Richard Redgrave RA: Artist and Administrator', *V & A Album*, 2, 1983, pp. 114–22.

FIG. 23 Varley, *Autumn*
Illustration to the 1804 edition of Thomson's *Seasons*

A note on imitations & forgeries

As his contemporaries noted, Varley's output was vast. The 700 watercolours he exhibited at the OWCS between 1805 and 1842 may be estimated as less than a tenth of his total production. In spite of the fire that wrecked his studio in 1825, there must have been over 7000 Varley watercolours available, and hence the market could be well satisfied without recourse to forgeries. Problem works can be grouped under the following headings:

1 *Wrong or doubtful attributions:* for example the town views of about 1800 optimistically considered to be early works by Varley. Some of these are now re-attributed, for instance the *Church by a river* in the Fitzwilliam Museum.

2 *Works by followers or pupils wrongly attributed to Varley*: **82** is an unsigned example, hitherto accepted as autograph. Provided with a false signature, such works can be very deceptive.

3 *Copies:* Varley himself produced endless repetitions of his more popular compositions, but there are also copies by pupils and imitators. For example, the third version of *Dolgelly Bridge* in the British Museum (1902-5-14-11) appears to be a copy of BM 1958-10-41 (see **32**). There are also copies of the plates in the *Treatise on the Principles of Landscape Design*, of which **83** is an example.

Chronology & list of Varley's addresses

1778	Born at Hackney	
1793-4	Apprenticed to Joseph Charles Barrow, portrait painter	
1796	Sketching tours in London with J.P. Neale	
1798	1st exhibition at the Royal Academy: *Peterborough Cathedral*	
1798-9	First visit to North Wales with George Arnald	12 Furnival's Inn Court
1800	Friendship with Dr Monro; (?)2nd visit to north Wales	33 Craven Street, Hoxton
1802	Last Welsh tour with Cornelius: met Cristall and Havell	2 Harris Place, Oxford Street
	First recorded in the Sketching Society	
1803	Married Esther Gisborne (d. 1824)	
	Tour of Yorkshire	
1804	Founder member of OWCS	15 Broad Street, Golden Square
	Growing reputation as a teacher	Summer cottage at Twickenham
1808	Tour of Northumberland	
1811		Summer residence in Chelsea
1813		5 Broad Street, Golden Square
1815		44 Conduit Street, Hanover Square
1817		10 Great Titchfield Street (becomes 10½ in 1824)
1820	First imprisonment for debt	
1825	Married Delvalle Lowry	
1830		2 Elkins Row, Bayswater
1833		3 Bayswater Terrace (still his address in 1842)
1840	Late style: revival of sales at OWCS	
1842	Death	
1843	Memorial exhibition at OWCS	

Public collections with works by Varley

Apart from the V & A, the largest collection is in the BRITISH MUSEUM (Binyon, 1907; Lyles, 1980), where a selection of early watercolours in good condition from the Dawson Turner collection is matched by examples from other periods and sketches of figures and boats, as well as six albums of landscape drawings.

All periods of his work are represented among the 11 drawings in the ASHMOLEAN MUSEUM, OXFORD (D. Brown, *Catalogue of British Drawings*, 1983), though the majority are post-1820 and only the *View of Oxford* (1818) is outstanding. A somewhat smaller selection at the FITZWILLIAM MUSEUM, CAMBRIDGE, includes a splendid view of the *Valley of Mawddach* dated 1805 (Hackney, 1978, 28). The ten works – including one of the rare oils – at the ETON COLLEGE GALLERY include four of the *Thames at Eton*, a view first popularized by Canaletto (National Gallery), and a fine version of the *Ouse Bridge, York*.

Outside London, however, the largest collection of Varley watercolours is in the CITY ART GALLERY, BIRMINGHAM. The view of *Barmouth* dated 1809 (A.E. Anderson gift, 1919) is discussed under **23** and the *Snowdon* of 1810 on p. 48. At MANCHESTER there are good examples both at the CITY ART GALLERY – in particular the *Old Horse Ford, Lambeth* (1817) – and the WHITWORTH ART GALLERY, including a late, *plein air*, suburban London view: *The windmill, Acton, Middlesex*, dated 1833. The CITY ART GALLERY, LEEDS, received three large, important Welsh views of 1804 in the bequest of Norman and Agnes Lupton (1952); two of them are unfortunately very badly faded. By contrast a small, early view of *Dolgelly* is much better preserved. At LIVERPOOL, the artist is represented in the WALKER ART GALLERY (*Early English Drawings and Watercolours*, 1968), and also by three examples in the LADY LEVER GALLERY, BIRKENHEAD. Apart from its well known *View of Polesden*, 1800 (fig. 2) the LAING ART GALLERY, NEWCASTLE, has concentrated on Northumbrian subjects and now includes some drawings by Varley's pupil, Lady Mary Monck, daughter of the Earl of Tankerville. Outstanding among the artist's work in the NATIONAL GALLERY OF SCOTLAND, EDINBURGH, is the view of *Bamburgh Castle, c.* 1810, from the bequest of Helen Barlow.

These are the larger holdings of Varley's work, but there is hardly an art gallery in the country which does not contain one or two of his watercolours. Of the smaller collections, the MUSEUM OF LONDON has two splendid views of *Millbank*, *c.* 1816, and the TATE GALLERY the unusual, panoramic *View of Bodenham and the Malvern Hills*, of 1801 (see fig. 11).

In the United States, the YALE CENTER FOR BRITISH ART has a large selection of Varley watercolours but, considering the importance of the collection in other areas, many of them are somewhat mediocre. The best are those exhibited in recent years (White, 1977; Bayard, 1981; Hawes, 1982), some of which remain in the private collection of Paul Mellon. Finally, there is the considerable collection in the HENRY A. HUNTINGTON ART GALLERY, SAN MARINO, CALIFORNIA, which was catalogued by Gleeson (1969).

List of works exhibited by John Varley

Compiled by BASIL S. LONG, Assistant keeper, Victoria and Albert Museum

Reprinted from *OWCS Club Volume*, II, 1924-5

Note: The spelling of the Exhibition Catalogues has been exactly followed, but quotations have been shortened, and frequently recurring names of Counties, etc., omitted. Varley also exhibited at provincial exhibitions at Liverpool, Norwich, etc., but owing to the difficulty of obtaining complete lists of these exhibits they have all been omitted.

The following abbreviations are used:
BI: British Institution.
OWCS: Old Water-Colour Society (now the Royal Society of Painters in Water-Colours).
RA: Royal Academy.
SBA: Society of British Artists (now the Royal Society of British Artists).

1798
RA
1011 A view of Peterborough.

1799
RA
323 Lime trees.
601 View in Northumberland.
647 View of Elingford church, Essex.
1083 Landscape and castle.

1800
RA
357 View of Llyn Gwenedd Lake.
612 View at Dolgelly.
789 View at Conway.

1801
RA
306 View of Cadr Idris.
370 View near Llangollen.
474 View on the road to Aberistwith.

1802
RA
378 Nottingham castle, Suffolk.
 [? Mettingham]
514 Ragland castle, Monmouthshire.
961 View of St Peter's church, Hereford.
965 View of the town hall, Leominster.

1803
RA
300 View of Harlech castle, looking towards Criccith Castle.
380 View of St Orkmond's church, Shrewsbury.
481 View of Conway.
510 View in Conway.
560 View of Harlech castle, with Snowdon.
722 View of St Peter's church, Chester.

1804
RA
385 View of a bridge at Brecknock.
402 View of Landberris pass.
 The above two pictures are catalogued as by S. Varley.
465 View of Conway castle.
577 View in York.
835 View of Ouse bridge, York.

1805
OWCS
5 View of Harlech Castle and Teguin ferry.
9 View near Bodenham, Herefordshire.
19 View of Carnarvon walls.
22 View of Moel Hedog.
29 View near Pont Aber Glass Lynn.
37 View of Bedd Gellert bridge.
40 Pont Aber Glass Lynn.
57 View of Harlech Castle.
62 Denbigh Castle.
70 Part of Ouse bridge, York.
83 One of the arches of Ouse bridge, York.
84 Harlech castle, and Snowdon.
88 Distant view of Bolton abbey, Yorkshire.
94 Ouse bridge, York.
96 Knaresborough castle, Yorkshire.
97 Handborough porch, Oxford.
106 St Peter's Well, in York Minster.
110 Cottage at Carnarvon.
111 Snowdon, from Moel Hedog.
132 St Winifred's Well, North Wales.
133 A study from nature.
136 Cottage at Conway.
138 Llanberris lake.
147 Bolton Abbey.
156 Fortress of Gavi in Italy, from a sketch by E. Lomax, Esq.
168 Llanberris lake, with Dolbadern Castle.
187 View at Nasing, Essex.
188 Conway Castle, from the Llanrwst road.
189 View near Conway.
190 Composition.
198 View of Llynn Ogwen.
199 Llangollen bridge.

200 View near Bedd Gellert.
201 Harlech Castle.
204 Conway Castle.
207 View near Carnarvon.
212 Conway Castle, with the broken tower.
215 View near Pont Aber Glaslyn.
223 Village and Abbey of Rivaux. (*For C. Fothergill's 'Natural and Civil History of Yorkshire'*.)
249 View opposite the castle, York.
257 View in Knaresborough.
275 View of the Mumbles, near Swansea, from a sketch by J. Wathen, Esq.

1806
owcs

7 St Alban's Abbey.
9 Composition.
16 A distant Shower.
25 View near the Locks at Windsor.
27 Part of Snowden, from Bedd Gelert.
38 The Shepherd's Boy.
39 Composition.
41 Bolton Abbey, Yorkshire.
47 New Weir, near Monmouth.
69 View from Eton Play Grounds.
79 Composition.
82 View near Windsor.
93 Composition.
95 Part of Cader Idris, from near Barmouth.
99 Evening, Composition.
118 A View of Harlech Castle, from Tegwin Ferry.
126 View of Windsor, from near Clewer.
139 Composition.
145 Composition.
159 Morning, a composition.
161 View in Llanberris Pass.
165 Composition.
170 Harlech Castle.
173 Christ Church, Oxford.
189 Snowden, from near Bangor.
196 A Composition.
221 Evening, a Composition.
223 Llyn Dinas, with Moel Hedog.
224 The Salmon Leap at Pont Aber-glass-llyn.
227 Evening, a composition.
228 Evening, a composition.
229 Evening, a composition.
230 A composition.
230 A composition.
231 A composition.

232 Evening, a composition.
235 View of the Castle at Chester.
236 View on the Thames.
237 Composition.
239 Composition.
240 Composition.
241 Composition.
276 Boat house at Reading, Berks.
286 Cottage at Brighton.

1807
owcs

3 Llyn Ogwin, N. Wales.
6 A mill.
27 View near Windsor, a sketch.
28 A corn field.
40 Evening, a sketch.
41 Evening.
45 The Devil's Bridge, and Hafod Arms, S. Wales.
59 A river scene, a sketch.
61 View of Conway Castle, from the Llanrwst road.
87 A landscape.
98 A sketch for a composition.
100 Evening.
106 Morning, a composition.
114 Sketch of a cottage.
124 Part of Kirkstall Abbey, Yorkshire.
132 A landscape.
133 A composition.
148 Llanberris Lake.
149 Scene near Brighton.
150 Sketch of the Ouse Bridge, York.
156 A landscape.
202 Barmouth, N. Wales, a sketch.
211 A landscape.
215 View of Goodrich Castle, Herefordshire.
229 Scene on the Thames.
240 Cottage near Bayswater.
246 A door way at York.
251 Evening, view of Eton College from Windsor, a sketch.
272 A fisherman's house.
278 View of Cader Iris, from Llanelltid.
280 Scene near Beddgelert, N. Wales.
303 A view of Eton College.
317 Handborough, Oxfordshire.
323 View near Bedd Gelest.

1808
owcs

2 Snowdon, from near Harlech.
4 Old building, a composition.
10 Porch of a cottage, Bolton.

11	Flint Castle.		**1809**	
12	Cottage in Windsor Forest.		OWCS	
16	Llyn Dinas.		8	Ferry-house, York.
17	Barmouth.		16	Ouse Bridge, York.
18	Ferry House, Teddington.		30	View from Warksworth Castle.
23	Interior of part of the paper mill, Ensham, Oxon.		32	A river scene.
27	Buildings in York, near Middlegate.		35	A landscape.
29	View of Windsor Castle.		36	A river scene.
31	Evening.		39	View of Cader Idris, near Towyn.
35	Conway.		41	A thunder storm.
39	View at Windsor.		48	Conway Castle, N. Wales.
40	Harlech Castle.		49	Evening.
44	Scene in a mountainous country.		57	A tower at Dunstanborough.
51	Morning, a sketch.		58	Conway Castle.
81	From a ruined window in Bolton Abbey.		64	Evening.
			70	Snowdon Capel Carig, N. Wales.
85	View on the Thames, near Kingston.		73	Windsor Castle.
			74	Windsor.
103	Cottage at Watford.		84	A river scene.
105	A sketch.		85	A sea port.
108	Old buildings at Watford.		90	Dunstanborough Castle.
122	Evening, a composition.		92	Llanberris lake, with Dolbadern Tower.
123	A mountain scene.			
135	Composition.		97	Landscape.
147	River scene.		105	Evening.
150	A sketch.		106	Cader Idris.
156	A composition.		114	View from Llaneltid, near Dolgelly.
159	Evening.		121	York, from the Castle.
163	Suburbs of an ancient city.		122	View of Eton.
168	Twilight.		132	Bamborough Castle, from Holy Island.
170	View of St Margaret's Porch, York.			
172	Fishing boats at Brighton.		141	A cottage.
175	Cottage at Watford.		142	Chillingham church, Northumberland.
179	Door-way at Dolgelly.			
187	Landscape.		151	Flint Castle.
189	Stanton Harcourt.		153	An evening scene.
197	Morning, a sketch.		158	Snowdon, near Teguin ferry.
203	Clewer Church, near Windsor.		177	Landscape.
208	Composition, from tile kilns, Brighton.		182	Part of Byland Abbey, Yorkshire.
			199	Barmouth, N. Wales.
209	Fisherman's cottage.		200	Warksworth Castle, Northumberland.
246	A lane scene near Richmond.			
251	Gleaners returning home.		215	A cottage.
257	Gateway at Vallis Cruce's Abbey.		216	River scene.
260	Evening.		219	Snowdon, from near Harlech.
280	View at Watford.		230	Landscape.
299	Snowdon, from Beddgelert.		248	Snowdon, from near Bedgelert.
306	Evening.		249	Evening.
307	View of Lambeth.		251	Castle in Holy Island.
315	Brecknock Bridge.		252	Windsor.
324	Conway Castle.		262	A river scene.
329	River scene.		264	Bamborough Castle.
			280	A castle on Holy Island, Northumberland.
			295	A cottage, near Windsor.
			296	A cottage at Watford.

297 A cottage.
298 Bamborough Castle, a sketch.
302 Evening.
303 A castle on Holy Island.
311 Bamborough Castle.
313 Byland Abbey, Yorkshire.
323 Lindisfarne Abbey, Holy Island.
331 Bala Lake.
335 A scene on the Thames.
340 A cottage scene.
341 A composition.

1810

OWCS

4 Brecknock Castle, South Wales.
6 Ouse Bridge, York, a sketch.
9 Dunstanborough Castle.
14 Part of Snowdon, near Bedgelert.
16 Keswick Lake, looking towards
 Lowdore.
28 Bedgelert Bridge.
30 View on the Thames.
32 Caernarvon Castle.
34 Barmouth.
36 Harlech Castle.
40 A River Scene.
43 View at Bedgellert.
64 View near Bedgellert.
66 Gateway at Helmsley Castle.
71 A River Scene.
76 View of Eton College.
92 A Landscape.
94 Evening.
99 Cader Idris.
102 Cottages at Watford.
113 Evening.
118 Snowdon, from Capel Carig.
119 Cottage at Watford.
123 A Country Scene.
127 Holy Island and Lindisforme
 Abbey.
137 A Composition.
152 Composition.
158 A River Scene, Evening.
177 Scene in a Mountainous Country.
179 View of Chester.
200 An Oratory at Shrewsbury.
221 Llanberris Lake, North Wales.
222 Scene on a Common.
223 Fisherman's Cottage.
227 A River Scene.
228 Bamborough Castle.
230 Cottage Scene.
232 A Landscape.
244 Morning, a Composition.
248 A Heath Scene.

250 A Landscape.
267 Harlech, from near Teguin.
277 Holy Island.
284 View on Millbank.
288 Fisherman's Cottage.
303 Conway Castle.
325 Doorway at Bolton, Yorkshire.
326 River and Fishing Boat.
327 Rhydlan Castle, North Wales.

1811

OWCS

21 Llanberis Lake, North Wales.
23 Torr Abbey, Devon, the Seat of G.
 Cary, Esq.
37 A Sketch.
59 Chillingham Castle,
 Northumberland, the Seat of the
 Right Hon. the Earl of Tankerville.
91 York Minster.
94 River Scene.
97 Chapel, near Killarton.
149 View from the Gate of
 Dunstanborough Castle.
158 View near Valle Crucis Abbey,
 North Wales.
168 An Old House in Yorkshire.
204 Fisherman's Cottage.
224 Harlech Castle, North Wales.
234 View near Llangollen, North Wales.
245 Composition.
252 Composition.
256 Cottage Scene.
258 View under Eton Bridge.
260 Chiswick.
261 Landscape.
274 Benton Castle, Somersetshire.
275 Harlech Castle.
282 Distant View of York.
310 Landscape.
335 View on the Thames, near
 Battersea.
344 View near Watford, Herts.
351 View of Morpeth Town.
353 River Scene.

1812

OWCS

18 Cottage at Tunbridge Wells, near
 the Road to the High Rocks.
27 View of Conway.
44 Eagle's Nest, Killarney.
76 Evening.
77 Composition.
91 Landscape.
96 Conway.

103 View of Battersea Bridge.
104 Composition.
109 A River Scene.
127 Coimbra, Portugal.
132 Cader Idris.
178 Dolgelly.
180 Cheney Walk, Chelsea.
187 Beddgelert Bridge.
225 A Ferry Boat with Mules.
226 Tork Lake, Ireland.
227 An Oak Tree.
230 Morning.
231 View on the Thames at Chelsea.
234 Inverary.
238 Kilchern Castle, Scotland.
239 Stirling Castle.
247 Castle in Holy Island.
253 Composition.
255 Bala Lake, North Wales.
257 A Sketch.
282 Cottage from Nature.
286 Caernarvon Castle.
288 Llanelted Bridge, North Wales.
289 Cottage from Nature.
292 Byland Abby, Yorkshire.
295 A Cottage at Edmonton.
297 Composition.
301 Scene on a Common.
309 Cader Idris, from Bala.
310 Moel Hebog, North Wales.
312 River Scene.
317 Honister Cragg, Cumberland.
318 Kilchern Castle, Scotland.
321 Bridgenorth, Shropshire.
322 A Cottage.
324 Cottage.

1813
OWCS
24 The Lake of Albano.
26 Ben Lomond, Scotland.
30 Cottage in Caernarvon.
38 View of a Forge, between Barmouth
 and Dolgelly.
39 View on Millbank, near the
 Regent's Bridge.
40 View of Llanberris Lake.
54 Dunmally Castle, Oben.
55 View of Snowdon, from Capel
 Careig.
75 View of Brusa, and Mount
 Olympus, in Bithynia, from an
 Original Sketch, taken on the Spot,
 in June 1812.
86 Beddgelart, North Wales.
88 Bamborough Castle.

102 Durham Cathedral.
103 Shepherd's Boy, a Sketch.
105 View of Teguin Ferry, North Wales.
126 View of Cader Idris.
129 View of Cader Idris, from near
 Towy.
130 View of Snowdon, from Moel
 Heydog.
149 Cottage near Edmonton.
204 Castle of Dunmally Oben, Scotland.
227 A Sketch.
233 View of Harlech Castle and
 Snowdon.
239 Caernarvon Castle.

1814
OWCS
23 Oft on a plat of rising ground,
 I hear the far-off curfew sound;
 Over some wild water'd shore,
 Swinging slow with sullen roar.

32 Thomson's Grave, from Collins's
 Elegy.

 In yonder grave a Druid lies,
 Where slowly winds the stealing wave
 The year's best sweets shall duteous rise,
 To deck the poet's sylvan grave. Etc.

65 Burgos, Spain.
127* View of Salamanca, in Spain.
139* The Bridge at Alcantara, in Spain.
140 Barmouth, North Wales.
144 Harlech Castle, North Wales, a
 Sketch.
152* View of the Escurial, in Spain.
157 Cader Idris.
159* Mondego River, in Portugal.
168* Figueras, in Spain.
175 Sketch of a Cottage.
186 Ross Castle on the Lake of
 Killarney.
187 View of Chester.
196 Harlech Castle, a Sketch.
197* Ciudad Rodrigo.
270 Beddgelert Bridge, North Wales.
290* View on the Douro, Portugal.
291 River Scene.
292 Bolton Abbey, Yorkshire.
295* Madrid.
298* View on the Mondego River.
299 A Cottage.
300 Moel Heydog, North Wales.

1815
OWCS
63 Barmouth, North Wales.
69 Tintern Abbey, Monmouthshire.

* From a sketch by Captain
Dumaresq, of the 9th
Regiment, in the possession of
the Quarter-Master-General.

80 JOHN VARLEY

70 Snowdon from Capel Cerrig.
71 Valle Crucis Abbey, near Llangollen.
77 Calcada, from the causeway, leading from St Sebastian to Passages, in Spain. From a Sketch, by Captain C. Paget, late of the 52d Regiment.
81 St Sebastian, in Spain, from a Sketch by Captain Dumaresq.
82 Lake of Killarney.
96 View of Rondo, in Spain.
111 View of Conway Castle.
126 Bala Lake.
133 Beddgelert Bridge.
225 Snowden, from near Harlech.
236 Berry Pomeroy, Devonshire.
241 Moel Hedog, North Wales.
253 Cader Idris, from Llanelltydd.
347 View of Cader Idris, from the Road to Barmouth.

1816
owcs
82 View of Villa Franca, in Spain, from a Sketch by J.D. King, Esq.
166 View on the Wye, South Wales.
241 View of Chiswick, from Barnes.
245 A Sketch.
246 Ross Castle, Killarney.
257 View of Cividad Rodrigo, in Portugal, from a Sketch, by Major Dumaresque.
283 View of Passages in Spain, from a Sketch by Colonel Halicomb.
315 Kilchern Castle, Loch Awe.

1817
owcs
1 View near Lewel at Chudley, Devon.
190 Cheyney Row, Chelsea.
208 View between Barmouth and Dolgelly.
234 Bamborough Castle, Northumberland.
276 A Frame containing four Drawings.
283 View on the River Tay, Perthshire.
298 A Frame containing four Drawings.

1818
owcs
46 Westminster Abbey, from Old Ranelagh, painted on the spot.
195 River Scene.
217 Conway Castle.

234 Cottage, at Watford.
261 Holy Island, Northumberland.
287 A Thunder Storm.—The Towers designed from a Persian Gateway, near to Mount Ararat.
299 Gateway at Totnes, Devonshire.
303 Cader Idris, North Wales.
305 Cottages.
327 River Scene.
346 Conway Castle, North Wales.
347 View from Holy Island, looking Northward.
369 Snowdon, from near Harlech.

1819
owcs
3 Eton College.
93 The Burial of Saul. (*With quotation from Samuel, Book 2, Chap. 1.*)
138 Eton College.
148 Cader Idris, North Wales.
188 Chiswick—on the Thames.
198 Turk Lake, Killarney.
258 View near Harlech.
316 View near Marseilles, France.
330 River Scene.
336 Barnes.

1820
owcs
91 Eton.
94 View of Coniston Lake.
103 Windsor.
113 View of Battersea Bridge from Millbank.
217 Scene near Battersea.
242 Evening. Oft on a plot of rising ground, etc.

1821
owcs
47 Skipton Castle, Yorkshire.
54 Turk Lake, Killarney, Ireland.
72 Scene from the Bride of Abydos. (*This picture was painted in consequence of* MR. VARLEY *receiving the last Annual Premium, which is given by the Society, at the close of each Season, for the purpose of inducing the Artist to undertake a Work of elaborate composition for the ensuing Exhibition.*) Within the place of thousand tombs, etc. *From The Bride of Abydos, Canto xxviii.*

1822
owcs
17 Conway Castle.

59 Destruction of the City of Tyre.
(*Quotations from Ezekiel, chap. 27, ver.
2, and Revelation, chap. 18, ver. 5 and
8.*)
146 Landscape.
147 Cottage Scene.
148 Chingford Church, Essex—Study
from Nature.
150 Greenwich from the Observatory.
152 A Forest Scene.
153 Putney on the Thames.
154 Brecknock Castle, South Wales.
155 Waltham Abbey, Essex.
156 Snowdon.
158 Battersea Bridge.

1823

OWCS

57 View near Battersea.
60 Evening.
61 River Scene.
62 Conway Castle.
63 Cottage Scene.
64 Mountains of Mourne, in the
County of Downe, Ireland.
66 Glenna Cottage, Killarney.
67 Turk Lake, Killarney.
71 Turk Lake, Killarney.
72 London, from Greenwich.
73 Sandgate, Kent.
74 Evening—a Sketch.
78 Composition.
79 Conway Castle—a Study.
132 Aqueduct near Langollen.
137 Thomson's Tomb.

In yonder grave a Druid lies, etc.
COLLINS.

149 Vanburgh House, Greenwich
Park—Study from Nature.
167 Thrasimene—where Hannibal
defeated the Romans.

Far other scene is Thrasimene now,
Her lake a sheet of silver, and her plain
Rent by no ravage, save the gentle
plough.
LORD BYRON.

168 Harlech Castle.
257 Wilsdon—Twilight.
258 A Study.
273 Composition.
275 A Study.
280 Chingford Church, Essex.
284 Trimmingham, near Cromer,
Norfolk.

288 View in Leyton, Essex—Study from
Nature.
295 Evening—Composition.
296 River Scene.

BI

191 A View of Dollgelly, North Wales.

1824

OWCS

4 Tintern Abbey.
11 Cromer, from the Light House.
42* Egripo, in Greece.
50* View of Athens looking towards the
Morea.
71 Tower at Berkhampstead, from a
Sketch by Lieutenant Dawson, of
the Royal Engineers.
72* Constantinople, looking towards the
Bosphorus.
80 View of Chelsea, from Battersea
Meadows.
81* View of Essouan, looking up the
Nile.
211 Days of Peace.

How sweet's the product of a peaceful
reign,
The heaven-taught Poet, and the
enchanting strain,
The well filled palace; the perpetual
feast;
A land rejoicing, and a people blest.
*Approaching in the distance are two youths,
who* Guide along The sacred Master of
celestial song; etc. *Vide the Odyssey.*

227 Cromer, Norfolk.
228 Holy Island and Bamborough
Castle.
236 London, from Greenwich Park.
253 Glamis Castle, the reputed scene of
Duncan's Murder.
260 Sandgate, Kent.
261 Cottage Scene.
267 Bamborough Castle.
268 North End—Hampstead.
273 Tegwin Ferry, near Harlech.

1825

RA

432 Sketch of cattle and landscape.
433 Sketch of a cottage scene.

OWCS

70 Waltham Abbey, Essex—A Study
from Nature.
72 Landscape.

* From a sketch by J. Rennie,
Esq.

* From a sketch by J. Rennie, Esq.

255 Tumulus of the Greeks, who fell in the battle of Marathon.

How sleep the brave who sink to rest,
With all their country's wishes blest! etc.

333 View on the Thames.

1829

602 View of Willsden church, lighted for evening service; Harrow in the distance.

OWCS
40 View in the Isle of France.
42 Composition.
120 Moel-Hedog, North Wales.
146 Harlech Castle—Composition.
207 Willsden Church, Middlesex.

1830
RA
62 View of the Lake of Killarney, taken from Innisfallen.

OWCS
138 Harlech Castle.
161 Pont Abberglaslynn.
309 Cottage near Knaresborough.

1831
RA
779 View, an Italian scene.

OWCS
39 Sketch of the Old Tower at Hackney.
117 A View of Vauxhall Bridge, from Millbank, finished on the spot.
151 Composition.
196 Study from Nature.
235 Composition.
369 Composition.
390 Rustic Scene.
397 Cottage Scene.
423 View at Millbank.

1832
RA
633 An evening scene.

OWCS
65 A Study from Nature—Carshalton, Surrey.
177 Cottage at Carshalton.
181 A Welsh Cottage.

229 Looking towards London from Craven Hill, Bayswater.
347 A Landscape.

BI
560 The Burial of Saul. (Perhaps by Varley.)

1833
RA
10 A view at Windsor.

OWCS
58 Chepstow Castle.
94 Tintern Abbey.
223 Andromache.

Not Priam's hoary hairs defiled with gore,
Not all my brothers gasping on the shore; etc.
Pope's Homer's Iliad, Book VI, v. 576.

238 Conway Castle.
248 [No title given.]

1834
RA
441 Landscape,—composition.

OWCS
5 Turk Lake, Killarney.
42 Harlech Castle, looking towards the Coast of Caernarvon.
170 Richmond Hill, Surrey.
255 Pont Aber Glaslynn.
347 Oft, on a plat of rising ground, etc.
Milton's Penseroso.
359 Lake Scene.
364 Beddgelert Bridge.

1835
RA
506 View of Harlech Castle.

OWCS
186 Snowdon, from Traethmawr.
211 View near Ensham, Oxon.
232 Hove, near Brighton.
302 View at Windsor.

1836
OWCS
56 As some tall cliff that rears its awful form,
Swells from the vale and midway leaves the storm;

Tho' round its breast the rolling clouds
are spread,
Eternal sunshine settles on its head.
Goldsmith.

115 Study from Nature in Wooton Park,
near Dorking, Surrey.

1837
owcs
86 Mountainous Scenery.
262 Bamborough Castle, from Holy
Island.
271 Mountain Scene.
272 Composition.
301 Moel Hebog, from Llyn Dinas.
322 Sunset.

1838
RA
616 Landscape.

owcs
65 The Disobedient Prophet Slain.
116 Mountainous Scene.
126 Composition.
176 Mountainous Scene.
199 St Allesia, Sicily.
240 View on the Croydon Canal.
277 A Landscape.
289 Landscape.
291 Evening.
308 View on the Thames, near
Battersea.
329 Loch Long.

1839
RA
600 A mountainous scene.

owcs
28 Gap of Dunlow, Ireland.
48 Llanberis Lake, North Wales.
201 Evening—Composition.
228 Carisbrooke Castle, from the Mill
Dam.
262 Winchester Tower, Windsor.
282 Cottage Scene.
303 Boyle Abbey, County of
Roscommon.
326 St Paul's and Westminster Abbey—
View taken from Chelsea Creek.

1840
RA
876 Landscape—evening.

owcs
41 Twickenham.
137 Bamborough Castle.
196 Harlech Castle.
206 Twilight.
210 Mountain Scene.
215 Landscape.
224 Evening.
282 Evening.
319 Chiswick.

1841
RA
615 Twilight.

owcs
6 Composition.
20 Evening.
21 Composition.
49 Landscape.
56 Sunset.
71 Twilight.
80 Landscape, with Cottage.
134 Composition.
142 Landscape—Composition.
146 Evening—Composition.
176 Composition—Evening.
192 Landscape, with Bamborough
Castle.
243 Mountain Pass.
245 Composition.
248 Landscape, with Ruins.
251 Lake Scene, with Ruins.
252 Welsh Scenery.
253 Composition.
274 Landscape—Composition.
288 Composition.
295 Composition.
301 Evening.
303 Mountainous Landscape.
306 Mountainous Landscape.
309 Twilight.
312 Landscape—Evening.
318 Composition.
322 Cintra.
327 Landscape.
332 River Scene, with Ruins.

1842
owcs
7 Sun-set.
19 Composition.
37 Landscape, with Ruins.
40 View in Spain.
56 Mountainous Scenery.
92 Composition.

ae **5** *Looking up the High Street, Conway*

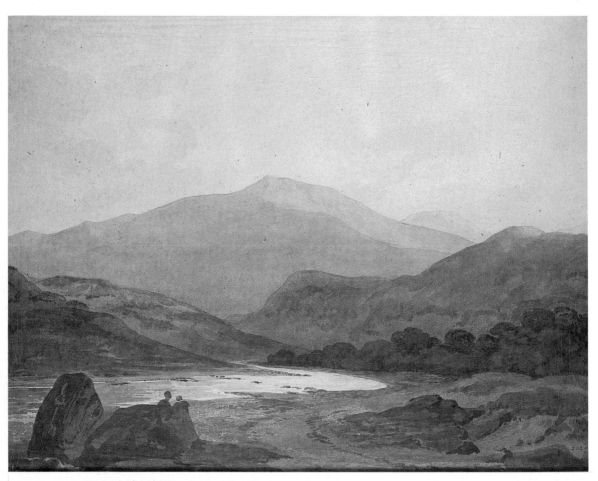

Catalogue **15** *Moel Hebog from near Dinas Emrys*

Catalogue **16** *Near Handborough, Oxfordshire*

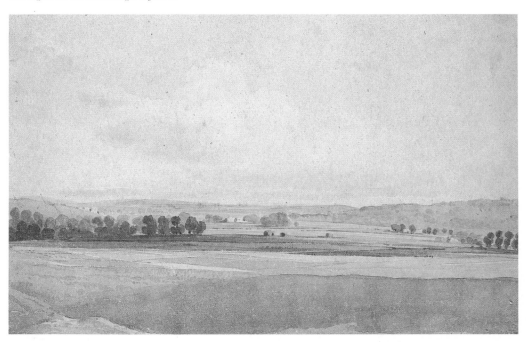

Catalogue **17** *Mountain landscape: view from Cader Idris*

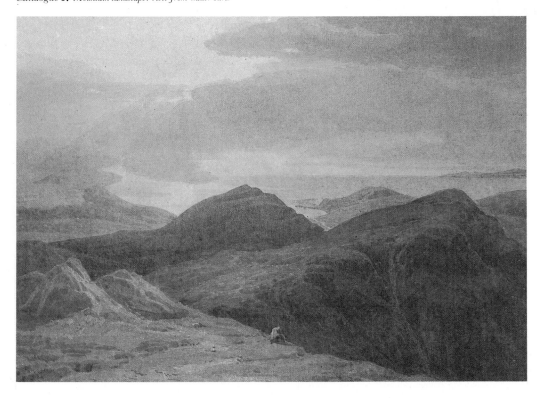

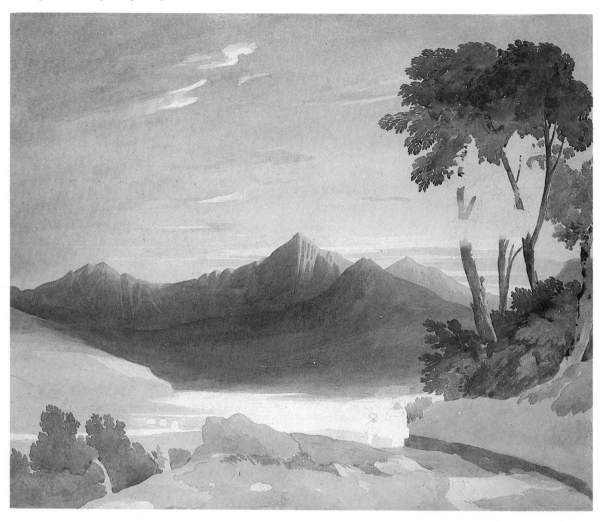

Catalogue **23** *Coast scene with houses: (?) Barmouth*

Catalogue **32** *Dolgelly Bridge, North Wales*

Catalogue **37** *The Pest Houses, Tothill Fields*

Catalogue **45** *Frognal, Hampstead*

Catalogue **73** *Classical landscape composition with an angler and two women in the foreground*

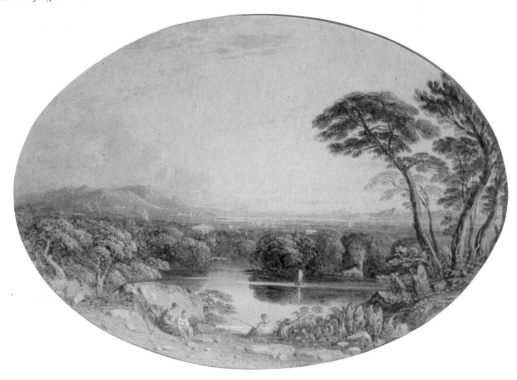

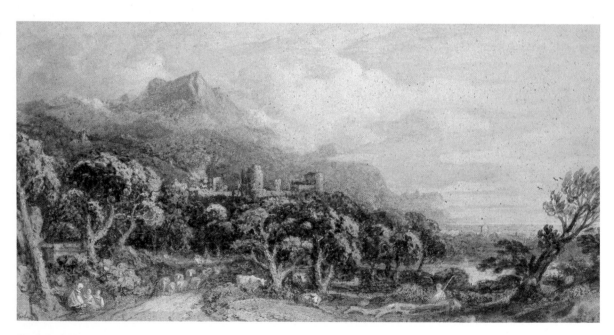

Catalogue **75** *Landscape composition with sheep, castle and mountains*

Catalogue of
John Varley's watercolours
in the collection of the
Victoria & Albert Museum

Catalogue

Sizes are given in inches and centimetres, height before width

1
Welsh sketchbook

Pencil on cream Whatman watermarked TW 1794 (p. 10 only) and 1798 (*passim*), 76 pp; 4½ × 7⅛ (11·5 × 18) in paper cover
E 3243-1931
(pp. 21, 23, 31 and 41 are illustrated)
CONDITION: Sheets soiled and foxed
PROV: Family descent to Harold Fleetwood Varley, grandson of the artist, from whom bought by the Museum in 1931
CONTENTS: Cottages (pp. 1, 27, 31). Figure studies (pp. 3, 23, 24, 38).
Studies of boats (p. 17). Landscapes: estuaries (pp. 19, 21), mountains (pp. 6-7, 13, 61, 69). Trees and foliage (pp. 54, 56). Conway Castle (pp. 33, 37, 39, 41, 42, 53). Close-up depictions of walls and plants (pp. 65, 67). Views through gothic archways (pp. 35, 71). Architectural moulding (p. 51). Wash drawing of a house (p. 75). Many pages are blank

The 1798 watermark unfortunately does not provide a precise date for the sketchbook. Varley was in Wales in 1798 or 1799, possibly in 1800, and certainly in 1802, and it could date from any one of these tours. The drawings vary from finely executed, detailed studies of cottages, figures and boats, to broadly treated landscapes done with a soft pencil, but they all have the lively spontaneity of sketches drawn on the spot.

As Conway Castle reappears at intervals through much of the book, it is likely that several of the landscapes were drawn in the same region. The estuary scenes are probably of the Conway, but the mountain landscapes are difficult to identify with any degree of confidence in Varley's finished watercolours. There are similar landscape sketches of Welsh and of Yorkshire subjects in a series of albums watermarked 1802, 1804, and 1805 in the British Museum (nos. 1892-8.4.27/32), as well as comparable studies of figures and boats (nos. 1932-12-20-149/160).

1 (p.3)

1 (p. 21)

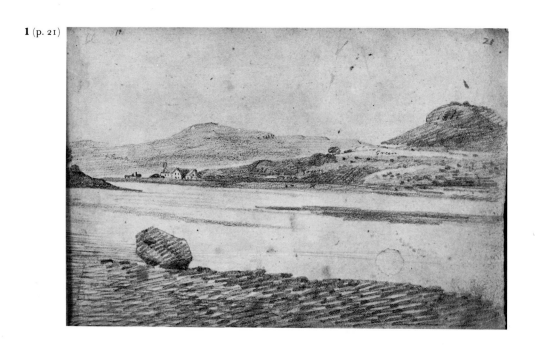

1 (p. 23)

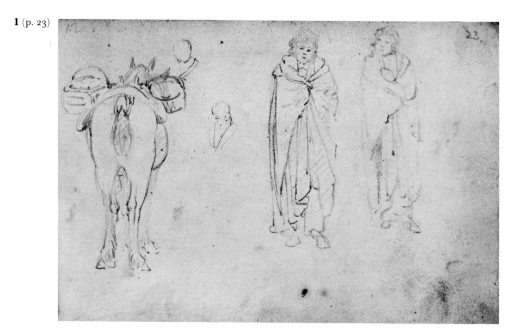

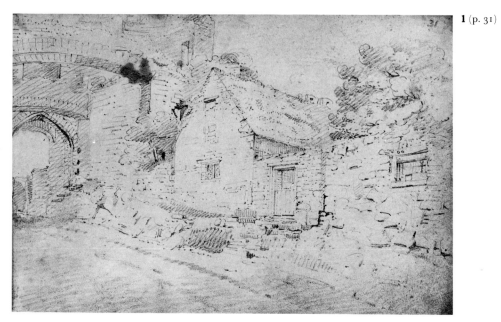

1 (p. 31)

1 (p. 37)

1 (p. 41)

2
Cader Idris, from above Llaneltyd

A rough pencil sketch of a landscape on
the reverse
Pencil and watercolour on wove; $16\frac{3}{4} \times 41\frac{5}{8}$
(42.5×105.7)
Inscribed on a label on the back *View of
Cader Idris/North Wales/by John Varley/No. 2
Harris's Place Pantheon/Oxford Street*
FA 381
CONDITION: Badly faded and discoloured;
the sky is uniformly beige (see below). Left
hand corners torn. Removed from old
stretcher, cleaned, repaired and re-
mounted in 1983
PROV: Bought for the Museum by Richard
Redgrave in 1858
EXH: RA 1801 (306)
LIT: Redgrave, I, 1866, p. 494. Redgrave,
*Descriptive Catalogue of Watercolour Paintings
in the SKM*, 1876, p. 209; Roget, I, 1891,
p. 271

Cader Idris is seen from the north, with
the River Mawddach and Llaneltyd Bridge
in the middle ground. The label on the
back indicating Varley's address at 2
Harris Place helps to fix the date. He
exhibited from there in 1802 and appears
to have lived there *c.* 1801-4; at any rate

he was still in Hoxton in 1800 and had
moved to Broad Street by 1805. The label
itself and the watercolour's very large size
suggest that it was an exhibition piece and
it may, therefore, be tentatively identified
with the only work of this title exhibited by
Varley in the period 1801-4: *View of Cadr
Idris* shown at the Royal Academy in 1801.
This identification, which was accepted by
Redgrave and Roget, would render it the
earliest extant exhibition watercolour by
John Varley, although its value as a
document is diminished by its faded
condition.

The 1876 catalogue describes it as 'In
the artist's early manner, tint sparely used',
but the strong blue visible along the edges
under the mount suggests that there has
been considerable fading of indigo,
particularly in the sky and clouds but also,
to a lesser extent, in the green areas.
Although the blue along the edges must
have darkened, probably through acidity,
it is tempting to speculate that the tonality
was originally more blue-ish throughout,
perhaps not unlike the almost identical,
smaller version of the composition dated
1802 formerly in the possession of Andrew
Wyld (*British Watercolours . . . 1750-1900*,
Wyld Gallery, June 1983, no. 14, repr.).

This has a blue sky and a strong blue-green in the landscape which may reflect the original tonality of FA 381.

In composition and technique the influence of Girtin is paramount, particularly in the short brush strokes on the distant trees and sheep, in the painterly foreground and in the layered treatment of the flat middle ground, which may be seen in identical fashion in Girtin's *Landscape with hill and cloud* in the British Museum (Binyon, 1907, 7). The wide panoramic scene from a slightly raised viewpoint is typical of Varley's early watercolours (cf. *Handborough*, **16**); this was before compositions of greater depth formed by triangular open foregrounds came to dominate in his work (cf. **11-15**). Pencil contours on clouds and mountains are bold and sketchy: only the broad outlines were pencilled in to guide the artist's brush. The most original feature, the regular cloud formation isolating the mountain peaks,

also reappears in the Wyld version, as in later works by Varley such as the *Snowdon from Capel Curig* (**19**). Swirling clouds round mountain tops are a commonplace of the Sublime; there are fine examples by Turner – *Llanthony Abbey*, 1794 (BM, Wilton, 1979, no 65; 1980, no. 1, col. pl. 1) and Girtin – *Near Beddgelert*, 1798 (BM; Girtin and Loshak, 1954, pl. 44). However, Varley's more stylized cloud, from whose engulfing embrace the peaks mysteriously emerge in a manner reminiscent of oriental painting, marks a departure from the naturalism of his contemporaries, and may well owe a debt to the influence of J.R. Cozens (e.g. *Between Chamonix and Martigny*, V & A, 158–1881).

A view of the same subject by Cornelius Varley (exh. *Cornelius Varley*, Colnaghi, 1973, no. 118, repr.) includes the village of Llaneltyd, just beyond the bridge, which John has purposely omitted.

2

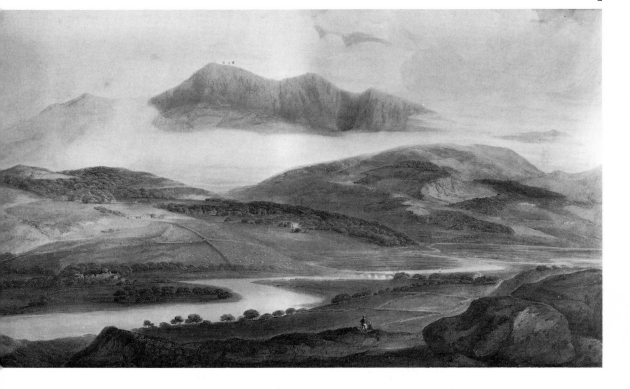

There is also a close-up view of Llaneltyd Bridge from the same side by Moses Griffiths in the National Museum of Wales, Cardiff. Varley himself painted the same scene many times: a version in the National Museum of Wales, Cardiff, dated 1811 is very similar to FA 381; a more Claudean composition dated 1815 and differing considerably is in the Walker Art Gallery, Liverpool (*English Watercolours in the Collection of C.F.J. Beausire*, 1970, no. 45, pl. 17).

3
St Mary Redcliffe, Bristol

Watercolour over traces of pencil on cream wove, stuck on to original mount; 15$\frac{7}{8}$ × 22$\frac{3}{8}$(40·4 × 56·7)
Signed lower right *J. VARLEY* 1802.
Inscribed on the back in pencil, *St. Mary Redcliff Bristoll/J Varley No. 2 Haris Place Pantheon*
P 116-1929
CONDITION: Some foxing in sky, otherwise good
PROV: R.H. Stephenson (d. 1927) Leicester; passed to the Museum in his bequest of miniatures and watercolours in 1928

The view is of the exterior of the church from the south. Queen Elizabeth I, it is said, called it 'The fairest, goodliest and most famous parish church in England' (quoted in N. Pevsner, *The Buildings of England, N. Somerset*, 1958, p. 398) and it is certainly one of the grandest in the country, measuring 240ft in length inside. It was built mainly in the fourteenth and fifteenth centuries: the tower, the north and south porches and the lower part of the south transept are fourteenth century, most of the remainder of the exterior is Perpendicular, *c.* 1440-70. The spire suffered from lightning in 1446 and remained truncated until it was rebuilt in 1872.
In the treatment of both building and sky this watercolour recalls Hearne's topographical views, finely detailed and with a feeling for the picturesque quality of crumbling masonry and of dark shadows on walls bathed in the light of the setting sun. It fits well with the two views of Conway (**4, 5**) which are of about the same date, differing in essence from the London

subjects, such as Waltham Abbey (**40**) which are characterized by a lighter palette and a greater interest in natural phenomena.
It was engraved by I. Rosse in 1802 for publication in John Britton, *The Beauties of England and Wales*, XIII, pt 2, 1813, p. 670. The engraving is in the same direction and differs only in having three figures instead of two and in the treatment of the right foreground. It seems unlikely that Varley was commissioned by Britton. Although a few of his drawings are reproduced in the *Beauties of England and Wales*, for example Llanthony and Chepstow (vol. XI, 1810, pp. 83, 174), these are very few when compared to Britton's regular artists, like J.P. Neale, and it is likely that Britton acquired the use of a handful of Varley's drawings he had seen. Bristol does not figure largely in Varley's *oeuvre*, but there is no reason why it should not have been included in his visit to Wales in 1802. The church appears in the 1836 view of the city in the Huntington Art Gallery (Gleeson, 1969. Cat. 2).

4
Looking up the High Street, Conway

Watercolour over traces of pencil on white wove, some scraping out; 14$\frac{3}{8}$ × 20 (36·5 × 51)
Signed lower left *J. VARLEY*. Inscribed on back of old mount in the artist's (?) hand *View up the High Street Conway/J. Varley* 1742-1871
CONDITION: Good; cleaned in 1981
PROV: William Smith, Vice-President of the National Portrait Gallery; gift of 86 watercolours in 1871 followed by a further selection on his death in 1876
LIT: E.B. Lintott, *The Art of Water-colour Painting*, 1926, p. 237 (repr.)
EXH: *English Drawings and Water-colours*, National Gallery, Washington, and Metropolitan Museum, New York, 1962, (93)

The shadow in the foreground leads the spectator into the centre of the composition, with its emphasis on the half-timbered houses on the right and on the street itself. In contrast to the strong blue of the companion piece, *Looking down the High Street, Conway* (**5**), there is a slightly greenish tint in the sky. These large

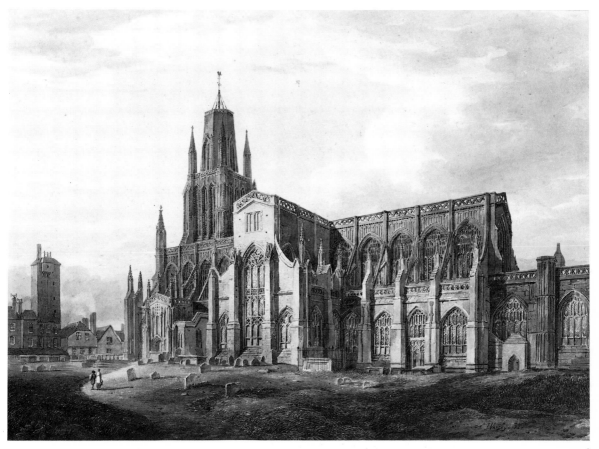

3

watercolours both belong to the group of town views, particularly of Hereford, Leominster and Conway, which Varley produced in 1800–3. Concentrating on the half-timbered houses so dear to the Picturesque aesthetic, these town views fall into the tradition pioneered by Hearne and perfected by Girtin and Turner in the 1790s. Exactly the same scene, including the figures and carts, appears in a drawing by Cornelius (formerly Squire Gallery, London). It was in the summer of 1802 that the two brothers were in Wales together, which indicates a date of 1802–3 for this large, finished watercolour, probably produced in the studio rather than on the tour itself. The date fits also with a very similar *View in Conway*, showing a different street but with the same emphasis on half-timbered houses, which is dated 1802 (formerly Peter Jones coll.,

repr. *Connoisseur*, LXX, 1924, p. 233; a related version at Christie's, 14.2.1978, 118). A slightly smaller, less finished version of 1742–1871 with fewer figures was formerly in the collection of G. Kersley.

5
Looking down the High Street, Conway

Watercolour over traces of pencil, some scraping out, on white wove; $14\frac{1}{2} \times 20\frac{5}{8}$ (36.8×52.2)
Signed lower left *J. VARLEY*. Watermark *J. WHATMAN 1801*. Inscribed on back of old mount in the artist's (?) hand *Conway looking down the High Street/NW J. Varley* 1743–1871
(see colour plate, between pp. 84 and 85)
CONDITION: Good, cleaned in 1981
PROV: As previous no.

4

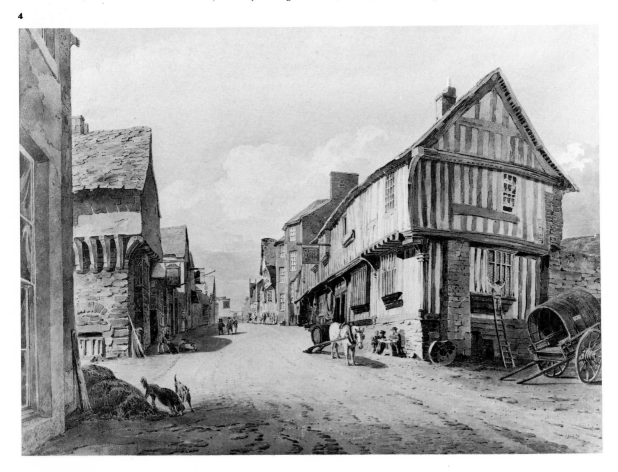

As with the companion piece, *Looking up the High Street, Conway*, the shadow in the foreground serves to draw the spectator's eye to the well-lit areas in the middle distance. The strong blue of the sky and the more firmly modelled clouds differentiate this watercolour from its companion, but there seems little reason to doubt that they were done at the same date. An old Museum mount bore the inscription *Exhibited at the RA 1800*, but the date on the watermark, though cut, is clearly 1801. *Looking up the High Street* has been dated 1802-3 and such a date can be given equally to this watercolour. A very similar but smaller version in the Mellon collection is dated 1803 (*English Drawings and Watercolours, 1550-1850 in the Collection of Mr and Mrs Paul Mellon*, Morgan Library, New York, 1972, no. 118 repr.; 20·7 × 29·5 cm.).

6
The Death of Milo

On the reverse an academic drawing of a foot, from a cast, by a different hand
Black and white chalk on blue laid, torn from a larger sheet; 13¾ × 11¼ (34·8 × 28·7)
Inscribed lower right (and also on the back in a different hand) *Milo/J. Varley*
E 1488-1939
CONDITION: Paper creased at right edge; otherwise good
PROV: J.S. Hayward (1778-1822) by family descent to J. Howard Barnes; given to the Museum by his descendants in 1939
LIT: Hamilton, 1971, p. 9, pl. 8

Milo of Crotona, famous for his great strength and six times victor in wrestling at the Olympic games, met his end in a particularly sad way. Enfeebled by old age, he attempted to tear apart a tree partially split by woodcutters. But the wood closed on his hands and held him fast until he was ultimately eaten by wolves.
 Varley was joined by Havell and Cristall for this session (Hamilton, 1971, pls. 8-10) and Cristall's rendering, in particular, of the athlete's posture, anatomy and expression, serve to stress Varley's weakness as an artist of figure compositions. Cristall's version, also, is closest to the traditional treatment of the theme, embodied in a drawing by Salvator Rosa (Hamilton, 1971, pl. 11).

6

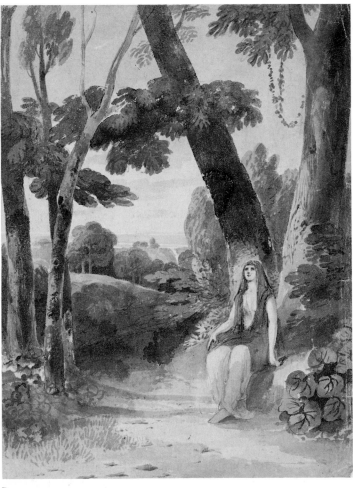

7

Pale melancholy

Pencil and grey wash on cream laid; 18¾ ×
14⅝ (47·8 × 37)
Inscribed on the back *J. Varley/'Pale
Melancholy'/Collins*
E 1521-1939
CONDITION: Creased and torn at right edge;
stained lower centre; otherwise good
PROV: J.S. Hayward (1778-1822) by family
descent to J. Howard Barnes; given to the
Museum by his descendants in 1939
LIT: A.P. Oppé, 'Cotman and the Sketching
Society', *Connoisseur*, 67, 1923, p. 192, fig. 7;
Hamilton, 1971, p. 10, pl. 15

In his *Ode to the Passions*, William Collins
follows Fear, Anger, Despair, Hope,
Revenge, Pity, Jealousy by the appearance
of Pale Melancholy:

With eyes up-rais'd, as one inspir'd;
Pale Melancholy sat retir'd
And, from her wild sequester'd seat,
In notes by distance made more sweet
Pour'd through the mellow horn her pensive
soul.

The ultimate source for the representation
of Melancholy as a solitary female figure is
Dürer's engraving. However, in subsequent
centuries she was usually dressed in
idealized classical costume and in England,
under the influence of poets from Gray to
Keats, she becomes a figure of elegiac
sadness rather than of black melancholy
(R. Klibansky, E. Panofsky and F. Saxl,
Saturn and Melancholy, 1964, pp. 228 ff.,
374 ff.).

Indeed, in Milton's *Penseroso* Melancholy
is described as a 'Pensive Nun, devout and
pure', and this probably accounts for her
garb in Varley's drawing. A contemporary
illustration to Collins's *Ode*, James
Hopwood's engraving after John Thurston,
also shows her as a heaven-gazing nun.

This is one of Varley's most successful
Sketching Society drawings. The broad
washes of the landscape and the bold,
sinuous trees, reminiscent of Cotman,
provide a suitably poetic setting for the
figure. Only two drawings made on that
particular evening have survived: the
other, with a more convincing figure, is by
Joshua Cristall (V & A E 1501-1939:
Hamilton, 1971, pl. 14).

7

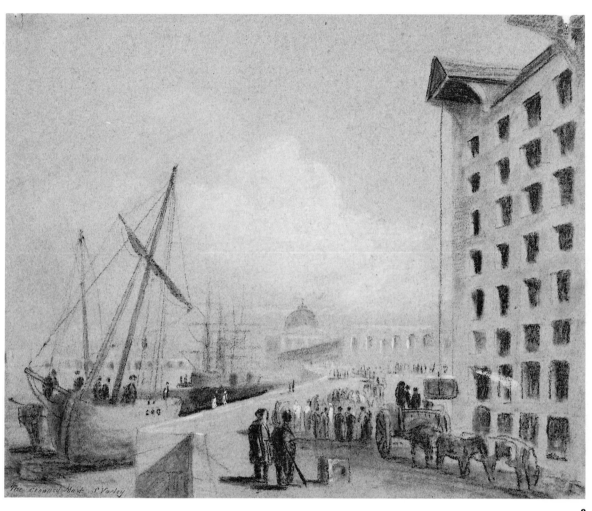

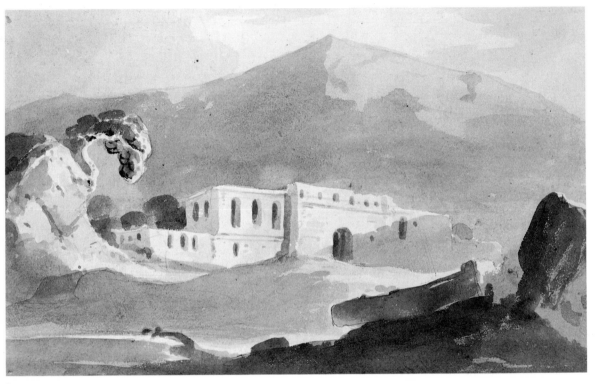

9

8
The crowded mart

On the reverse, lower half of a drawing of a male figure from a plaster cast, by a different hand
Charcoal and Chinese white on blue laid, torn from a larger sheet; $11\frac{5}{8} \times 14$ (29×35.5)
Inscribed lower left and again on the back in a different hand, *The Crowded Mart J Varley*
E 1535-1939
CONDITION: A few small stains, otherwise good
PROV: J.S. Hayward (1778-1822), by family descent to J. Howard Barnes; given to the Museum by his descendants in 1939
LIT: Hamilton, 1971, p. 9, pl. 12

Although the subject is taken from Charles Lloyd's poem *London* (1795) the pictorial inspiration derives from Claude's harbour scenes (e.g. LV 10; LV 28). Nevertheless, Varley has replaced Claude's classical palaces by a warehouse of distinctly contemporary appearance.

Of the six members attending the Society for this session only Varley, Cristall and Havell are named. Varley's composition suffers by comparison with those by the other two, both of whom are more adept at figure subjects.

9
Shipwreck

Pencil, black chalk and sepia wash on cream wove; $10\frac{5}{8} \times 17$ (26.7×43.3)
Inscribed on the back *Jn. Varley*
E 1504-1939
CONDITION: Good
PROV: See next entry

10
Shipwreck

Pencil and sepia wash on cream wove; $11\frac{3}{8} \times 16\frac{5}{8}$ (28.8×42.2)
Inscribed lower right and on back *J. Varley*
E 1502-1939

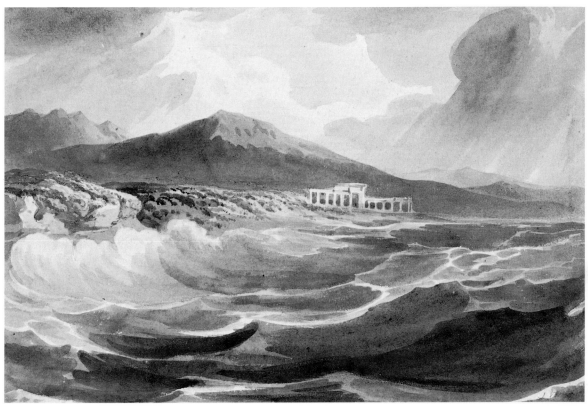

CONDITION: Creased upper right corner, otherwise good

PROV: J.S. Hayward (1778–1822), by family descent to J. Howard Barnes, given to the Museum by his descendants in 1939

According to Hayward's notes, the subject was William Falconer's *Shipwreck*, and it is the last section of the poem that appears to be most relevant to these compositions:

But now Athenian mountains they descry
And o'er the surge Colonna frowns on high
Where marble Columns long by time defaced,
Moss covered on the lofty Cape are placed . . .
CANTO III, *section 5*

The 'marble columns' are the central feature of E 1502 whereas E 1504 shows what appears to be the wrecked ship. They are comparable to Nicholas Pocock's illustration to Canto III engraved by J. Fittler for the 1804 edition of Falconer's poem, but it is worth remembering that shipwreck was one of the most popular subjects of Romantic painting (T.S.R. Boase, *J.W.C.I.* XXII, 1959, p. 332).

11
View in the Pass of Llanberis

Watercolour on cream wove, laminated;
10¾ × 16⅛ (27·3 × 41)
Signed lower right *J. VARLEY 1803*
Inscribed on the back by the artist *View in the Pass of Llanberis N. Wales. Looking towards Llanberis Lake./From near the Large fragments of Rock in which an old Woman liv'd for some years & made a . . ./by J. Varley 1803*
2954–1876
CONDITION: Good
PROV: William Smith, Vice-President of the National Portrait Gallery; in whose bequest it passed to the Museum in 1876
EXH: *British Watercolours from the V & A Museum.* Circulated by the International Exhibition Foundation, 1966–67 (95); *Dr Thomas Monro,* V & A, 1976 (78); Hackney 1978 (14)
LIT: Bury, 1943, p. 20 repr; Bury, 1946, p. 39, pl. 25

The treatment is in broad washes punctuated by short, Girtinesque strokes of

10

the brush. There is an emphasis on diagonals, with the dominant rock in the foreground, the mountainside and the sunbeams, while the carefully modelled white clouds parallel the shape of the mountains. The tonality shades from the blue of the sky to deep blue in the background (possibly a reference to the reputation of the pass as the 'blue vale') to the grey-green in the foreground. The old woman and her cows are shown in the middle distance.

Jones and Co., *Wales Illustrated in a Series of Views* (1830, p. 93) throws light on Varley's inscription:

From Llanberis to Capel Curig is a curious and romantic pass between three and four miles in length ... called Cwm glas or 'blue vale'. The rocks on each side are of tremendous height, in some places nearly perpendicular ... About three miles from Llanberis is a huge fragment of rock ... once probably loosened from the

impending heights above; under which is a large cavity, where a poor woman resided for many years during the summer season, to tend her sheep and milk her cows: the place is called Ynys Hettws, Hetty's Island.

There is a preparatory drawing in the British Museum ($3\frac{1}{2} \times 5\frac{3}{4}$ in.; 1859-5-28-126; Binyon, 1907, no. 10[b]). Identical in composition with the V & A watercolour except that it omits the old woman, it is considerably smaller and broader in treatment. It was probably drawn from nature in 1802 or 1803. A view of the pass taken from the opposite side is in the Whitworth Art Gallery, Manchester.

12
Cader Idris across Lake Bala

Watercolour with traces of pencil and scraping out on coarse cream wove, laminated; $7\frac{5}{8} \times 11\frac{1}{2}$ (19·4 × 29·2)

11

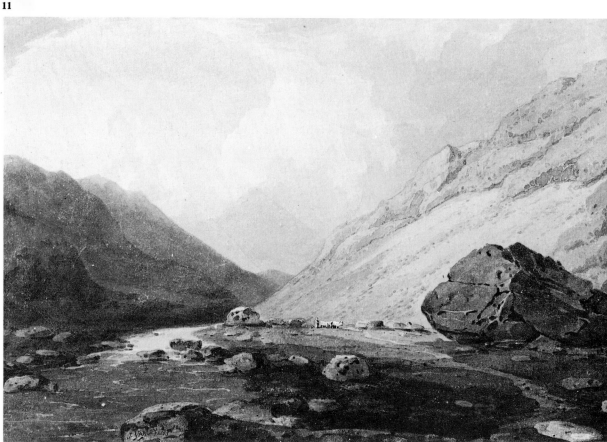

Signed lower left *J. Varley 1804*. Inscribed on the back *View of Cader Idris across Lake Bala N Wales by J. Varley 1804*
1438–1869
CONDITION: Somewhat faded
PROV: The Rev. C.H. Townshend (d. 1868) in whose bequest it passed to the Museum

Entitled, simply, *Lake Scene* when it was acquired, this watercolour was subsequently re-named *Tal-y-Llyn, North Wales* and as such it was published in all Museum catalogues from 1908 to 1980. The view from Tal-y-Llyn is, indeed, very similar, but there is no need to question the veracity of the inscription on the back which identifies the scene as Cader Idris across Lake Bala. Cader Idris is about 20 miles south-west of Lake Bala and Varley has, as usual, brought it nearer to dominate the composition. This is clear from a comparison with a similar watercolour by Girtin of 1800–1 on which Varley's is based (Girtin and Loshak, 1954, no. 413, pl. 65) and also with the same view by Moses Griffith engraved in Pennant's *Journey to Snowdon*, 1781 (p. 68) in which Cader Idris is more convincingly 20 miles distant. Pennant himself describes the view: '. . . on the right appear the two *Arrenigs*, *Vawr* and *Vach*; beyond the farther end, soar the lofty *Arans*, with their two heads . . .; and beyond all, the great *Cader Idris* closes the view'.

12

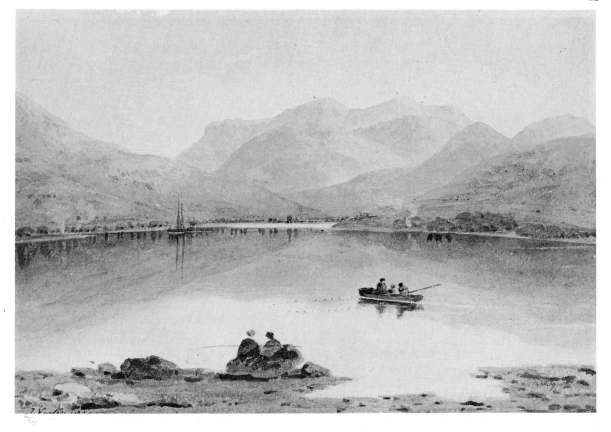

13

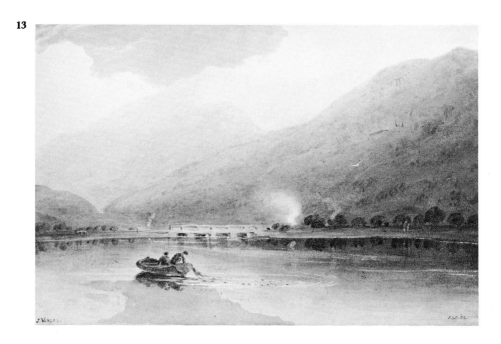

14

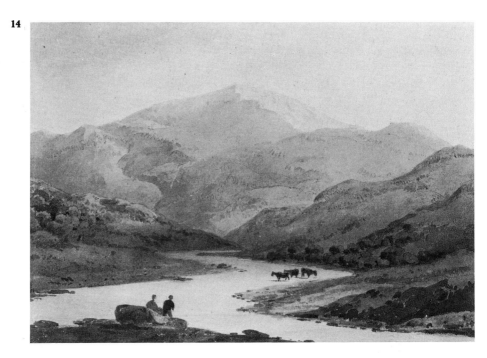

The watercolour is executed in broad washes of grey-green and grey-blue punctuated by Girtinesque dabs of the brush. Large areas of unpainted ground stand for the water at both ends of the lake. This scheme is derived from Girtin's watercolour but it also accords with Varley's precept for treating landscape in which the focus of interest lies in the distance; shadow in the foreground should be succeeded by a mass of light in the next distance and in the far distance (*Principles*, 1816, no. I, pl. 1).

There is another version, closer in detail to the Girtin, formerly in the collection of Lt Cmdr G. Agnew, RN (Bury, 1946, pl. 21).

13
Landscape with mountains, lake and bridge

Watercolour over traces of pencil and scraping out on cream wove; $6\frac{7}{8} \times 10\frac{3}{8}$ (17·5 × 26·5)
Signed lower left *J. VARLEY* (first two letters strengthened)
840–1884
CONDITION: Small damage in paper on left; somewhat faded
PROV: Bought for £5 5s od in 1884

The paper is smoother, but in style and subject this watercolour is very similar to *Lake Bala* (**12**) (1438–1869) which is dated 1804. This is probably a variation on the theme of mountains and lake rather than an identifiable place.

14
River scene with cattle in shallows

Watercolour and pencil on coarse cream wove; $9\frac{1}{4} \times 13\frac{1}{4}$ (23·2 × 33·7)
1440–1869
CONDITION: Discoloured in sky; otherwise quite good
PROV: The Rev. C.H. Townshend (d. 1868); collection bequeathed to the Museum

Paper, handling and tonality are identical with the view of *Cader Idris across Lake Bala* which is dated 1804. It differs only in the use of pencil for modelling and outlines, which is rare for Varley at this date. In composition it is very close to *Moel Hebog from near Dinas Emrys* (**15**) and it is clearly a free adaptation of this scene. From his earliest years, Varley exhibited untitled subjects called simply 'composition' at the OWCS and they were usually variations upon the Welsh lake and mountain views.

15
Moel Hebog from near Dinas Emrys

Watercolour and pencil on cream wove, laminated; $13\frac{7}{8} \times 18\frac{1}{8}$ ($32 \cdot 7 \times 46$)

Inscribed in pencil on the back *John Varley/Splendid specimen of his early style/Bought of J.W. Lowry, whose sister was J. Varley's second wife./See my catalogue/Sir E. Landseer saw this drawing at my house/& much admired it.* In the right hand corner *No. 12/Cat.* 202–1890

(see colour plate between pp. 84 and 85)

CONDITION: Faded, especially in sky

PROV: Joseph Wilson Lowry (1803–79), engraver, illustrator of scientific books and friend of John Varley who married his sister Delvalle in 1825; Dr John Percy, FRS (1817–89), metallurgist, whose large collection was sold at Christie's, 24 April 1890 (1294: *River scene with mountains and figures*); bought by the Museum for £8 16s 5d

LIT: Rich, 1918, p. 206 (repr.); Bury, 1946, p. 39, pl. 27

Moel Hebog is seen in the distance from the north-east: the view is taken from Dinas Emrys and shows the river Dinas in the foreground. Broad washes of blue-grey dominate; the foreground is brown. The outlines of a third figure are partially pencilled in. A comparison with a photograph of the same view shows the extent of Varley's tampering with nature for the sake of a picturesque composition (fig. 7). As was his custom with distant views of well known mountains – compare, for example, the view of Snowdon from Capel Curig (**19**) – Moel Hebog has been brought closer and increased in size to become the dominant feature. The contours of the hills in the middle ground are rendered with topographical accuracy, but the river Dinas has been given an additional curve, for the sake of balance.

A version identical in composition and similar in style, though with more Girtinesque stippling, was in the collection of Gerald Agnew (Agnew's *109th Annual Exhibition of Watercolours*, 1982, no. 90, pl. IV; $13 \times 17\frac{7}{8}$ in.). This is dated 180(?4) and 202–1890 may be placed in the same period. It is closely comparable in style with *Cader Idris* (**12**) which is also dated 1804. A version showing the same composition painted in a more finished manner in 1835 was sold at Christie's, 20.3.79 (156, repr.).

16
Near Handborough, Oxfordshire

Watercolour on coarse wove; $9 \times 14\frac{1}{2}$ ($23 \times 36 \cdot 5$)

Inscribed lower right by the artist *Study from Nature/near Handborough Oxon/J. Varley 1804*

s. EX 2–1889

(see colour plate between pp. 84 and 85)

CONDITION: Faded and discoloured in sky

PROV: Bought to circulate to art schools from Mrs Varley, 57 Beaufort Street in 1889 for £3 3s 0d

Handborough is in Oxfordshire, on the edge of the Cotswolds, just north of Woodstock.

The wide panoramic view and totally horizontal composition is typical of Varley's earliest watercolours, though rare in his later work. Similar naturalistic compositions date from his early years in the Monro 'school': the *View from Polesden near Bookham Surrey* – 'study from nature' – which is dated 1800 is essentially similar (fig. 2) as is the more finished *Vale of Clwyd*, dated 1804 (with Agnew's, 1982). However, the early dependence on Girtin has given way to a predominance of the broad, flat washes in which Varley specialized. The broadly blocked-in trees are miniature versions of those in *Afterglow* (**18**). It is in these early studies from nature, also, that John is closest to the work of Cornelius.

17
Mountain landscape: view from Cader Idris

Watercolour and touches of body colour on cream wove, laminated; 9⅝ × 13⅝ (24·5 × 34·6)
Inscribed on the back *Top of Cader Idris* and, in a different hand, *Mr Griffith*
AL 5737
(see colour plate between pp. 84 and 85)
CONDITION: Slightly faded, otherwise good
PROV: Bought in a group of seven watercolours, from F. Ford in 1868
LIT: Lyles, 1984

Although this watercolour was traditionally entitled *Landscape*, the inscription *Top of Cader Idris*, apparently in Varley's hand, clearly identifies the location. The view is towards the north-west over the river Mawddach and the Barmouth estuary. A smaller version is the *View from the top of Cader Idris* in a private collection (17·5 × 25·3 cm.; Bicknell, 1981, no. 123). These two watercolours are related to a third which is inscribed *View of Sunrise from the Top of Cader Idris, N Wales with Bala Lake in the distance, at Half Past 3 in the morning by J Varley 1804* (38·5 × 58·9 cm., Scott-Elliot coll., fig. 12). The inscription not only provides a date *c.* 1804 for the two undated works, but also indicates, as Peter Bicknell has pointed out, that Varley actually climbed Cader Idris on one of his Welsh tours in 1800 or 1802. Anne Lyles has drawn attention to the high horizon, unusual in Varley's drawings and directly contrary to his own precepts, following Claude, that the horizon line should be about one-third from the base of the picture (*Practical Treatise on the Art of Drawing in Perspective*, 1815). In style, these watercolours are inspired by J.R. Cozens and, as John Gage has suggested, the bird's eye view on to a meandering river is probably derived from a Cozens composition of the type of his *Pays de Valais* (*Burl. Mag.*, CXXIII, 1982, p. 570).

18
Mountainous landscape: afterglow

Watercolour over faint traces of pencil on coarse wove, scraped off old board support; 10⅝ × 18⅜ (27 × 46·5)
P 27-1930
CONDITION: Slight abrasion in sky, otherwise good
PROV: Mrs Helen K. Tooth, OBE; bought by the Museum for £25 in 1930
EXH: V & A *Masterpiece of the Week*, September 1932; V & A, *Dr Thomas Monro and the Monro Academy*, 1976, no. 79
LIT: *Illustrated London News*, 17.9.1932; Bury, 1946, p. 39, pl. 26; Williams, 1952, p. 226; Henri Lemaître, *Le Paysage Anglais à l'Aquarelle 1760–1851*, Paris, 1955, p. 364; Hardie, II, 1967, p. 104, pl. 88

According to tradition in the family of the vendor, this watercolour was held to be by Girtin, and when it was acquired by the Museum in 1930 it was catalogued as 'ascribed to John Varley'. It is, indeed, unusual in Varley's work: the washes are broader and less broken and the conception more powerfully monumental than in any other of his early watercolours. Yet it is possible to find close parallels for the details of the execution, if not for the conception of the whole. The *Handborough, Oxfordshire*, dated 1804, (**16**) provides perhaps the closest comparison in the collection, particularly for the washes and the treatment of the trees, while the deep blue-grey tonality offset by orange and pink streaking in the sky recurs, for example, in the *View of Newcastle*, of 1808 (Newcastle, 1981, no. 140). These comparisons certainly place *Afterglow* firmly in Varley's *oeuvre* and serve to confirm Martin Hardie's date of *c.* 1805.

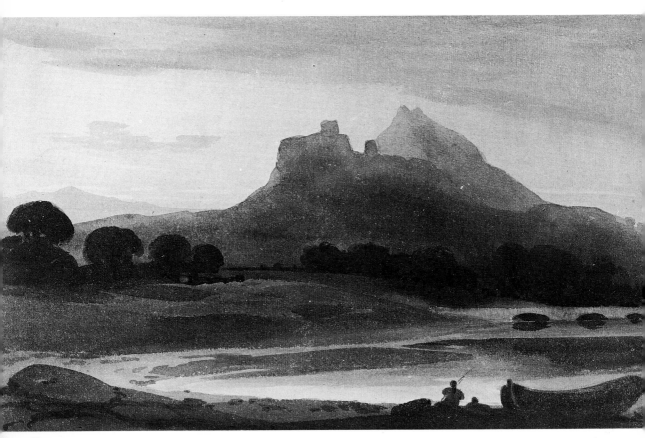

18

After the initial hesitation over the attribution, Basil Long accepted Varley's authorship and exhibited the watercolour as the Museum's *Masterpiece of the Week* in September 1932 (handsheet in Dept files), and it has been accepted ever since. Indeed, characterized by Lemaître (1955) as *un triomphe du fantastique crépusculaire*, it is clearly one of Varley's most imaginative works, a conceptual landscape far removed from the tradition of topographical watercolours. Claude drawings and Alexander Cozens were the forerunners best known to Varley of this type of landscape, and Cozens also pioneered the use of dramatic pink streaks in the sky. Conceivably, the dramatic lighting may also owe a debt to de Loutherbourg's theatrical maquettes and *Eidophusikon* of the 1780s (*P. J. Loutherbourg*, exh. Kenwood, 1973, nos 85–7). Martin Hardie pointed out that the foreground figure and prow of a boat parallel the shape and outline of the castle and mountain: an indication of Varley's underlying concern with balanced composition even when he was at his most 'abstract'.

19
Snowdon from Capel Curig

Pencil and watercolour on white wove, laminated; 14⅞ × 18¾ (37·6 × 47·6)
Inscribed in pencil in lower left margin *J. Varley*
P 52–1924
(see colour plate between pp. 84 and 85)
CONDITION: Slight fading in sky, marginal strip shows remains of former colour; otherwise good
PROV: B. Fleetwood Walker, Sutton Coldfield, bought by the Museum for £10 10s in 1924

EXH: Colnaghi, 1973, no. 110; *42 British Watercolours*, V & A, 1977, no. 25
LIT: Williams, 1952, p. 226, fig. 362; Hardie, II, 1967, p. 105, pl. 85

In its 'unfinished' state with uncoloured outline figures and branches and with the whole of the lake in the middle ground left uncoloured, this watercolour is closer to Cornelius Varley than to John's usual products. However, the flat, unshaded washes and the dark colouring of the mountain are similar to John's *Afterglow* (**18**) and to the Dolbadarn Castle in the British Museum (Binyon, 1907, no. 9), and the uncoloured pencil outlines recur occasionally in Varley's work, for example in the *Castle on the hill* (Christie's, 16.11.65, lot 38, repr. *Art News*, February 1966). A date *c.* 1805–10, in his 'broad wash period', is likely. It is the unfinished character, with clouds obliterating tree trunks in an almost oriental manner, that gives this drawing much of its appeal to the twentieth-century viewer. Although the mountain may be described as more conceptual than naturalistic, the scene represented can be identified as Snowdon from Capel Curig with Llynnau Mymbyr in the foreground.

20

The same range of peaks appears in the British Museum version (Binyon, 1907, 4) which may be contemporary but is more finished, and a version dated 1810 in the City Art Gallery, Birmingham, which is much more elaborate (56′09). Nor was Varley the first to popularize this view: the same composition appears in Moses Griffiths's *The summit of Snowdon from Capel Curig* which was engraved in Pennant's *Journey to Snowdon* (1781, p. VII) and in de Loutherbourg's painting of 1787 (Hawes, 1982, no. I.6) and, indeed, it remains a much photographed view to this day. What does not become apparent in Varley's watercolour is the fact that Capel Curig is about eight miles distant (west-north-west) from the peaks of Snowdon. As was his custom, he has brought them forward to dominate the composition, in line with Picturesque theory.

20
Beddgelert Bridge

Watercolour over traces of pencil with scraping out on coarse cream wove; 18¾ × 23½ (47·5 × 59·7)
Signed and dated lower right *J. VARLEY, 1805*
1741–1871
CONDITION: Much faded, particularly in the sky, which presumably contained tints of blue
PROV: William Smith, Vice-President of the National Portrait Gallery, gift of 86 watercolours in 1871, followed by a further selection on his death in 1876

The view of the River Colwyn is taken from the west, looking towards Moel Hebog in the distance. The treatment consists of broad washes with short brush strokes of brown, particularly on the ground. A warm, mellow light directed from the right, or south, side suffuses the composition, casting long evening shadows. The tonality is uniformly brown.

Beddgelert was prized as a place of great attraction in the eighteenth century. 'Situated at a beautiful tract of meadow at the junction of three vales . . .' wrote Thomas Pennant (1781, p. 176). 'Its situation was the fittest in the world to inspire religious meditation, amidst lofty mountains, woods and murmuring streams.' A comparable view of the bridge – then still a wooden structure – engraved after J. Evans, is reproduced in Pennant's book (see fig. 8). Varley has made a balanced Claudean composition of it, but has otherwise been content to take a very traditional viewpoint of a recognized beauty spot. Comparison with a recent photograph of the same view shows how topographically accurate Varley remained within the convention of a Picturesque composition.

This is the second extant version of the composition: the earliest, dated 1804, is in the Manchester City Art Gallery (14½ × 18¾ in.) from which 1741–1871 differs only in minor details and particularly in the greater compositional emphasis placed on the trees on the right. It is impossible to tell whether the Manchester or the V & A version or, indeed, another, was the one exhibited at the OWCS in 1805 (37). It remained one of Varley's most popular compositions. Versions were exhibited at the OWCS in 1810 (28), 1812 (187), 1814 (270), 1815 (133), 1834 (364) and, apart from the Manchester and V & A watercolours, at least eight others were recently extant:

Christie's 30.6.1981 (76 repr.), s. & d. 1811
($17\frac{3}{4} \times 25\frac{1}{4}$)
ex-M. Newman (repr. *Apollo*, March 1966),
s. & d. 1811
Leverhulme sale, Anderson, New York,
2.3.1926 (330 repr.), *c.* 1810, ($9\frac{3}{4} \times 13\frac{3}{4}$)
ex-Agnew's, *c.* 1810 ($13\frac{1}{4} \times 18$)
Christie's, 18.11.1980 (156 repr.) s. & d.
1812 ($20\frac{1}{2} \times 26\frac{7}{8}$)
Birmingham City Art Gallery (Bury, 1946,
pl. 44) s. & d. 1825 ($18 \times 23\frac{1}{2}$)
Sotheby's, 14.12.1972 (153) s. & d. 1830
($9\frac{1}{2} \times 13$)
ex-Agnew's, s. & d. 1834 ($8 \times 11\frac{1}{2}$)

Although these versions differ only slightly
in composition, the stylistic changes are
clearly recognizable. The two earlier
drawings of 1804–5 are the broadest in
treatment. Those of 1810–12 are very
similar though somewhat more finished,
particularly in the detail of the foliage. It
is, however, the Birmingham version of
1825 that provides a strong contrast not
only in its meticulously detailed finish but
also in that the watercolour has been
heightened with a considerable amount of
white and yellow gouache and with streaks
of pink in the sky. The result emulates a
Claudean oil painting even more clearly
than do the earlier versions.

 John Varley's very classical composition
may be compared with Cornelius's more
direct and brightly coloured view taken
from the other side of the bridge (V & A
p. 53-1924). Another view, taken from the
same side as John Varley's, is that by Paul
Sandby Munn, dated 1804 (V & A: E 206-
1939). It is in an eighteenth-century
topographical style, as opposed to the
watercolour by Copley Fielding (V & A
P 52-1919), which shows the bridge in
close-up, in the broad style of his teacher,
John Varley.

21
Mountain landscape with bridge

Watercolour with touches of gum on white
wove, the figures left unpainted; $10\frac{5}{8} \times 14\frac{5}{8}$
(27×37.3)
Inscribed on the back *J. Varley/a Lesson*
s. EX 3-1889
CONDITION: Bleached foxing on mountain
and sky, centre; slightly faded and rubbed.
Tear repaired lower left corner
PROV: Bought to circulate to art schools
from Mrs Varley, 57 Beaufort Street, SW3,
for £1 1s od in 1889

Although this is not a recognizable view, it
is generally reminiscent of Varley's Welsh
landscapes and, in particular, of his
numerous versions of Beddgelert Bridge
(**20**). The very broad washes, typical of his
early years, are similar to those in *Afterglow*
(**18**) and *Snowdon* (**19**); the green and light-
brown modelling of the mountain is very
close to the *Dolgellau* of 1811 (**32**), which
suggests a date *c.* 1805–10.

 The inscription on the back is unusual:
this is clearly a rapidly executed
composition for a student to copy and
throws some light on Varley's teaching
technique. The lack of pencil outlines is
unusual and differentiates the watercolour
from the unfinished *Snowdon* (**19**) which is
otherwise similar in the use of
unmodulated washes and in the
prominence of the unpainted figures.

21

22

22
Porch of St Margaret's Church, York

Watercolour over traces of pencil on coarse cream wove, laminated; 10⅛ × 13⅞ (25·7 × 36·2)
780–1870
CONDITION: Paper damaged upper left, at top of porch and on the arch. Scraping out in lower left corner could indicate the erasure of an inscription, but this can no longer be verified under magnification or ultraviolet
PROV: Bought in 1870 for £3
EXH: *1066: English Romanesque Art*, Hayward Gallery, 1984 (534)

The porch is seen from the front and the left; a girl squats within it.

Varley's visit to Yorkshire in the summer of 1803 is attested by several dated watercolours including those of *Kirkstall Abbey* (Stoke on Trent Art Gallery) and the *Ouse Bridge, York* (exh. OWCS, 1804). An almost identical view of St Mary's porch, though without the figure, by William Mulready is also dated 1803 (BM; Heleniak, 1981, fig. 29), and it is possible that the two were produced at the same time. The use of shadow and the treatment of the ground and masonry is very close to the Chester and Conway scenes of *c.* 1802–3 (**4, 5**). A *View of St Margaret's Porch, York*, was exhibited at the OWCS in 1808, and a date *c.* 1803–8 may be proposed for this watercolour.

The porch of St Margaret's Church was recognized as one of the sights of York in the eighteenth century. As Francis Drake put it (*Eboracum: Or the History & Antiquities of the City of York*, 1736, p. 307), 'The church has one of the most extraordinary porches ... I have ever observed,' and this view is echoed in later histories and guide books (*The History and Antiquities of the City of York*, II, 1785, p. 324; Wm. Hargrove, *History and Description of the Ancient City of York*, 1818, p. 316: 'The Porch ... is an object of considerable interest; being

perhaps the most curious and extraordinary specimen of Saxon sculpture and architecture this country can exhibit.'). According to Drake (op. cit., p. 250) it originally formed part of the St Nicholas Hospital and was moved to St Margaret's after the hospital was destroyed in the siege of 1644. It is a typical example of the Romanesque doorways of Yorkshire and can be dated in the third quarter of the twelfth century (T.S.R. Boase, *English Art 1100–1216*, 1952, p. 238 f., cf. pl. 39[B] for similar carvings).

Although such close-up views of architectural monuments are not typical of Varley's work, one can understand his and Mulready's interest in a site that was recommended viewing in all the guide books as redolent of a very ancient past. In fact, the detailed treatment of the porch is derived from an engraving of it by James Basire after John Haynes, published in Drake's *History* in 1736 (2nd ed., 1788) (fig. 9). Varley, like Mulready, shows the porch somewhat from the left whereas the engraving is taken from the right and does not indicate the rest of the building, but both are essentially frontal views. The engraving clearly depicts the signs of the zodiac on the outer arch and the decorative designs on the inner arches. These also appear in a recognizable if more generalized form in the watercolour by Mulready, but Varley has indicated them in a more sketchy manner. He has depicted a clearly recognizable Norman porch, but remained more interested in the details of the shadows and of the crumbling masonry behind than in the antiquarian details of the porch itself.

23
Coast scene with houses: (?) Barmouth

Watercolour with scraping out on white wove, laminated; $5\frac{1}{2} \times 7\frac{1}{4}$ (14×18.5)
Dyce 947
(see colour plate between pp. 84 and 85)
CONDITION: Good
PROV: The Rev. Alexander Dyce; collection bequeathed to the Museum in 1869

Both the subject and the style are somewhat unusual for Varley. The very sketchy treatment of foreground landscape and urban buildings, the fresh, *plein air* appearance and the almost Constable-like interest in clouds are all relatively uncommon in Varley's output. However, the heavy cloud opening to show a small area of blue sky is a feature of his work in the period *c.* 1805-10, appearing at its most carefully controlled in the *Distant view of Bamburgh Castle* (National Gallery of Scotland). A town view of comparable sketchiness is the *Ouse Bridge, York* (Eton College), but the scenery is more precisely echoed in Varley's depiction of the beach at Barmouth of which there are several versions: Sotheby's 13 March 1980 (130), dated 1804 and inscribed with the location; Birmingham City Art Gallery (22.19), dated 1809, and a smaller one, Sotheby's 19 July 1973 (98), dated 1813. Although these are larger, finished watercolours, the two earlier ones share the basic stylistic features of D 947 and provide an anchor to fit it into Varley's *oeuvre*. It may well represent the same place, though the evidence is insufficient for a firm identification (cf. also the view of Barmouth in J.G. Wood, *The Principal Rivers of Wales*, II, 1813, p. 196).

The blue-grey urban background and stress on smoking chimneys is reminiscent of early Cotman (e.g. *St Mary Redcliffe, Bristol: dawn*, Rajnai, 1982, no. 11).

24
Studies of trees and boats

Two sheets from a sketchbook and 10 other drawings

River bank: willow tree and figures
Black chalk on blue laid, watermarked C & C; $7\frac{1}{2} \times 5\frac{7}{8}$ (19×14.9)
E 240-1984

River bank with willow trees; a church indistinctly shown in the distance (conceivably Westminster from Millbank)
Black chalk heightened with white on blue laid; $5\frac{7}{8} \times 7\frac{1}{2}$ (14.9×19)
E 241-1984

Warehouses on a river bank
Black chalk on blue laid; $5\frac{5}{8} \times 8$ (14.3×20.4)
E 242-1984

Sailing boats
Black chalk on blue laid; $3\frac{1}{8} \times 6\frac{1}{2}$ (8.1×16)
E 243-1984

Landscape with clump of trees
Black chalk on grey wove; $5\frac{3}{4} \times 9$ (14.6×23)
E 244-1984

Ducks and hens
Black chalk on grey wove, watermarked 1803; $5\frac{3}{4} \times 10$ (14.6×25.4)
E 245-1984

Six pencil drawings on white wove of boats and one pen drawing on tracing paper of boats, various sizes
E 246 to E 252-1984

PROV: Family descent to Cmdr Peter Varley, great-great-grandson of the artist; Sotheby's, 15 March 1984, Lot 51 (one of four lots from this source, other drawings from the same source are in the Andrew Wyld Gallery)

24

The family provenance supports the
attribution of these drawings to John
Varley, though the possibility that some
are by other hands in the Varley circle
cannot be excluded. The black chalk
drawings on blue paper are similar to some
of those in the British Museum albums,
which, as a group, bear watermarks
ranging from 1801 to 1805. E 240 and E
241–1984, however, are unusual in showing
a river bank and probably date from the
period c. 1806 when Varley is recorded as
taking his pupils on sketching sessions on
the banks of the Thames (see Introduction,
p. 37). They are, indeed, very similar in
style and technique to two drawings of the
banks of the Thames by William Turner of
Oxford (E 253 and E 254–1984) who was
Varley's pupil at this time. Turner, like
Varley, shows an informal close-up view of
trees and a river bank with figures seen
from below. On the other hand, the
landscape with trees on grey paper (E 244) is
almost equally close to a drawing done by
William Henry Hunt at the same period (E
255–1984). A date in the first decade of the
century may also be suggested for the
pencil drawings of boats which are
comparable with those in the early
sketchbook in the V & A (E 3243–1931,
fol. 17) and in the British Museum albums.

25
Northumberland sketchbook

Pencil on cream Whatman, watermarked
MJL 1806 (on 7, 19, 23), 36 pp; 4¼ × 7¼
(11 × 18·4), in paper cover
Inscribed on back cover *Castles &c/Sketches
at Bamborough Dunstanborough/& Warkworth/
J. Varley. 1808*, and on inside front cover *J
Varley Nº. 15 Broad St./Golden Square/London*
and *J Varley/3 Bayswater Terrace Bayswater*
(his addresses 1805–12 and 1833–42
respectively)

E 3242–1931
(pp. 1, 15, 23 and 25 are illustrated)
CONDITION: Some leaves frayed at edges
and soiled; cover damaged; stitching loose
PROV: Family descent to Harold Fleetwood
Varley, grandson of the artist, from whom
bought by the Museum in 1931
CONTENTS:
p. 1 Bamburgh Castle from the south-east
 3 Bamburgh Castle from the south-west;
rough sketch inscribed with colour notes
 5 Bamburgh Castle from the north-west
 7 Moored boats
 9 Coast near Bamburgh (? Beadnall)
 11 Dunstanborough Castle, a distant
view, inscribed *12 o clock Septr 20*
 13 Dunstanborough Castle, inscribed
Dunstanboro
 15 Dunstanborough Castle, inscribed
Dunstanborough south front Septr. 20. 1808
 17 Dunstanborough Castle
 19, 21 Coast near Dunstanborough
 23 Warkworth Castle, inscribed
Warkworth
 25, 27, 28, 29 Gateway at the south end
of Warkworth Bridge
 31 Warkworth Bridge
 33, 34, 35 Views of Warkworth,
including Warkworth Church (p. 35)

On some of the even-numbered pages there
are rough sketches and, on the inside back
cover, profiles similar to those in Varley's
Zodiacal Physiognomy

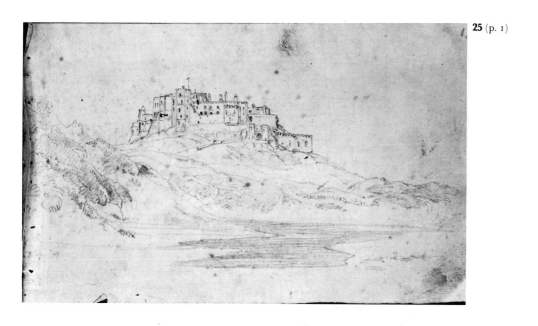

25 (p. 1)

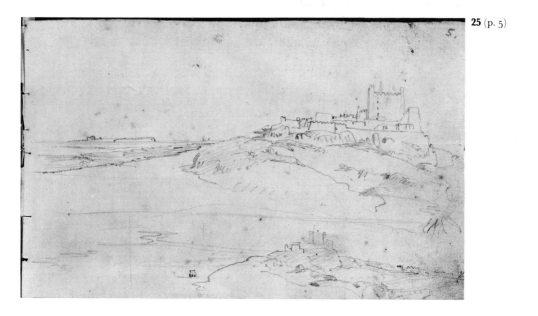

25 (p. 5)

25 (p. 13)

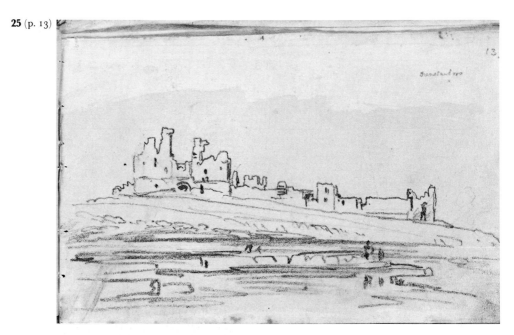

25 (p. 15)

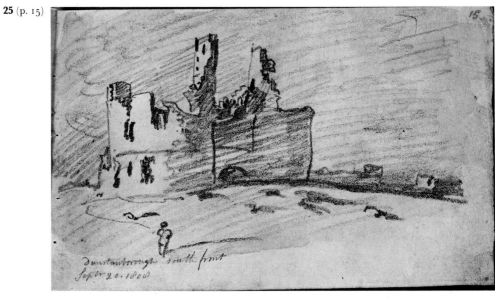

25 (p. 23)

25 (p. 25)

These sketches of Varley's Northumbrian tour of 1808 include some meticulously detailed architectural drawings such as *Bamburgh Castle* (p. 1) and *Warkworth Castle* (p. 23) but the majority are broadly executed in soft pencil. Some of the views reappear in exhibition watercolours painted soon afterwards. *Bamburgh Castle from the north-west* (p. 5) served as a precise model for the large watercolour of 1808, one of a set of four, recently on the London art market (Martyn Gregory Gallery, *British Paintings and Watercolours*, 1979, no. 43d) of which there is a version dated 1811 in the Whitworth Art Gallery, Manchester. The other views of Bamburgh are not as closely paralleled in extant watercolours (cf. **52**) and the *Dunstanborough Castle* in the Birmingham Art Gallery (Bury, 1946, pl. 38), while reflecting these drawings in a general way, features the Lilburn tower which does not appear in this sketchbook.

26
Lindisfarne Castle and Priory

Watercolour over traces of pencil with some scraping out, on coarse white wove, laminated; 9 × 11½ (23 × 29·3)
Inscribed on back in ink in a nineteenth-century copperplate hand: *Castle at Holy Island & Lindisfarn* (sic) *Abbey/J. Varley/1811/Exhibited at the Water color* (sic) *Exhibition* (to which has been added in pencil *1812 no. 247*) and, below, £2.2
Inscribed in pencil below, perhaps in the artist's hand, *Castle at Holy Island/J. Varley* and, in another hand, *Lindisfarne Abbey* and at the top in pencil *Mr. Dobson* and *no. 22*
2955–1876
CONDITION: Slightly faded; small areas of restored foxing upper left, otherwise good
PROV: William Smith, Vice-President of the National Portrait Gallery, in whose bequest it passed to the Museum in 1876
EXH: Perhaps OWCS 1812, no. 247; Hackney, 1978, no. 18
LIT: Rich, 1918, p. 202; Randall Davies, *Chats on Old English Drawings*, 1923, p. 24 (quoting Rich); Newcastle, 1982, p. 97

Lindisfarne Castle occupies the centre of the composition; the ruins of the Priory appear in the distance.

This is an identical view to Varley's watercolour dated 1810 in the Laing Art Gallery, Newcastle (25·8 × 30·8 cm., repr. Bury, pl. 36, and in colour on the cover of P. Orde, *Lindisfarne Castle*, National Trust, 1978). It differs only in the disposition of the figures and cattle. Alfred W. Rich, to whom the Laing version belonged, wrote of 2955–1876,

An apparent replica ... evidently done in the studio ... If these two drawings are compared it is very evident that the earlier one, which was no doubt painted out of doors, is the great work and that the carefully laboured one done at a later time falls far below in merit (Rich, 1918).

There is some justice in this view; the Laing version is much stronger in colour and somewhat broader in execution, but many of the weaknesses – the cardboard appearance of the castle, for instance – are common to both, and the contouring of the hillside, which is lost in the broad wash of the Laing drawing, is very characteristic of Varley at this date. The notion that the 1810 version was painted out of doors is highly questionable. Varley visited the Northumbrian castles in 1808, as we see from the V & A sketchbook of that year

26

(**25**), and exhibited two drawings entitled *Castle at Holy Island* in the following year (OWCS, 1809, nos. 251, 303). It is probable that both the 1810 Newcastle and the 1811 V & A drawings were done in the studio from earlier sketches and it is not clear which of them, if either, was exhibited at the OWCS in 1812 (no. 247, priced £4 4, which differs from the £2 2 inscribed on 2955-1876). Certainly, the description could fit equally any one of several Varley compositions (cf. **27**).

The inscription *Mr. Dobson*, probably in Varley's hand, indicates that this version was made for a student to copy. John Dobson of South Shields, subsequently the architect of Newcastle Railway Station, was Varley's pupil in 1810-11. There is a drawing by him in the Laing Art Gallery, Newcastle, formerly inscribed on the mount *This drawing was executed by John Dobson when studying under John Varley*, and in the memoir of him by his daughter there are several anecdotes concerning their master–pupil relationship (see p. 37). Another drawing in the collection with a similar inscription, *Mr. Griffith*, is the *View from Cader Idris* (**17**).

Lindisfarne, or Holy Island, connected with the Northumbrian mainland by a causeway submerged at high tide, enjoyed a period of prominence in the seventh and eighth centuries. In 634 Oswald, King of Northumbria, gave it to Aidan, missionary bishop of Iona, as the see for his diocese, and St Cuthbert was bishop there in 685-7, but in 874 the monastery was destroyed by Danes. In 1083 a Benedictine Priory was founded there as a cell of Durham and it is the twelfth-century ruins of these buildings that survived to Varley's day and to our own. The castle dates from 1543 and was built as a bulwark against Scottish forays. It was still garrisoned when Varley drew it, but fell into disrepair after the mid-nineteenth century, to be restored as an Edwardian country house by Sir Edwin Lutyens in 1903. Like the other Northumbrian castles, it was a popular subject for artists in search of the Picturesque. Northumbria, it is true, had not been included by the Rev. William Gilpin among his Picturesque tours, yet its principal sites were widely publicized in

the eighteenth century. Of the general histories and guide books, *A Description of England and Wales ...*, 1769, contains ten Northumbrian views, including one of Lindisfarne Castle (vol. VII, p. 110), and the subject has been recently aired in an exhibition (Newcastle, 1982).

There are comparable views by Girtin and others though from a slightly different angle, showing the approach to the entrance on the north side whereas Varley's view is from the south-west (e.g. Girtin watercolour, 1796-7, Metropolitan Museum, New York; Girtin and Loshak, no. 185, pl. 32; William Daniell engraving, 1822, Orde, op. cit. pl. 1). Varley has tampered with nature in bringing the Priory ruins nearer to the castle in order to provide a focal point in the background, but otherwise he has kept closely to appearances. The sketchily indicated building in the distance to the left of the Priory is presumably the parish church, dominated by its massive thirteenth-century bell tower.

27
Lindisfarne Castle

Watercolour over traces of pencil with scraping out, on coarse white wove; $17\frac{3}{8} \times 22\frac{3}{8}$ (45 × 56·8)
Signed lower right *J. VARLEY*
FA 437
CONDITION: Faded; surface rubbed and badly stained, cleaned in 1979
PROV: Bought in 1859

Lindisfarne Castle is shown across the sea from the east; a boat and figures on the beach are in the foreground. It is a late afternoon scene: the east side of the castle is in the shade, the sun shines on to the fields beyond the castle in the distance.

This is very much Varley in his broad style: even the haystacks in the sunlit fields receive only cursory treatment and the sea and shadows are laid on in broad washes. The sunrays breaking through the clouds on the left are ruled in pencil. Although the tonality is more dominantly brown, the style is similar to the other view of Lindisfarne Castle in the collection (**26**); the contouring by shadows on the hillside,

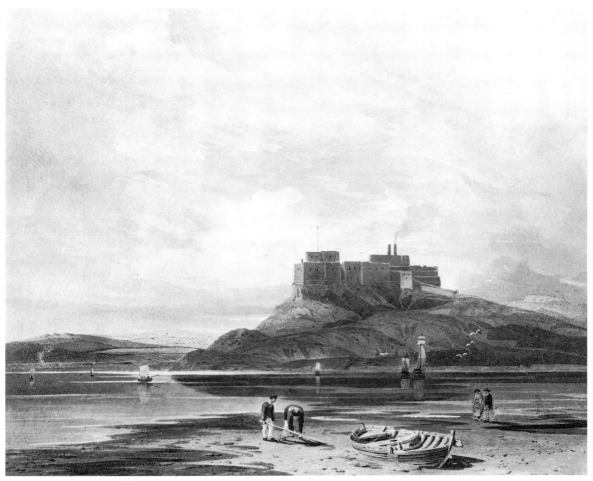

27

for example, is identical in treatment. The
latter is dated 1811, and FA 37 may also be
placed in the period 1809 (when Varley
first exhibited a *Castle in Holy Island*) to
1811. It is likely that all of these were
taken from sketches made during his visit
to Northumberland in 1808. A third
version, with the same figures as FA 437
but without the cattle in the foreground
was once at the Walker Galleries
(reproduction in Witt Library).

Lindisfarne Castle, like the other
Northumbrian castles, figures prominently
in eighteenth-century guide books (see **26**).
A similar side view, though taken from the
west, is engraved in Hutchinson, 1778,
p. 106.

28
Ruins of the Priory Church, Lindisfarne

Watercolour over traces of pencil (thick pencil outlines on ruin on left), on coarse white wove; 11 × 13¾ (28·4 × 35·4) 1925-1900
CONDITION: A narrow strip of deep blue colour at the top and right edges under the mount demonstrates the extent of fading in the sky
PROV: H.S. Ashbee, bought from Agnew's in March 1898 for £18 18s; collection bequeathed to the Museum in 1900

Looking westward, we are shown the interior of the west end of Lindisfarne Priory with the parish church behind. The composition is lit by the setting sun in the distance, hence there are large patches of deep shadow in the foreground.

The architecture of the ruins is treated in a very cursory manner. However the broad handling of buildings and landscape is similar to that in the other Lindisfarne watercolours (**26, 27**) and, although this is somewhat weaker in detail, it is reasonable to consider it as autograph. Indeed, the strong emphasis on the setting sun and the curiously oriental appearance of the shepherd give this watercolour a more tranquil, romantic appeal than the other two. A version showing the same composition but in a more distant view (G.H. Hay coll., sold Christie's 14.3.1967, lot 91) is dated 1811, which is the likeliest date for 1925-1900 also.

The Benedictine Priory on Lindisfarne

28

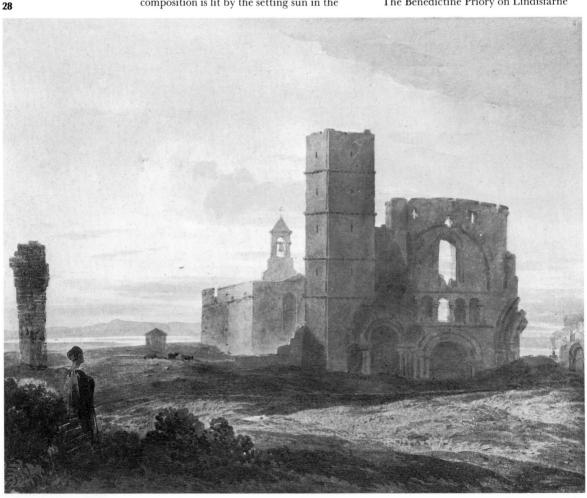

was founded on the site of the original seventh-century monastery in 1083 (see **26**). It fell into disuse after the Dissolution in 1540 but the parish church behind, with its thirteenth-century bell tower, remained in use. The Lindisfarne ruins were a popular subject for engraving in eighteenth-century antiquarian and guide books, and they appear for example in *A Description of England and Wales* (VII, 1769, p. 110, a rather fictional general view); Hutchinson, 1778 (p. 111, north transept); Francis Grose, *The Antiquities of England and Wales*, new ed. I, 1783 (transept, frontispiece). Indeed Francis Grose singled out Lindisfarne Priory for the frontispiece to his first volume and embellished it with allegorical figures showing *History Preserving the Monuments of Antiquity* (from the ravages

of a scythe-swinging figure of Time). However, none of these shows Varley's view of the west end with the parish church, nor does any of Girtin's several drawings of the Priory which he made in 1793 and 1796-7 (Girtin and Loshak, 1954, nos 67, 163, 164, 184; J. Mayne, *Girtin*, 1949, pl. 43).

29
Landscape with figures and a cottage

Watercolour over traces of pencil, some trees left uncoloured, on coarse wove, laminated; $12\frac{3}{4} \times 17\frac{7}{8}$ (32.2×45.5)
Inscribed on the back *Drawing by J. Varley*
2956-1876
CONDITION: Fading in sky can be gauged by stronger blue at edges, below mount
PROV: William Smith, Vice-President of the

29

30

National Portrait Gallery, in whose bequest it passed to the Museum in 1876

The rustic cottage had been a central feature of Picturesque aesthetics from the beginning, along with castles and ruins (see p. 47) and it reached the peak of its popularity in English painting in the first two decades of the nineteenth century. There are engravings after Varley's *Cottages* by F.C. Lewis dated as early as 1806 (*Cottage near Burford*) and Varley contributed to the collection of *Picturesque Sketches of Rustic Scenery including Cottages and Farm Houses*, 1815, which contained etchings by F. Stevens after Prout, Munn, Pyne, Cristall and others. This fixes the period of Varley's principal preoccupation with cottages at *c.* 1806-15. The style of the watercolour also indicates an early date: the broad washes of light and shade, the predominant grey-brown tonality and the squat solidity of the figures dressed in red or blue costumes are very similar, for example, to the watercolour of *Lindisfarne Castle* (**27**) which may be placed in about 1810. *Landscape with a cottage* (**30**) belongs to the same period as do the two watercolours of *Cottage by a river* in the British Museum (Binyon, 1907, nos. 7, 8).

30
Landscape with a cottage

Watercolour over traces of pencil on thick wove; 8½ × 12 (21·7 × 30·5)
Dyce 953
CONDITION: Somewhat faded, otherwise good
PROV: The Rev. Alexander Dyce; collection bequeathed to the Museum in 1869

Similar in date and type to *Landscape with figures and a cottage* (**29**).

31
Cheyne Walk, Chelsea

Watercolour and traces of pencil with some scraping out on white wove, laminated; 14⅛ × 19½ (36 × 50)
Signed lower right *J. Varley 1811*
176-1894
(see colour plate between pp. 84 and 85)
CONDITION: Faded, and foxed in places
PROV: J. Henry Chance (inscription in pencil on back); bought by the Museum from Agnew's for £19 19s in 1894
EXH: Probably OWCS, 1812 (180) 'Cheney Walk'; Colnaghi, 1973 (113, pl. 38); Louisville, Kentucky, *English Watercolours*, 1977 (82)
LIT: Repr. *The Connoisseur*, June 1923; *Apollo*, January 1928, p. 23; Bury, 1946, p. 41, pl. 41

The view is taken from the east, looking towards Chelsea Old Church, with Battersea old bridge in the distance.

In 1811 Chelsea was still a relatively isolated riverside village and Cheyne Walk, named after Charles Cheyne (d. 1698), Lord of the Manor of Chelsea, was one of its most distinguished residential streets. Chelsea Old Church (Church of All Saints) was the parish church until the building of St Luke's in 1819. Founded in the thirteenth century, it was rebuilt in 1669-72; the wooden cupola, still in evidence here, was removed in 1815. The old wooden bridge, erected in 1772, was pulled down and replaced in 1877.

This view was favoured by generations of artists. Varley's composition is very much in the classically calm tradition of eighteenth-century town views. Although the treatment of the architecture is much broader and there is a more subtle effect of

the play of shadows on the houses, the composition is similar to James Miller's watercolour of 1776 which shows the same scene in reverse (731-1893; repr. in V & A *Summary Cat.*, 1980, p. 254; Hardie, I, pl. 196).

Nearer in date and all but identical in composition is Rowlandson's watercolour of *c.* 1810-15 in the Museum of London (A.16189; J. Hayes, *Thomas Rowlandson in the London Museum*, 1960, cat. 28, pl. 19). Varley also painted a slightly different view, *Cheyne Walk from the river*, showing the church in the centre (ex. coll. Mrs Bethune, Sotheby's, 28.11.74, lot 135), presumably at about the same date, when he appears to have had a summer residence in Chelsea. At any rate Linnell (*Journal* MS) records that he 'dined at Mr. Varley's at Chelsea' on 28 April and 8 September of that year.

32
Dolgelly Bridge, North Wales

Watercolour and traces of pencil on coarse white wove; 8⅝ × 18⅞ (22 × 48)
Signed in ink lower right *J. Varley 1811*
P 32-1936
(see colour plate between pp. 84 and 85)
CONDITION: Slightly faded; some foxing in sky, otherwise good
PROV: Miss M.E.B. Paton (d. 1953), Hinderton, Cheshire, given to the Museum in 1936 in memory of her brother, Alexander Allan Paton, CB
EXH: (?) OWCS, 1812 (178 *Dolgelly*)
LIT: Bury, 1946, pl. 42

The bridge over the river Wnion is seen looking inland from the east, with St Mary's church and the town of Dolgelly on the right. Broad washes are dominant though there are subtle colour gradations and shading, particularly following the sunbeams that pierce a cloudy, threatening sky. Such skies are typical of Varley at this period, as is the long, narrow panoramic format.

Not everyone thought highly of Dolgelly: H.P. Wyndham (2nd ed., 1781, p. 106) wrote of 'the miserable hovels of the town', but all later writers echoed the sentiments of Thomas Pennant (1781, p. 87) that 'the situation is in a beautiful vale ... watered by the river Onion; over which, on account of its floods, is a bridge of several arches'. It became a favourite stop for travellers and artists on their Welsh tour and John Varley must have gone there on his first visit to Wales in 1798 or 1799, for he exhibited a *View of Dolgelly* at the Royal Academy in 1800 (612). When he returned with Thomas Webster they fell in 'with several brother artists, Joshua Cristall and young William Havell among the number' (see p. 15). Cotman was also there that year and there are three watercolours by him of the bridge taken from the west with the church on the left, one of which is dated 1802 (Cecil Higgins Museum, Bedford; cf. the sketch in Norwich, Rajnai and Allthorpe-Guyton, 1979, p. 44, no. 23, pl. 10, and the version in the Fitzwilliam Museum, Cambridge, *c.* 1804-5).

Varley's earliest sketch of the bridge follows Cotman in showing it from the west (Leeds City Art Gallery, *c.* 1802). More closely related to P 32-1936 are two versions in the British Museum:

BM No. 1958-10-41 (Leonard Duke Gift) which is very similar to the V & A composition except for being slightly cut on the right; there are differences in the figures, and only six arches of the bridge are visible.
BM No. 1958-10-42 (Leonard Duke Gift) which is smaller and modelled in flatter washes than the above, but seven arches are visible. Probably by Varley himself.

There is a third watercolour in the British Museum (1902-5-14-11) called Cotman but attributed to Varley by Rajnai and Allthorpe-Guyton. It is in fact a poor copy of BM 1958-10-41, inscribed on the back

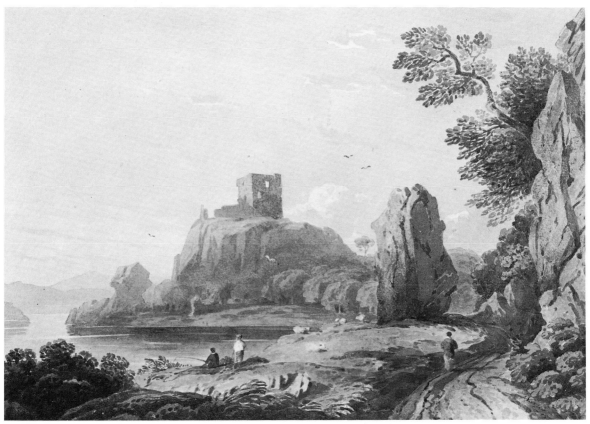

33

H.E. Mar 15th 1817 and is presumably by one of Varley's pupils. Finally, there is a close-up view of the bridge from the east, which was in the collection of G. H. Hay (Christie's 14.3.67; exh. Leger Galleries, November 1967, dated 1811, 8¾ × 12¾ in.). Yet, having listed all these versions, it should be added that Dolgelly was not one of Varley's much repeated subjects, since he appears to have exhibited it only three times throughout his career (RA 1800; OWCS 1812; B.I. 1823).

33
Landscape with lake and ruins

Watercolour over traces of pencil with scraping out, on white wove; 10½ × 14½ (26·8 × 37)
Signed lower right *J Varley 1812*
AL 5738
CONDITION: Somewhat faded, particularly in the sky, original blue visible under the mount. Otherwise good
PROV: Bought in 1868 for the topographical collection of the Art Library

Both in the treatment of the landscape and in composition this work is very close to the view of Lindisfarne Castle of *c.* 1811 (**26**); indeed, Varley has essentially re-used the composition, merely reversing it in the process.

34a

34
Fourteen portraits drawn with the aid of the patent graphic telescope

John Bannister (1760–1836), actor
Pencil on pink wove; 13¾ × 9¼ (33·6 × 23·5)
Inscribed in pencil *J. Bannister Esqr of
Drury Lane*, and *by C. Varley s Graphic
telescope* (the latter in Varley's hand); and
in ink *John Varley. John Bannister Esqr.*
E 1139–1927 (vol. II.4)

The Rev. Mr Cannon
Pencil on cream wove; 13⅛ × 9¼ (33·4 × 23·5)
Inscribed in pencil *Revd. Mr. Cannon – well
known in the fashionable Circles who was once
noticed by the King.*
E 1142–1927 (vol.II.7)

Edward Conant
Pencil on cream wove; 10⅜ × 8¼ (26·5 × 21)
Inscribed in pencil *Edward Conant Esqr. son
of the Late Mr. Nathaniel Connant and an
amateur,* in ink *John Varley*
E 1146–1927 (vol.II.11)

Charles Cranmer (exh. 1793–1815),
painter of genre and landscape
Black chalk on pink wove; 14 × 9⅞ (35·4 ×
25)
Inscribed in pencil *Mr. C. Cranmer; Pictor .
Son of Charles Cranmer the Porter at the
Academy*
E 1148–1927 (vol. II.13)

Joshua Cristall (1767–1847), painter
Pencil on cream wove; 8¾ × 7¼ (23·3 × 18·4)
Inscribed in pencil *Joshua Cristall Painter*
E 1149–1927 (vol. II.14)
Varley and Cristall had been friends at
least since 1802 when they joined forces on
their sketching tour of north Wales.

Walter Fawkes (1769–1825)
Black chalk on cream wove; 13 × 9 (33 ×
22·8)
Inscribed in ink *John Varley* and *Walter
Fawkes*
E 1158–1927 (vol. II.21)
Walter Fawkes of Farnley Hall, Yorkshire,
Whig politician and agriculturalist, is best

known as Turner's patron, but he was also a patron of Varley who appears to have made his acquaintance on his first Yorkshire tour in 1803.

The Hon. Sir Charles Greville
Pen and ink on cream wove; 9 × 6¼ (22·8 × 15·8)
Inscribed *Honble. Genrl Sir Charles Greville brother to the Earl of Warwick*
E 1161-1927 (vol. II.25)

James Hewlett (1768–1826), painter
Pencil on cream wove; 10 × 8⅛ (26·8 × 20·6)
Inscribed in pencil *Hulet Flower Painter of Bath*: in ink *John Varley*
E 1168-1927 (vol. II.32)

George Francis Joseph, ARA (1764–1846), portrait painter
Pencil on cream wove; 11½ × 7⅝ (29 × 19·3)
Inscribed in pencil *Josheph Esqr. ARA*
E 1172-1927 (vol. II.36)

Delvalle Lowry, second wife of the artist
Black chalk on cream wove; 11⅛ × 7¼ (28·3 × 18·3)
Inscribed in pencil *Miss Delvalle Lowry*; in ink *John Varley*
E 1176-1927 (vol. II.40)
(illustrated)
Delvalle Lowry was the daughter of Varley's friend Wilson Lowry (1762–1824) and his second wife Rebecca Delvalle (1761–1848). They were married in 1796, and if her birth date is reckoned *c.* 1797–1800, and her age here estimated at about 16, the drawing can be very approximately dated *c.* 1815. She married Varley in 1825 (see p. 58).

Dr Thomas Monro (1759–1833)
Pencil on cream wove; 12½ × 8½ (31·7 × 21·7)
Inscribed in pencil *Dr. Monroe the first Collector of Turner and Girtins Drawings Done with the Graphic Telescope April 12th 1812* (the last words perhaps in the artist's hand) and in reverse *Dr. Monro*; in ink *John Varley 1812*
E 1179-1927 (vol. II.43)
(illustrated)

On the reverse, just visible through the mounting sheet, are drawings of heads in profile similar to some of those in Varley's *Zodiacal Physiognomy*, 1828 (see p. 43). For his friendship with Dr Monro see p. 13. The reverse inscription may have been the result of Varley copying an inscribed drawing done in the opposite direction.

— Nepean
Pencil on cream wove; 12⅝ × 8¾ (32·3 × 22·3)
Inscribed in pencil *Nepean Esqr. April 24th 1812 Son of Sir Evan Nepean*; in ink *John Varley 1812*
E 1180-1927 (vol. II.44)

Archer James Oliver, ARA (1774–1842)
Black chalk on cream wove; 12⅞ × 9⅛ (32·8 × 23·3)
Inscribed in pencil *Mr. J. Oliver A.R.A. London. June 17 1812*; in the artist's hand: *J Varley – done with Graphic Telescope*; in ink *John Varley 1812*
E 1181-1927 (vol. II.45)
Oliver was a painter of portraits in oils and miniature.

John Wheeler
Pencil and chalk on cream wove; 7⅜ × 6¼ (18·6 × 16)
Inscribed in pencil *John Wheeler Esq. Collector of drawings*
E 1202-1927 (vol. II.66)

PROV: Dawson Turner (1775–1858) of Great Yarmouth, whose crest is stamped on the cover (apparently not sold in the three sales of his library in 1853, and May–June 1859), probably remained in the family; sold Sotheby's in 1927 and bought by the Museum
LIT: S.D. Kitson, 'Notes on a collection of portrait drawings formed by Dawson Turner', *Walpole Society*, XXI, 1932–3, pp. 67–104; Butlin, 1973, p. 300

This is the second of two volumes of portrait drawings put together by Dawson Turner, the Yarmouth banker, collector and antiquarian, who is best known as Cotman's patron. It was Cotman who,

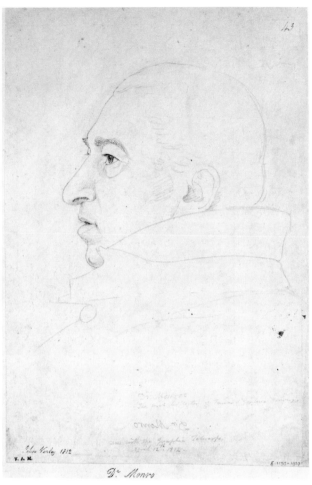

John Varley 1812
V. A. M.

Dr. Monro

34b

living at Yarmouth for 12 years from 1812, taught his daughters drawing, drew for him the architectural antiquities of Norfolk and of Normandy, and, as Sydney Kitson surmised, it may well have been Cotman who suggested the compilation of these portrait albums.

Volume I, containing 40 drawings, is dated 1819; volume II, here exhibited, bears the date 1825 and contains 69 drawings. Apart from Cotman and Varley, several well known artists contributed drawings, among them Sir Francis Chantrey, RA, Sir Thomas Phillips, RA, and R.R. Reinagle. The largest contributor, however, was Elizabeth Turner (1799–1852), Dawson's daughter, who afterwards took her mother's maiden name and became Lady Palgrave. It appears that when an artist came to stay with the Turners, a gift of portrait drawings was often forthcoming and if a well known figure in another walk of life visited Yarmouth, his portrait was drawn by Elizabeth Turner or by Cotman and then etched by Mrs Turner.

Three of Varley's drawings are dated 1812 and to judge from the stylistic uniformity of the whole group, it is likely that they were all made at about that time, though the one of Delvalle Lowry is probably two or three years later. On the other hand, the only record of Varley visiting Yarmouth is contained in a letter of October 1822 from Elizabeth Turner. The fact that all his drawings appear in volume II supports the view that they were presented to the Turners during the 1822 visit, even though they were drawn a decade earlier. Of the sitters, the majority were friends or fellow artists, though perhaps as many as six (Cannon, Fawkes, Monro, Greville, Nepean, Wheeler) may be numbered among his patrons.

Cornelius Varley registered the patent of his graphic telescope on 4 June 1811: 'Patent of a New Construction of a Telescope or Optical Instrument for Viewing Distant Objects & for other Useful Purposes, with a suitable Table or Stand for the same' (Patent no. 3430).

Like the contemporary *camera lucida*, it was essentially a more portable version of the *camera obscura*, and projected the image by a system of mirrors on to a flat table so that it could be readily traced on paper. The idea was to enable the artist to depict a more true and precise apprehension of nature and for this purpose it was widely used in landscape drawings by Cornelius Varley and by Cotman (Pidgley, 1972). John Varley was apparently the first to use it for portraits. A drawing of Miss E. Hayes (Christie's 20 October, 1970, lot 1; Butlin, 1971, p. 300) is inscribed *Nov. 25 1811 The first Portrait Drawn in the Patent Graphic Telescope invented by C. Varley*. The drawings in the Dawson Turner Album all have the same salient characteristics even though some are more fully shaded than others. Striking for their distinctive boldness of outline, they are marred by the stiff, laboured quality of the traced line.

35
Mr Grant
Pencil on cream wove; 12½ × 9¼ (31·8 × 23·6) Signed lower right *J. Varley fecit 1812*; inscribed by the artist lower left *drawn in the Patent Graphic Telescope invented by C. Varley* and in reverse *Mr Grant*
E 391–1951
CONDITION: Paper much creased
PROV: Bought by the Museum in 1951

See previous entry for a series of closely similar portraits; that of Dr Monro also has a reversed inscription.

35

36

36

Landscape with Harlech Castle, and Snowdon in the background

Watercolour and gum with scraping out, on cream wove, laminated; 12⅜ × 17¾ (31·7 × 45)
Signed in white, lower left, *Varley*
1735-1900
CONDITION: Slight discoloration upper right, otherwise good
PROV: James Orrock, RI; bought by Henry S. Ashbee for £42 in 1893 ('*A classic landscape*'); collection bequeathed to the Museum in 1900

Harlech Castle is seen from the south with the Snowdon range in the distance, suitably brought nearer in the composition. This is a good example of the finished, exhibition watercolour of Varley's mid career, with carefully detailed foliage and thoroughly Claudean in balance of composition and blue and orange tonality. Only the broad washes in which the sea and mountains are executed recall Varley's early style. Comparison may be made with the *Cader Idris from Llaneltydd* in the Walker Art Gallery, Liverpool (*English Watercolours in the Collection of C.F.J. Beausire*, 1970, no. 45, pl. 17) which is dated 1815 and it is tempting to place 1735-1900 in the same period. However, Varley's exhibition watercolours of the 1820s are very similar and it would be rash to insist on a precise date.

Harlech Castle had long been a popular subject and there are watercolours of it by Girtin, 1798 (Girtin and Loshak, 1954, no. 267) and Turner (cf. Wilton, 1979, no.

867). Varley exhibited two views of it at the Royal Academy in 1803, one of which, *Harlech Castle with Snowdon in the distance* (560) may well have been a comparable composition. It remained one of his favourite subjects, exhibited in 23 versions between 1803 and 1840. This version may conceivably be the one exhibited in 1813 (233) or possibly 1823 (168). There are two other versions in the collection, both showing a nearer view of the castle and both dating from the 1830s; 298-1900 and FA 343 (**55, 56**).

37

The Pest Houses, Tothill Fields

Pencil and watercolour on coarse laid; 11 × 16⅛ (28 × 40·8)
Signed in ink lower right *J Varley* and inscribed on the back, apparently in the artist's hand *The Pest Houses Tothill Fields*
46-1876
(see colour plate between pp. 84 and 85)
CONDITION: Somewhat faded in the sky (original pale blue colour visible under mount). Slight foxing and discoloration in sky, otherwise good. There is an unpainted pencil outline of a tree between the two trees on the right
PROV: Bought for £5 15s in 1876

Hitherto catalogued as *Cottages in a landscape*, the subject of this watercolour is clearly inscribed on the back. The Pest Houses in Tothill Fields were situated at what is now the west end of Victoria Street, abutting Vauxhall Bridge Road. They were built in 1644, originally for

38

victims of the plague and converted into alms houses in the eighteenth century. With the construction of Victoria Street in 1845-50 they were demolished, together with much else in the area. The Pest Houses were also known as the 'Five Chimneys', and these are clearly a feature of the buildings on the left. In the distance, on the right, is the Church of St John, Smith Square – built in 1714-28 – which is about a mile to the east.

In both style and subject this work is very similar to Varley's watercolours of the Westminster area, of which several are dated 1816 and 1817. He concentrated on Millbank (BM 1880-11-13-1246, dated 1816, Yale, 1816; Museum of London nos. A23097 and 66.25) and the old Horseferry, subsequently Lambeth Bridge (Manchester City Art Gallery, 1817; BM 1880-11-13-1245). The interest in crumbling masonry is perennial in Varley's work, but these London drawings have a luminosity and directness far removed from his usual classicizing compositions. In this view the anecdotal depiction of the cat on the fence adds a further touch of the particular and the momentary. It is likely that these London scenes were drawn from nature, though it is only in some of the later ones, such as the *Hackney Church* and the *Mill near Vauxhall* both of 1830 (BM) that they are inscribed *Study from Nature*.

38
Hay barges on the Thames

Watercolour and traces of gum on white wove; $5\frac{7}{8} \times 10\frac{1}{4}$ (14·9 × 26·8)
459-1882
CONDITION: Slight areas of damage where foxing has been removed in the sky; cleaned, 1982
PROV: Bought for £6 in 1882

Acquired as *Hay barges*, this watercolour is very close in style and subject to Varley's views of the Thames, *c.* 1816–20, and it is reasonable to assume that the subject is inspired by such Thames scenes. The precise stretch of river can hardly be identified; although the church in the distance is generally similar to Chiswick Church, the views from Hammersmith are very different (**47**). Comparable Thames scenes featuring barges are of Millbank (Museum of London), Vauxhall (Yale) and Lambeth ferry (dated 1817; Manchester City Art Gallery). This watercolour is smaller and it differs in that the barges are the focus of attention, whereas most of the London views of this period present a recognizable topographical setting. In this respect it is reminiscent of the studies of barges that form the subject of watercolours and etchings by Cornelius Varley.

39

Illustration to Byron's *Bride of Abydos*

Watercolour, heightened with body colour and varnished; $6\frac{1}{8} \times 8\frac{1}{2}$ ($15 \cdot 6 \times 21 \cdot 7$)
1515–1882
CONDITION: Varnish slightly flaking in places, otherwise very good
PROV: Sir Edward Denny, Bt (1796–1889) of Tralee Castle, Co. Kerry; given to the Museum in 1882
EXH: OWCS, 1821 (72); V & A, *Byron*, 1974 (S.42); Hackney, 1978 (16)
LIT: Reviews of OWCS exhibition, Ackermann's *Repository of Arts, Literature, Commerce . . .*, XI, 1821, p. 372 ff.; *European Magazine*, LXXIX, 1821, p. 434; Bury, 1946, p. 44

Within the place of thousand tombs
That shine beneath, while dark above
The sad but living cypress glooms,
And withers not, though branch and leaf
Are stamp'd with an eternal grief
THE BRIDE OF ABYDOS (1814), *Canto II*, 28

This is very near the end of Byron's oriental tale. After her lover Selim is killed by her father's men, Zuleika dies of grief (stanza 27). The poem ends in the graveyard on an elegiac note, following the violent drama of the previous sections.

The origin of this watercolour is explained in the OWCS catalogue:

This picture was painted in consequence of MR. VARLEY receiving the last Annual Premium, which is given by the Society, at the close of each Season, for the purpose of inducing the Artist to undertake a Work of elaborate composition for the ensuing Exhibition.

As it was a prize winner, it received more attention in the reviews than the run-of-the-mill of Varley's work:

Within the place of thousand tombs . . . This solemn and sacred spot, so sanctified by the poet's genius, is that to which Mr Varley hoped

to give a palpable resemblance. It would be in vain to deny him the praise of considerable merit in the execution of the work, for this society deemed him entitled to their premium for his picture: that it has a good deal of poetical delicacy must be admitted, but there is a hardness of execution in parts of it, which detracts a little from the general effect. It is, however, on the whole, a creditable effort, and we are glad it has met with general approbation (*Ackermann's Repository*, XI, 1821).

For the highest attributes of art, this picture ranks among the foremost we have ever seen in water-colours. The drooping cypresses, the dark tombs, the mourning figure, the dilapidated columns, and the broken vases, all combine to give it interest and sublimity, and it amply merited what, we observe, it has received, – the premium of the Society (*European Magazine*, LXXIX, 1821).

Varley is not generally remembered as an illustrator of poetry, yet he exhibited an illustrative work at the OWCS as early as 1814: Thomson's Grave from Collins's *Elegy*. After the favourable reception of the *Bride of Abydos* in 1821, he usually exhibited at least one illustration to the Bible or to Homer, Milton, Collins, Goldsmith, Byron or Scott at the OWCS in subsequent years. Such themes were not new to Varley in the 1820s; he had had experience of them in his early Sketching Society days, but they had not featured in his exhibited work as a successful landscape painter in the first decade of the century.

Most illustrations to the *Bride of Abydos* concentrate on the central figures of Selim and Zuleika – for example those by Stothard in the V & A, and by Westall – but such themes were clearly not suitable for a landscape painter. For his 'place of thousand tombs' Varley has adapted a Claudean composition of shore, lake, bridge and classical ruins as it appears, for example, in Claude's *Landscape with the rest on the flight into Egypt* (Richard Cavendish

39

collection; Roethlisberger, 1961, fig. 168).
However, to illustrate an eastern cemetery,
Varley has produced a stylized landscape
of visionary resonance, far removed from
the pastoral naturalism of Claude. This
type of sombre, almost theatrical classicism
in turn inspired the work of Francis Oliver
Finch who was Varley's pupil from *c.* 1814
to 1819 and, indeed, there may have been

mutual influences between the two. The
dark green tonality, orange sky seen
through trees and dark foreground with
classical ruins set a pattern for Finch's
Poetry and Sentiment throughout his career.
Closely comparable, for example, is his
Landscape with pond in the Museum (D 911-
1904).

40

40
Waltham Abbey

Watercolour over traces of pencil on laid paper; 11⅞ × 19½ (30·3 × 49·4)
1743–1900
CONDITION: Small abrasions, otherwise good
PROV: Sir James Linton, artist; bought by Henry S. Ashbee for £36 15s od in 1890; collection bequeathed to the Museum in 1900
EXH: Probably OWCS 1822 (155) or 1825 (70): RA, *Old Masters*, 1891 (52); Colnaghi, 1973 (115)
LIT: Bury, 1946, pl. 53

On the left is the south-west corner of Waltham Abbey; to the right of the path is the village which bears its name. The Church of the Holy Cross at Waltham was founded by King Harold in 1060 and the interior retains its early Norman character. But the exterior, including the west front and the tower, is thirteenth century. At the Dissolution in 1552 the monastic buildings were largely destroyed and the Abbey church was taken over by the parish.

This church was a popular site for artists. There is, for example, a watercolour of 1778 in the style of Rooker (Museum of London), an engraving by J. Greig published in *Select Views of London and its Environs*, 1804 (p. 44) and a watercolour by Turner of *c.* 1796 (exh. Leger Galleries, *English Watercolours*, November 1981, no. 2). However, these are of different aspects of the Abbey and it appears that Varley's view is without precedent. He exhibited the subject twice at the OWCS, in 1822 (155) and 1825 (70). On the latter occasion the title given was *Waltham Abbey Essex – a study from nature* and this supports the appearance of the watercolour as a *plein air* sketch. The composition, with its central path leading the eye into the distance, is traditional, very close indeed to the *Cheyne Walk* of 1811, and the crumbling masonry is in the language of the Picturesque. Yet *Waltham Abbey* contrasts strongly with the earlier work and is clearly a product of early nineteenth-century naturalist tendencies. Claudean gold tints have been replaced by strong blues and blue-greens, and the whole is characterized by qualities of luminosity and freshness. The almost incidental inclusion of a close-up of a small part of the church and the concentration on tree and village is also contrary to the eighteenth-century topographical tradition.

There is a reduced replica of this composition (exh. Martyn Gregory Gallery, *Fine English Watercolours*, November 1981 (126); 4 × 6¾ in.). Varley's other view of Waltham Abbey, showing the whole church from the south-east, is represented by a small replica (4 × 6½ in.) dated 1826 in the Epping Forest Museum at Waltham Abbey. The two views as they appear today are illustrated in the booklet by H. R. Darby, *Waltham Abbey* (Pitkin Pictorials, 1965, cover and frontispiece).

41

On the Thames, Millbank

Inscribed on the back in a contemporary
hand *Mill Bank Varley* and in the upper left
corner, *49*
Watercolour over traces of pencil,
varnished, on cream wove (pencil
pentimenti left foreground); 6 × 8½ (15·2 ×
21·5)
2953–1876
CONDITION: Brown stains in sky on left
PROV: William Smith, Vice-President of the
National Portrait Gallery, in whose bequest
it passed to the Museum in 1876
EXH: Guildhall Art Gallery, *London and the
Greater Painters*, 1971

The view is of the north side of the river,
looking west. An engraving by F. Jukes
after L. Laporte, 1795 (Museum of
London, no. A 18113) shows the same view
and similar cottages on the right.

Millbank, named after the Westminster
Abbey mill which once stood on the site,
marked the end of Westminster and the
beginning of a country walk to Chelsea. It
proved to be very popular for painters
seeking rural views on what were then the
outskirts of London. There is a watercolour
of Millbank by Cornelius Varley which can
be dated about 1805 (Tate Gallery;
T.1712), but the earliest dated views by
John are 1816 (BM 1880-11-13-1246;
Yale). John Varley's favourite Millbank
subjects were the horse ferry (e.g. BM
1880-11-13-1245) and the area of the
Penitentiary, the present site of the Tate
Gallery (Museum of London). These are
all in his *plein air* style, fresh and luminous,
and dominated by a light palette. 2953-
1876, on the other hand, is covered by a
thick layer of yellowing varnish which
makes it very difficult to discover the
tonality beneath. It is not among the best

41

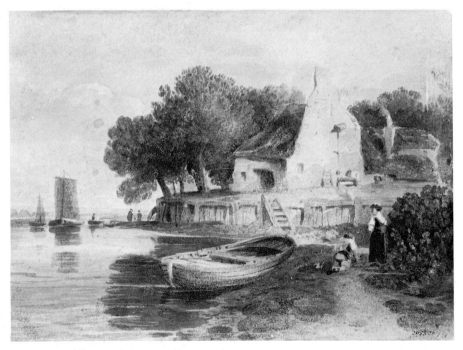

of his Millbank drawings, but there seems little reason to question its authenticity, and a date of *c.* 1820 may tentatively be proposed.

42
Landscape with church and windmill

Oil on millboard; 8¼ × 12¼ (21 × 31)
Signed on lower right *J. Varley*
1836–1900
CONDITION: Good
PROV: T. Webster; 1890, James Orrock, RI; Henry S. Ashbee; collection bequeathed to the Museum in 1900

Varley painted very few oils and there is no means of dating them. It may be presumed that he felt no need to venture into this field before the OWCS began to exhibit oil paintings in 1813 and it is unlikely that this painting is earlier than the 1820s, when he began to varnish his watercolours. The composition consists of several disparate elements from his watercolours, in particular the windmill from his low-horizoned views of London, and the church, with its reminiscence of St Nicholas, Chiswick.

One of the few undoubted oil paintings by Varley which may be adduced for comparison is the view of *Eton Chapel from the river* in the Eton College Collection, which has the same pink sky contrasting with a predominantly green tonality.

42

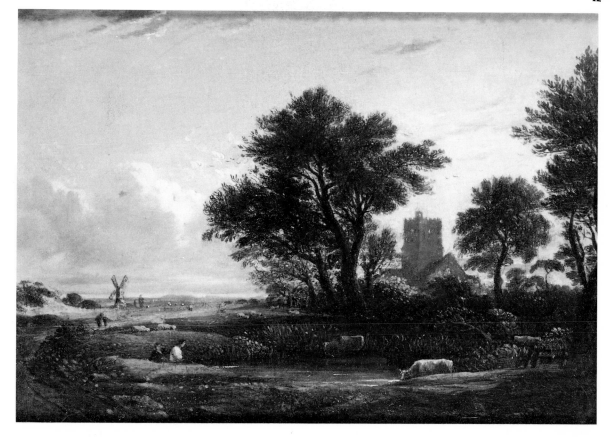

43

46

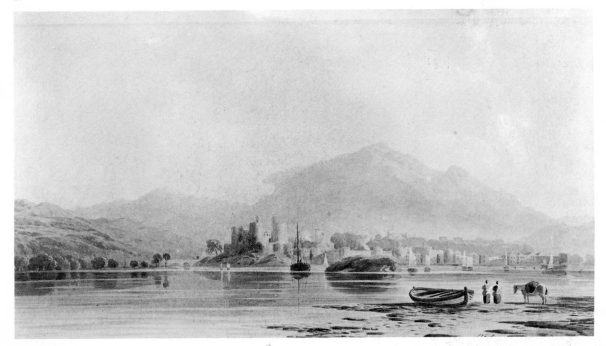

43
Landscape with tree

Pencil on cream wove watermarked
STAINS & CO 1822, 7¼ × 8⅞ (18·5 × 22·6)
Signed in pencil lower left *J. Varley/1824.*
Inscribed on the back of a second sheet,
perhaps in the artist's hand, *Mr Varley/
Great Titchfield St./Cavendish Square*
E 285-1926
CONDITION: Paper badly light stained
PROV: Miss E.M. Spiller, given to the
Museum in 1926

44
Landscape with tree by a pond

Pencil on white wove; 9 × 7⅞ (23 × 17·7)
Signed in pencil lower right *J. Varley*
E 191-1973
(Not reproduced here)
CONDITION: Paper light stained
PROV: Andrew Robertson (1777-1845)
miniaturist; by family descent to his great-
granddaughter, Miss R.M. Scott, who gave
several drawings to the Museum (see also **63**)

These are both demonstration drawings
done for students to copy. They follow in
the wake of several published books
demonstrating the drawing of trees of
which William Delamotte's *Forest Trees*,
1804, was one of the first, and Varley's
own *Studies of Trees Consisting of Rudiments of
Foliage of the Oak, the Weeping Willow the
Chesnut* (sic) *and the Elm*, was published
before 1820.

45
Frognal, Hampstead

Watercolour over traces of pencil on laid
paper; 10¼ × 15⅝ (26 × 39·7)
Signed lower right *Painted on the spot . J.
Varley 1826.*
3048-1876
(see colour plate between pp. 84 and 85)
CONDITION: Faded in the sky (compare 2
mm. margin under mount); paper worn
where de-foxed
PROV: William Smith, Vice-President of the
National Portrait Gallery, before 1873; in
whose bequest it passed to the Museum in
1876
EXH: Probably OWCS 1826 (187, *View of
Frognall, Hampstead*); RA Winter
Exhibition, 1873 (391); *British Watercolours
from the Victoria and Albert Museum,*
International Exhibitions Foundation,
Washington, 1966-7 (96); Colnaghi, 1973
(114, pl. 39); Hackney, 1978 (15)
LIT: Bury, 1943, p. 21 repr.; Bury 1946, pl. 51

Hampstead was becoming a popular
subject for painters in the 1820s; Constable
was by no means the only artist to be
attracted to the wide open expanse and
low horizons of the heath. Varley may
have been drawn to the place because
Linnell lived there in 1824-8. He left
relatively few views of the area; a
comparable watercolour of Hampstead,
also dated 1826, was at Christie's, 2 March
1976 (127).
 In type and style this watercolour
belongs to Varley's naturalistic sketches of
London, many of them 'painted on the
spot', of which the earliest, for example the
Old houses, Millbank, in the British Museum,
are dated 1816. They are characterized by
a freshness and light tonality, the facture
consisting of short brush strokes of
contrasting dark and highlights, alternating
with broad washes.

46
Conway, north Wales

Watercolour with traces of pencil on cream
wove, laminated; 10½ × 19 (26·7 × 48·2)
Signed lower right *J. Varley*
FA 436
CONDITION: Badly faded
PROV: Bought in 1859

The view of Conway, dominated by the
castle, is from the estuary to the north of
the town. Its faded condition leaves little
by which to judge the quality of the
watercolour. Nevertheless, the treatment of
the foreground and of the rather squat
figures is closely comparable to the *Dolgelly*
of 1811 (**32**), though the predominant
orange tone suggests a somewhat later
date.
 Views of Conway were among Varley's
very earliest exhibits at the Royal
Academy (1800: 789; 1803: 481) and
subsequently Conway Castle figures
prominently in his exhibits at the OWCS
(1805, 1808, 1809, 1810, 1812, 1818, 1822,
1823, 1833). A similar composition was at
Sotheby's, 4 April 1968 (148; subsequently
at the Leger Galleries) and another is in
the National Library of Wales,

Aberystwyth ($9\frac{1}{4} \times 6\frac{1}{4}$ in.). The view was a popular one well before Varley's visit; it appears in the earliest illustrated guide: Buck's *Antiquities*, II, 1774 (pl. 371, engraving dated 1742). Varley also depicted the castle from the south side, for example in a watercolour dated 1813 formerly belonging to the Fine Art Society (Bury, 1946, pl. 42) and the engraving in his *Treatise on the Principles of Landscape Design*, 1816.

47
Chiswick

Watercolour over pencil heightened with touches of Chinese white on white wove; $6\frac{3}{4} \times 10\frac{1}{8}$ (17.2×25.6)
On the reverse, the main outlines traced from the front in pencil and inscribed *J. Varley*, roughly in imitation of a signature
P 11–1953
CONDITION: Somewhat faded; discoloured under the mount: bleached foxing upper left, tears at upper corners repaired. Otherwise good
PROV: Miss M.E.B. Paton, Hinderton, Cheshire, bequeathed to the Museum in 1953, in memory of her brother Alexander Allan Paton, CB

When this watercolour entered the Museum it bore the inscription *Chiswell Church* on the mount – clearly a misreading of Chiswick. For the view is one of Varley's favourites: Chiswick seen from the east, near Chiswick Mall, with the fifteenth-century tower of St Nicholas Church in the middle distance. His earliest Chiswick

composition is a preparatory drawing of 1813 in Mrs Guillan's collection, followed by an exhibition watercolour, dated 1814, based on it, in the Yale Center ($3\frac{3}{4} \times 8\frac{1}{2}$ in., no B.1979.12.702). The view in these watercolours is from a point at the Upper Mall West, Hammersmith, from where the curve of the north bank at Chiswick appears accentuated and the church situated near the centre of the vista. A similar arrangement, often with the church brought nearer for greater prominence, persists in several later versions of the scene, including British Museum nos. 1944.10.14.187 (formerly dated 1830 on the back) and 1944-10-14-186, a variant with a barge; formerly Agnew's, also with the barge (called *On the Thames*, $4\frac{3}{4} \times 6\frac{3}{4}$ in.), and formerly F.R. Meatyard, dated 1832 (Bury, 1946, pl. 67; 10×15 in.). A view taken from near Hammersmith Bridge, with an inn in the foreground, is represented by watercolours in the Birmingham City Art Gallery, dated 1816 (Bury, 1946, pl. 6) and at Eton College.

P 11–1953 is taken from nearer the church, almost at Chiswick Mall, at which point the tower is on the right of the vista from the north bank. Varley has again made the church tower larger and more dominant than in fact it is from this distance. The cottages in the foreground, bathed in evening sunlight with deep shadows (even though the view is from the east) are also typical for the artist, comparing closely, for example, with the view of Rochester (**48**).

47

48

48
Rochester Castle

Watercolour with slight traces of pencil on white wove; 5 × 7½ (12·6 × 19)
Partially torn remnant of signature on back (*J. V*)*arley*
1436–1869
CONDITION: Repair at top right hand corner; some foxing on sky crudely removed
PROV: Rev. C.H. Townshend (d. 1868); collection bequeathed to the Museum

Rochester Castle, built by Bishop Gundulph in the reign of William the Conqueror, is seen from the south-west, with the old bridge over the Medway, replaced in 1856, in the distance. Varley has taken several liberties with the topography in order to balance his composition: the bridge has been distanced to provide a focal point on the horizon, and the square cottage, which was situated on the hill near the castle (see F.W.L. Stockdale, *Etchings . . . of Antiquities in the County of Kent*, 1810, pl. 7), has been

brought forward to add weight to the right foreground. This is not one of the usual views of Rochester Castle; more commonly it was shown from the other side of the bridge (e.g. W.H. Ireland, *History of the County of Kent*, IV, 1830, p. 321) or from the river (Francis Grose, *Antiquities of England and Wales*, III, 1784, p. 94). Varley, however, was keen to include the picturesque cottages on the south-west which are shown in closer view from the same angle in *Excursions in the County of Kent*, 1882, p. 96. He has in fact reproduced his Chiswick composition (**47**) and the south-west viewpoint has enabled him to include his characteristic mellow light and lengthening shadows of the setting sun.

A date of *c.* 1830 or in the early 1830s, not much later than the V & A version of Chiswick, may be reasonably proposed. A larger version of the composition, with variations in the figures and in the disposition of the trees, was in the Phipson Sale (Anderson Gallery, New York, 15.11.1923, lot 88, 11½ × 19 in.).

49

The Castle of Chillon, on the Lake of Geneva

Watercolour over pencil outlines on white wove; blue strip 7 cm. wide added on right side; 4⅜ × 6 (11·3 × 15·2)
1514–1882
CONDITION: Somewhat faded, otherwise good
PROV: Sir Edward Denny, Bt (1796–1889) of Tralee Castle, Co. Kerry; given to the Museum in 1882
EXH: V & A, *Byron*, 1974, no. S.43 (repr.)
LIT: Gettings, 1978, p. 110, fig. 141

In spite of its obvious weaknesses, in particular the half-hearted modelling of the mountains which compares unfavourably with otherwise similar work, such as the *Aberglaslyn Falls* (**50**), this watercolour could well be by Varley in the 1830s. He is not recorded as ever visiting Switzerland and the composition is clearly derived from a painting or print.

The castle of Chillon, situated between Clarens and the end of the lake at Villeneuve, was sufficiently picturesque to attract English artists at an early date and,

for example, Turner's watercolour of *c.* 1809 (BM; Wilton, 1979, cat. 390, pl. 100) could conceivably have served as a model for Varley. However, the great popularity of the subject dates from Byron's poem *The Prisoner of Chillon*, written when the poet was staying on Lake Geneva in 1816. Its hero is the Swiss patriot Bonnivard imprisoned in the castle in the sixteenth century, but the poem's essence has been seen as concerning the condition of Europe in 1816 under the repressive regimes of the post-Napoleonic period, rather than as purely historical romance.

49

1514.'82

50

50

The Aberglaslyn Falls, near Beddgelert

Watercolour with gum and scraping out on white wove, laminated; $8\frac{1}{2} \times 6\frac{1}{8}$ (21.5×15.6). The composition ends 3 mm. from the bottom of the sheet

P 30-1960

CONDITION: Somewhat faded; some surface dirt, otherwise quite good

PROV: Henry Herbert Harrod (d. 1948); bequeathed to the Museum in a collection consisting largely of illustration material

Acquired as 'attributed to John Varley', this watercolour may be more firmly given to him. A composition, identical except in size ($14\frac{1}{2} \times 11\frac{3}{8}$ in.) and in having two figures in the foreground, was in the possession of Abbott and Holder, Barnes, in 1971. It was signed *J. Varley*. Its very close similarity in style suggests that P 30-1960 is a smaller repetition by the artist, probably dating from the 1830s.

The Abbott and Holder watercolour, or a closely similar version, was sold at Sotheby's 26 June 1980 (281; $14 \times 10\frac{1}{2}$ in.), where it was catalogued as *Aberglaslyn Falls, Snowdonia*. This is a convincing identification, even though most views of Aberglaslyn show the bridge which divides Caernarvonshire and Merionethshire (e.g. engravings in W. Sotheby, *A Tour through Wales*, 1794, p. 33; Wyndham, 1781, p. 125; T. Roscoe, *Wanderings and Excursions in N. Wales*, 1836, p. 204). Varley's view, taken from the bridge or from a point just below it, is unusual, but the road skirting the mountainside provides an unmistakable landmark.

The appeal of the view from Pont Aberglaslyn looking northwards towards Beddgelert was summarized by Wyndham: 'The eccentric and romantic imagination of Salvator Rosa was never fired with a more tremendous idea, nor has his extravagant pencil ever produced a bolder precipice.'

51
St Michael's Mount, Cornwall

Pencil and watercolour with scraping out, on white wove; $8\frac{7}{8} \times 12\frac{3}{4}$ (22·6 × 32·4)
Signed in ink lower right *J. Varley*
P 48–1919
CONDITION: Somewhat faded
PROV: Bought by B.H. Webb for £3 12 6d in 1907; bequeathed to the Museum in 1919

In general terms the composition approximates to views of St Michael's Mount from the north-east, from somewhere on the shore between Marazion and Perranuthnoe. It may be compared, for example, with the engravings in F. Hitchins and S. Drew, *The History of Cornwall*, 1824 (I, pl. 17; from the east) and in J. Britton and E.W. Bailey, *Description of Cornwall*, 1810 (p. 463; from the north-east) or with Turner's

watercolour of *c.* 1812 (Wilton, 1979, 445) engraved in the *Southern Coast* series by W.B. Cook, 1814, on which the oil painting in the V & A (FA 209; RA 1834) is based.

However, comparison with any one of these demonstrates that Varley has rendered only a general approximation of the buildings on the site, which include a late fourteenth to fifteenth-century monastic church, tower and refectory. Indeed, there is no record of his ever visiting St Michael's Mount, and it is likely that his view is a generalized rendering based on one or other of the well known engravings. The blue ridge of hills in the distance could represent the bay south of Penzance.

The Mount had been a monastic site since at least the eleventh century when it was a Priory of the Norman Abbey of Mont-Saint-Michel, and its attractions to

51

the artists of the Picturesque were summed up by Francis Grose, *The Antiquities of England and Wales*, 1797 (VIII, p. 37),

... the peculiar romantic situation of the building, the beauty of the surrounding scene, and the operations of the pilchards fishery, present a variety of rich prospects scarcely to be conceived by those who have not had the pleasure of seeing them.

Typically for Varley, the buildings are lit by the yellowish rays of the setting sun, allowing for strong contrasts between light and shadow. The treatment of the rock is very close to that in the *Frognal* of 1826 (**45**) suggesting a date in the late 1820s or early 1830s.

52
Seascape with Bamburgh Castle, Northumberland

Watercolour over traces of pencil with scraping out on white wove, laminated; 6¾ × 9⅞ (16·2 × 25·2).
Signed lower right *J. Varley*
P 6-1935
CONDITION: Good
PROV: Given by Mrs A. C. Taylor, 1935, in memory of her husband, John Easton Taylor

Essentially a seascape centred on a sailing boat; Bamburgh Castle, seen from the north east, is shown in the middle distance. In general terms this is very close to *St Michael's Mount* (**51**) which shares with it the treatment of the seascape foreground, the orange hillside and the heavy clouds opening in the middle to reveal a patch of blue sky. However, the hill and the castle

52

itself are more perfunctorily treated than in the *St Michael's Mount* and there is rather more scraping out of surf, and hardly any pencil outline on the boat. In these respects it is less carefully executed, and when it entered the Museum in 1935 Basil Long noted, 'I do not feel quite sure that this drawing is an original, but Martin Hardie thinks that it is.' Considering the close similarity with, for example, the *Sailing boats in a storm* in the British Museum (1936-7-15-1) in which the middle ground is as cursorily painted, it is reasonable to maintain the attribution to Varley's hand. The British Museum drawing is dated 1835 which gives an approximate date for this one also.

Bamburgh has played an important part as a royal centre in the period of the Northumbrian kings but the present castle owes its origin to William the Conqueror. The great Norman keep remains the dominant feature, as it was in Varley's day. Indeed, the castle had long attracted the antiquarian and topographer: the engraving (from the south-west) by Samuel and Nathanial Buck in *Buck's Antiquities* (I, 1774, p. 214) is dated 1728. A view from the shore on the north side appears in Hutchinson (1778, II, p. 155) and, among the leading watercolour painters, Varley followed in the footsteps of Girtin (Girtin and Loshak, 1954, nos. 35, 1793, Ashmolean Museum; and 192, fig. 34, 1797, private collection).

Varley himself drew various aspects of the castle in his sketchbook of 1808 (**25**) and proceeded to portray it in close-up detail in four large watercolours, also dated 1808 (Martyn Gregory Gallery, *British Pictures*, Catalogue 21, 1979, no. 42). He used it as a focal point of the middle ground rather as he has done here in the splendid *Distant view of Bamburgh Castle* in the National Gallery of Scotland.

53
Pool and woods at Wotton, near Dorking

Watercolour, with some scraping out, on cream wove; 15⅛ × 27⅝ (38·3 × 70·4)
Signed lower right *J. Varley 1834*
1058–1873
CONDITION: Faded and discoloured at top of sky; torn at lower right owing to acidity of support paper, otherwise good
PROV: J. & W. Vokins, Dealer in Drawings, 5 John Street, Oxford Street (label at back); Richard Ellison (d. 1860) of Sudbrooke Holme, Lincoln; Mrs Elizabeth Ellison (d. 1873); given to the Museum with 50 other watercolours in 1873, 43 having been given in 1860
EXH: *Art Treasures Exhibition* (Manchester, 1857); *International Exhibition*, 1862, no. 735
LIT: Armand Dayot, *La Peinture Anglaise*, 1908, p. 293 (repr.)

This is a carefully composed and finished exhibition watercolour in which particular emphasis is given to the reflection of trees and sky in the water. There is much scraping out for highlights on the foliage in the foreground and among the trees, but larger areas have been left unpainted to form white clouds and their reflection. However, even though the composition is distinctly Claudean, the light palette, in particular the strong blue sky, is in the tradition of Varley's more naturalistic London views. The high esteem in which this work was held is indicated in the catalogue of the 1857 Art Treasures exhibition at Manchester: 'A River scene: the chef d'oeuvre of the artist'.

Varley knew this part of Surrey from the time he used to visit Dr Monro at Fetcham near Leatherhead in 1800–5. However, no early drawings of this subject survive, and it was not until 1836 that he exhibited a *Study from nature in Wooton Park near Dorking* at the OWCS.

53

54
View near Woolwich

Watercolour and gum with some scraping out, on white wove, laminated; $9\frac{1}{4} \times 15\frac{1}{4}$ ($23\cdot6 \times 38\cdot7$)
Signed lower right *J. Varley 1837*
297–1900
CONDITION: Some fading in sky
PROV: Bought with 298–1900 (**56**) for £8 in 1900
EXH: Hackney, 1978 (19)

The view appears to be of the Charlton marshes near Woolwich with the Thames in the distance. A comparable view, attributed to Varley and firmly titled *Charlton Marshes*, with the Thames on the right, is in the Museum of London (no. 78.265). Among the relatively few watercolours by Varley of this area is one of *London from the Greenwich Observatory*, dated 1835 (exh. Leger Galleries, 1955).

Although the admixture of gum is a feature of his later work, this watercolour is in other respects very similar to the *Frognal* of 1826 (**45**). It serves to demonstrate that Varley's *plein air* sketches of London retained their light tonality and freshness throughout his career.

55
Harlech Castle with Snowdon in the distance

Watercolour and gum with scraping out on cream wove; $7 \times 10\frac{7}{8}$ ($18 \times 27\cdot6$)
Signed lower right *J Varley 1837*
FA 343
CONDITION: Faded in the sky
PROV: John Sheepshanks (1787–1863); who gave his collection to the Museum in 1857

Apart from the difference in the foreground, the composition is very similar to that of 298–1900 (see **56** and also **36** for a discussion of the subject). The broad and cursory treatment, the liberal use of gum on rocks, tree trunks and foliage and the dominant orange tonality herald the beginnings of Varley's late style.

54

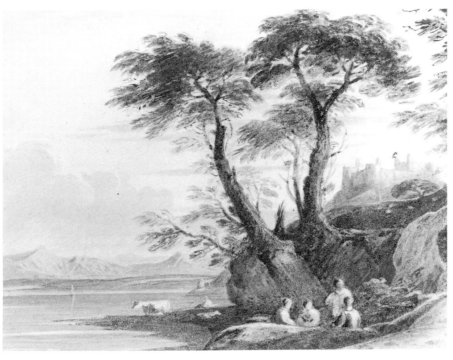

55

56

Harlech Castle with Snowdon in the distance

Watercolour and touches of gum on cream wove; $10\frac{3}{8} \times 14\frac{5}{8}$ ($26\cdot5 \times 37$)
Signed lower right *J. Varley*
Inscribed on the back *Harlech Castle & Snowdon N. Wales J. Varley* and *Baeswater Terrace* and *Hadley 1847*
298–1900
CONDITION: Surface rubbed
PROV: Hadley coll., 1847; bought with 297–1900 (**54**) for £8 in 1900

Harlech Castle is seen from the south with the Snowdon range in the distance, suitably bought nearer in the composition. This watercolour is close in style and composition to **55** which is dated 1837. As it is less dominated by gum and by orange in the sky, it may be slightly earlier, but the Bayswater Terrace address on the back suggests a date not earlier than 1833 when Varley is first recorded as living there.

The popularity of Harlech Castle as a picturesque subject and within Varley's *oeuvre* is discussed under **36**.

298–1900 may conceivably be the version exhibited at the OWCS in 1834 (42): 'Harlech Castle looking towards the Coasts of Caernarvon'. Apart from FA 343 (**55**) there are closely similar compositions of equivalent date in the Whitworth Art Gallery, Manchester ($12\frac{3}{4} \times 19$ in.; a more finished version); in Sotheby's sale 27 July 1978 (214 repr.), and a more finished and somewhat earlier version in the Lady Lever Art Gallery, Liverpool (no. 201, $4\frac{3}{4} \times 7\frac{3}{8}$ in.; Bury, 1946, pl. 2).

56

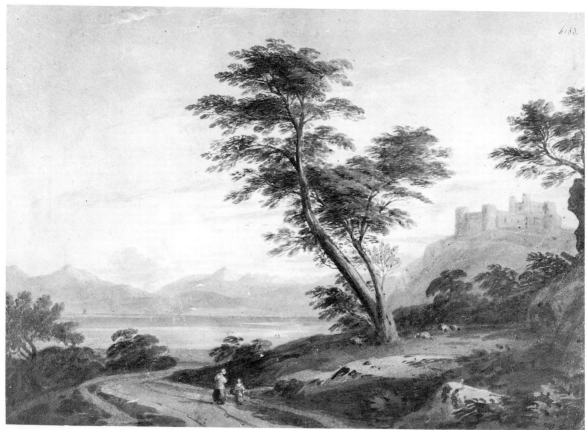

57
The burial of Saul

Watercolour with gum over pencil on white wove; 2½ × 3¾ (6·5 × 9·5)
1517–1882
CONDITION: Somewhat faded: strip of blue sky visible under mount
PROV: Sir Edward Denny, Bt (1796–1889), of Tralee Castle, Co. Kerry; given to the Museum in 1882
LIT: Bury, 1946, p. 44

Saul died in the battle against the Philistines and was buried under the tamarisk tree at Jabesh (1 Samuel 31). The opening chapter of 2 Samuel contains David's lament, 'How are the mighty fallen/in the midst of the battle!' Varley shows the bier carried across the bridge, the procession silhouetted in white against a dark background. However, the event itself is secondary to what is in essence a classical composition with an ancient city at twilight.

Varley first exhibited this subject at the OWCS in 1819 (93), but this tiny watercolour is a much reduced and somewhat simplified copy of the composition engraved by Linnell after the painting of 1831.

58
River scene with a church in the distance

Watercolour with touches of gum over traces of pencil, on white wove, laminated; 3¾ × 6⅛ (9·8 × 15·6)
1516–1882
CONDITION: Some discoloration in the sky
PROV: Sir Edward Denny, Bt (1796–1889), of Tralee Castle, Co. Kerry; given to the Museum in 1882

In the treatment of the trees and the water and the orange and green tonality, this watercolour is similar to the tiny *Burial of Saul* (**57**). The cursory execution and postcard size also support a date in the 1830s.

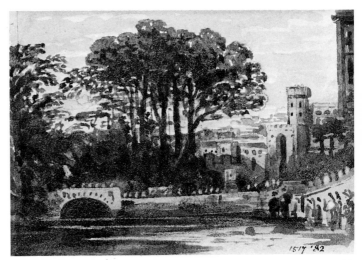

57

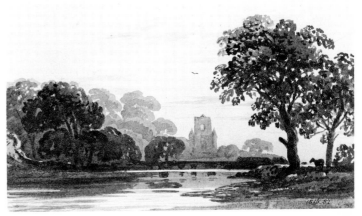

58

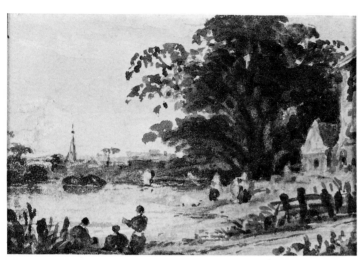

59

59
Cottages on a river bank with a church spire in the distance

Watercolour and gum on white wove; $2\frac{3}{8} \times 3\frac{5}{8}$ (6×9)
Signed lower centre, partially obliterated — *Varley*
E 2711–1929
CONDITION: The scraping on the left may be due to damage rather than the artist's intent
PROV: Given by C. Robert Rudolf, notable collector of drawings, in 1929

This is a typically bold, small sketch of the 1830s, based on Varley's composition of Chiswick (**47**).

60
A sunset at sea seen through the ruins of a castle on a cliff

Watercolour on white wove; $2\frac{3}{8} \times 4$ (6×10)
E 2710–1929
CONDITION: Minor discoloration upper right; otherwise good
PROV: Given by C. Robert Rudolf, notable collector of drawings, in 1929

This small essay in a Turneresque sunset is unusual in Varley's work. Yet the figures are typical and the pink and yellow ochre colours in the sky recur on occasion throughout his career, and it is reasonable to retain the traditional attribution.

60

61

Italianate landscape with road and trees

Watercolour on white wove, laminated and mounted on card; 3½ × 5¼ (9 × 13)
1497-1869
CONDITION: Good
PROV: The Rev. C.H. Townshend (d. 1868), collection bequeathed to the Museum

62

Landscape with pond and trees

Watercolour on laid, laminated and mounted on card; 3¾ × 5⅜ (9·5 × 13·7)
Signed lower left *J. Varley*
1498-1869
CONDITION: Good. Paper incised, as for trimming, along lower edge
PROV: As for **61**

In spite of the difference in the paper, these two watercolours are closely similar in size and style. Mounted on the same buff card, they appear to have been treated as a pair from an early date. They are characterized by an emphasis on dark brown colours, sketchy treatment and general verve of execution, which immediately precedes the expressive landscapes of Varley's last years. Indeed, they are typical of the small format sketches of the later 1830s, and may also be compared with his brown wash drawings of that period (e.g. Bury, 1946, pl. 70).

61

62

63

63
Six wash drawings of trees and lakes

A tree with a distant view on the right
Pen and brown wash on white wove; 4⅛ × 6
(10·5 × 15·1)
Inscribed on mount in pencil *J. Varley*
E 185-1973

A tree by a lakeside, a tower on the right
Brown wash on white wove; 4¼ × 5½ (11 ×
14)
Signed in ink lower right *J. Varley*
E 186-1973

A tower among trees by a lake
Brown wash on white wove; 4¼ × 5⅜ (10·7 ×
13·5)
Signed in ink lower right *J. Varley*
E 187-1973

Trees by a lakeside, a castle in the distance
Brown wash on white wove; 4 × 5⅞ (10·2 ×
15)
Signed in ink lower right *J. Varley*
E 188-1973

A river; trees on an island
Brown wash on white wove; 4¾ × 5⅝ (11 ×
14·3)
Inscribed in pencil lower left *J. Varley*
E 189-1973

Lake scene with figures and a castle in the
distance
Brown wash on white wove; 4¼ × 5½ (10·7 ×
14·1)
Signed in ink lower right *J. Varley*
E 190-1973

CONDITION: Paper light stained; all sheets
inlaid
PROV: Andrew Robertson (1777-1845)
miniaturist; by family descent to his great-
granddaughter Miss R. M. Scott, who gave
them to the Museum in 1973 (see also **44**)

These broadly executed wash drawings are
very similar to some of the small
watercolours of the late 1830s, for example
nos. 1497/8-1869 (**61-2**), and they most
probably date from the same period. In
constructing variations on the arcadian
theme of trees, lake and castle, they owe
their inspiration to Claude, and the
technique of bold, brown wash drawings,
modelled with emphasis on light and shade
contrasts, is also Claudean. It is of interest

to note, though there can hardly have been any direct connection, that Constable made broad sepia sketches just a few years earlier (*c.* 1830–36: V & A, Reynolds, 1974, nos. 410–11).

64
Landscape with bridge over a moat and castle

Watercolour over pencil with scraping out on coarse white wove; 5 × 7⅛ (12·9 × 18·2)
Signed lower centre *J. Varley*
Dyce 946
CONDITION: Good
PROV: The Rev. Alexander Dyce; collection bequeathed to the Museum in 1869

65

65
Landscape with cottage, stream and cattle

Watercolour and gum over traces of pencil with scraping out on white wove; 5⅜ × 8½ (13·7 × 21·6)
Dyce 948
CONDITION: Slight discoloration: otherwise good
PROV: The Rev. Alexander Dyce; collection bequeathed to the Museum in 1869

Although the paper is different and D 948 shows a plentiful use of gum, these two watercolours are very similar in style and composition. In both they are related to Varley's late versions of Harlech Castle, in particular, for example, to **55**. This is dated 1837 and these two fairly routine works may be placed in about the same period.

66

66
Lake scene with mountains and pines

Watercolour over pencil on white wove; 5¾ × 7⅞ (14·6 × 20·2)
Signed lower left *J. Varley*
Dyce 945
CONDITION: Some discoloration in sky
PROV: Rev. Alexander Dyce; collection bequeathed to the Museum in 1869

The pines are most unusual in Varley's compositions and are perhaps intended to convey a Swiss view. In all other aspects, however, it is typical of his work in the 1830s.

67

68

67
Lake scene with classical tomb and buildings and ruins

Watercolour on white wove; $3\frac{5}{8} \times 5\frac{1}{4}$ ($9\cdot3 \times 13\cdot3$)
Signed lower centre *J Varley*
Dyce 949
CONDITION: Good
PROV: The Rev. Alexander Dyce; collection bequeathed to the Museum in 1869

The composition, with classical arches partially blocking a vista of distant landscape, is reminiscent of the graveyard in the *Bride of Abydos* (1821, **39**), but for its cursory technique and small format this watercolour is closer to the *Burial of Saul* and the other small sketches of the 1830s.

68
Landscape with castle

Watercolour and gum with scraping out on white wove; $3\frac{3}{8} \times 5\frac{1}{4}$ ($8\cdot5 \times 13\cdot5$)
Signed lower right *J Varley* partially hidden by gum surface
1512-1869
CONDITION: Gum surface cracked, otherwise good
PROV: The Rev. C.H. Townshend (d. 1868); passed to the Museum with his bequest

The composition is closely derived from Claude (Roethlisberger, 1961, figs. 154-5, LV 81), but Varley has followed his usual practice in bringing the castle, as focus of attention, nearer to the viewer.
 This is an early example, probably dating from the late 1830s of the glazed and scraped trees which came to dominate his work in 1840-2.

69

69
Tal-y-Llyn with Cader Idris in the background

Watercolour and gum with scraping out on white wove, laminated; $7\frac{3}{4} \times 16\frac{1}{4}$ ($19\cdot8 \times 41\cdot3$)
Signed lower right *J. Varley 183(9)*
1107–1886
CONDITION: Small tears at right and lower edge; otherwise good
PROV: Joshua Dixon Bequest to the Bethnal Green Museum, 1886

The last digit of the date is no longer clearly legible; 7 or 9 are the most convincing readings. On stylistic grounds 1839 is the more acceptable date. The tonality and the wispy trees on the right are very close to the *Harlech Castle* of 1837 (**55**), and, in particular, there is none of the predominant orange and purple of the late works of 1840–2. However, the glazing and scraping on the trees on the left and in the foreground herald the new style.

The traditional title *Tal-y-Llyn with Cader Idris* is open to some doubt as the peak of the mountain, so prominent in this composition, is in fact hardly visible from the lake. Conceivably, it could be a view of Cader Idris across Lake Bala (see **12**) but it may be misleading to seek topographical accuracy in Varley's late works.

70

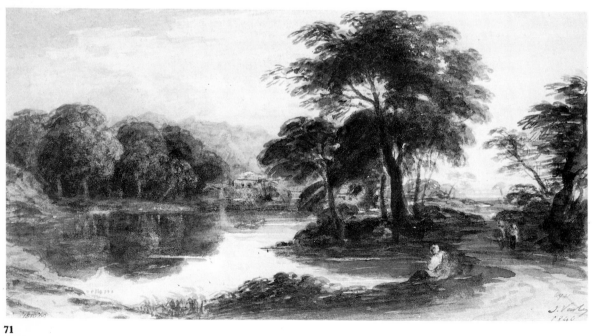

71

70
River scene – a composition

Watercolour and gum with touches of
Chinese white and scraping out on coarse
wove; 8 × 14⅝ (20·5 × 37)
Signed lower right *J. Varley/1840*
1056–1873
CONDITION: Gum medium flaked in small
areas; otherwise good
PROV: Richard Ellison (d. 1860) of
Sudbrooke Holme, Lincoln; Mrs Elizabeth
Ellison (d. 1873); given to the Museum
with 50 other watercolours in 1873
LIT: Bury, 1946, pl. 73

The broad treatment resembles that of a
sepia sketch, with the addition of a thick
layer of gum arabic, which also
characterizes the other dated works of 1840
(**71-2**). On the left is a single glazed and
scraped tree of the type that was to
dominate Varley's compositions of 1841–2.

71
Landscape with pond in the foreground

Watercolour and gum over traces of pencil,
with some scraping out, on white wove;
5⅝ × 10¾ (14·2 × 27·3)
Signed lower right *J. Varley/1840*
1510–1869
CONDITION: Some fading in sky, otherwise
good
PROV: The Rev. C.H. Townshend (d.
1868); collection bequeathed to the
Museum

The unmistakable reddish tonality and the
heavy use of gum for the dark areas
indicate the appearance of Varley's late
style in 1840. However, this is not yet the
fully developed version of that style,
lacking as it does the deep blue, purple
and pink tones favoured by Varley in
1840–2. The smooth, white paper also
contrasts with the very coarse wove
characteristic of his late work.

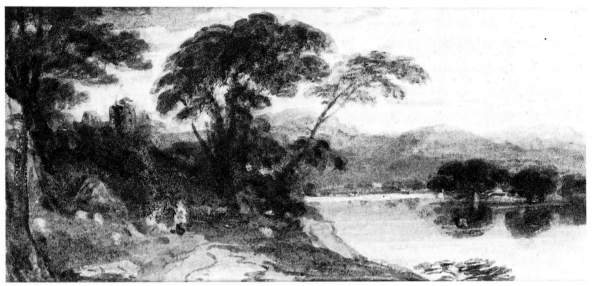

72

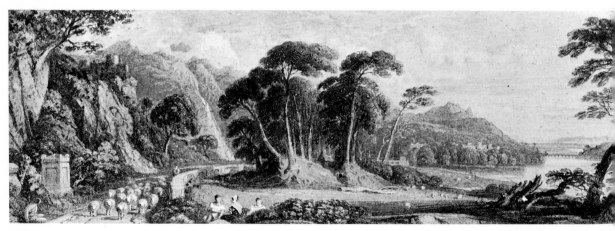

74

72
Landscape with path beside a lake, and a castle

Watercolour and gum on coarse wove; $4\frac{1}{2}$ × $9\frac{3}{4}$ (11·7 × 23·7)
Signed lower right *J. Varley 1840*
1520–1869
CONDITION: Slightly faded in sky, otherwise good
PROV: The Rev. C.H. Townshend (d. 1868); collection bequeathed to the Museum

For its rapid, sketchy treatment and *capriccio* subject, this is close to **71** which is also dated 1840. However, the more extensive use of gum, and the pink to purple tones of the mountains signal the more complete development of Varley's late style.

73
Classical landscape composition with an angler and two women in the foreground

Watercolour with gum and Chinese white over traces of pencil, some scraping out, on coarse wove, laminated, oval; $12\frac{5}{8} \times 18\frac{3}{8}$ $(32 \times 46 \cdot 5)$
Signed lower centre *J. Varley 1841*
P 49-1919
(see colour plate between pp. 84 and 85)
CONDITION: Some fading in the sky, otherwise good
PROV: Hawkins collection; bought by B.H. Webb in 1905 for £9, bequeathed to the Museum in 1919

This is a typical, carefully finished exhibition watercolour of Varley's last years. It is an archetypal Claudean composition, complete with a bridge over the lake and classical buildings, comparable for example with the *Landscape with Jacob* at Petworth and the *Pastoral landscape* belonging to the Duke of Westminster (Roethlisberger, 1961, figs. 227, LV 134; 213, LV 124 respectively). Equally, the composition is not dissimilar to Varley's own earlier Claudean exercises, such as the *Harlech Castle* of about 1815 (**36**), though the strong emphasis on the trees in the middle distance appears to run counter to his own statement that 'distant landscape should be emphasised by the mildness of the middle tint...'. (*Treatise*, 1816, plate E, 'Epic'.) Yet these late works are sharply differentiated from similar compositions done at different periods in Varley's career by their dominant orange, pink and purple colouring and the heavy use of gum arabic, particularly on the trees. The scraping of the gum gives the trees an emphasis and indeed an air of mystery reminiscent of Samuel Palmer, though the technique is strictly Varley's.

74
Landscape composition with classical tombs

Watercolour and gum over traces of pencil, with touches of Chinese white, on coarse wove; $6\frac{3}{8} \times 18\frac{5}{8}$ $(16 \times 47 \cdot 3)$
FA 548
CONDITION: Fine cracks in gum surface; otherwise good
PROV: J. and W. Vokins, 14-16 Great Portland Street (label on original frame); Richard Ellison (d. 1860) of Sudbrooke Holme, Lincoln; Mrs Elizabeth Ellison, given to the Museum with 42 other watercolours in 1860

This is another of the most elaborate and carefully finished exhibition watercolours of Varley's last years in the collection. As with **73** the source for the composition is Claude, of the type of the *Jacob and Laban* at Dulwich (Roethlisberger, 1961, fig. 308, LV 188).

75
Landscape composition with sheep, castle and mountains

Watercolour and gum, with touches of Chinese white on coarse wove; $9\frac{1}{2} \times 18\frac{1}{2}$ (24×47)
Signed lower left *J. Varley 1841*
P 50-1919
(see colour plate between pp. 84 and 85)
CONDITION: Cracking of heavy gum medium; slight fading in sky, otherwise good
PROV: Hawkins collection, from which acquired by B.H. Webb in 1905 for £8; bequeathed to the Museum in 1919

In subject matter this work does not differ essentially from other large exhibition watercolours of 1840-2 such as **13, 14**. However, by means of the dark, uneven surface of the scraped gum medium Varley shows an expressive intensity not seen in his work since the early years of the century.

76

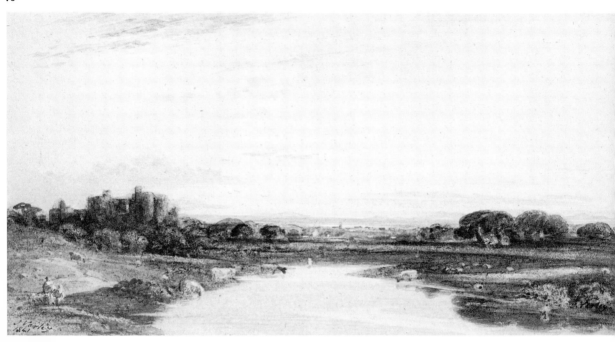

77

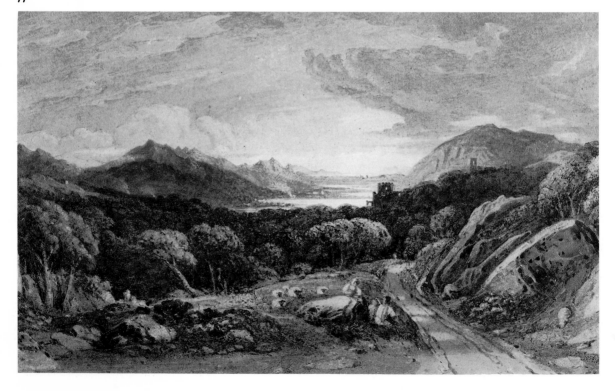

76
Landscape with cattle: evening

Watercolour and gum with scraping out on coarse wove; $6\frac{1}{2} \times 13\frac{1}{4}$ ($16\cdot5 \times 33\cdot6$)
Signed lower left *J. Varley/1841*, lower right *J Varley* and inscribed on the back, apparently in the artist's hand, *Landscape Evening/J. Varley/1841*
1481–1869
CONDITION: Faded in the sky
PROV: The Rev. C.H. Townshend (d. 1868); collection bequeathed to the Museum

77
Mountain landscape

Watercolour and gum over traces of pencil, with scraping out on coarse wove; $10\frac{3}{4} \times 18\frac{1}{4}$ ($27\cdot4 \times 46\cdot5$)
1055–1873
CONDITION: Some cracking of gum medium
PROV: Richard Ellison (d. 1860) of Sudbrook Holme, Lincoln; Mrs Elizabeth Ellison (d. 1873); given to the Museum with 50 other watercolours in 1873
EXH: (?) OWCS, 1841, no. 303; bought by Richard Ellison for 15 gns

Apart from the widespread scraping typical of Varley's late work, there are incised striations on the blue areas in the middle ground to add to the effect of distance, sunlight and haze.

In technique this watercolour is very close to **73** which is dated 1841 and it may, therefore, be tentatively identified with the *Mountainous landscape* exhibited at the OWCS in that year and bought by Richard Ellison.

78

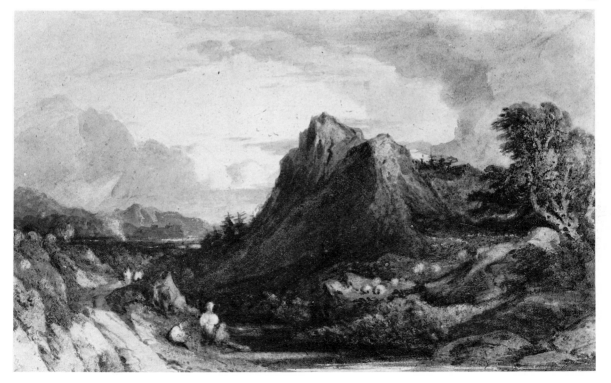

79

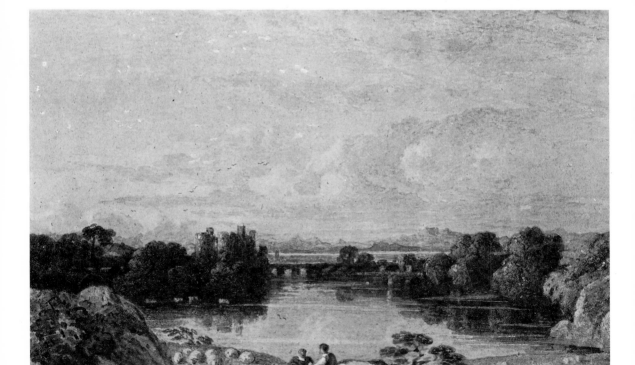

80

78
Mountain scenery

Watercolour and gum with some scraping out on coarse wove, laminated; $8\frac{7}{8} \times 14\frac{1}{4}$ ($22\cdot5 \times 36\cdot3$)
1448-1869
CONDITION: Fine cracks in gum surface; otherwise good
PROV: The Rev. C.H. Townshend (d. 1868); collection bequeathed to the Museum

The pine trees suggest that alpine scenery is intended. In any case, with the matching darkness of clouds and mountain, the mood is sombre, almost violent, nearer to that of **75** than to the calm classicism of **73** and **74**, though the technique is common to the whole group.

79
Landscape: sketch of rocks and trees

Watercolour and gum on coarse wove; $4\frac{7}{8} \times 10\frac{3}{4}$ ($12\cdot5 \times 27\cdot4$)
Dyce 950
CONDITION: Good
PROV: The Rev. Alexander Dyce; collection bequeathed to the Museum in 1869

Varley produced a considerable number of these bold, broadly executed, sketches in his last years. They are, typically, dominated by dark brown tones, strengthened by gum arabic, contrasting with delicate washes of orange and purple.

80
Landscape with lake and castle

Watercolour and gum, with touches of body colour and scraping out on coarse wove; $8\frac{3}{4} \times 13\frac{3}{4}$ ($22\cdot2 \times 35$)
Signed lower right *J. Varley 1842*
1455-1869
CONDITION: Badly faded in the sky, leaving isolated touches of body colour in what now appear as unpainted areas
PROV: The Rev. C.H. Townshend (d. 1868); collection bequeathed to the Museum

81
Bolton Abbey, Yorkshire

Watercolour and gum over traces of pencil with some scraping out, on coarse wove, laminated; $11\frac{1}{4} \times 24$ ($28\cdot7 \times 61$)
Signed lower right *J. Varley 1842*
1057-1873
CONDITION: Gum surface cracked, spots of damage in the sky, somewhat faded. Paint overspill on the back board at the edges of the watercolour indicates that it was fixed to the laminated sheets by the artist before he began painting
PROV: Richard Ellison (d. 1860); Mrs Elizabeth Ellison (d. 1873); given to the Museum with 50 other watercolours, 43 having been given in 1860
EXH: OWCS 1842 (157); Hackney, 1978 (13)
LIT: Davies, 1924-5, pl. VII; Bury, 1946, p. 47, pl. 73

The view is from the north, with the River Wharfe forming the centre of the composition, and the ruins of the east end of the thirteenth-century Priory church overlooking the river and reflected in it. Although painted in Varley's late style, this watercolour is more calmly classical than some of his work of 1840-42. Varley visited Bolton during his Yorkshire tour of 1803 and there is a closely related pencil drawing of that date in the British Museum (no. 1892-8-4-29, fol. 3). He exhibited views of and from the Priory at the OWCS in 1805, 1806, 1808, 1810 and 1814. This particular composition is essentially the same as the one in the Leeds City Art Gallery (1805), though the view is more extensive on the left.

Bolton Priory was established in the mid-twelfth century at a point on the Wharfe that marked the death by drowning of the founder's son. Dissolved in 1540, its ruins became a popular site for artists both because of these romantic origins and for the natural beauty of its location. Wordsworth commemorated the boy's drowning in his poem *The Founding of Bolton Priory* (composed 1807; published in 1815):

The stately Priory was reared;
And Wharf as he moved along,
To matins joined a mournful voice,
Nor failed at even-song.

The attraction for artists was clearly stated by Thomas Allen (*History of the County of York*, III, 1831, p. 341):

Bolton Priory stands upon a beautiful curvature of the Wharfe, on a level sufficiently elevated to protect it from inundations, and low enough for every purpose of picturesque effect.

The engraving in the book shows the same popular view, though from the south. Identical with Varley's composition is one of Turner's, dated 1809 (BM 1910-2-12-282; Wilton, 1979, 532).

81

82

Follower of John Varley

Landscape with cypress trees

Watercolour with traces of pencil, cream wove, watermarked J WHATMAN 184(7); 11 × 8⅝ (28 × 22)

1098-1884

CONDITION: Faded; marks of removed foxing in sky

PROV: Bought for £4 in 1884

Although it is unsigned, this watercolour was bought as by John Varley and the attribution has not been queried since it was acquired. However, the date on the watermark is clearly 184—, and the last number is most probably a 7. As Varley died in 1842, '1847' would rule him out automatically and in view of the fact that his late style is so very different, his authorship can be effectively excluded even if the watermark is 1840-42.

Indeed, although the style is closely derived from Varley's watercolours of the 1820s and 1830s, a comparison with a genuine work of the period, such as the *Aberglaslyn Falls* (**50**), highlights certain weaknesses. The mountains, for instance, are ineptly painted and lack a coherent structure, and the brush strokes shaping the foothills are meaningless in terms of light or modelling. Even in his most cursory works, Varley was much too professional for such vagueness.

82

83

After Varley

Conway Castle

Watercolour over traces of pencil on coarse
wove; 9½ × 12¼ (24·8 × 31·2)
Inscribed lower left *J. Varley 1828*
P 19-1952
CONDITION: Considerably faded and
discoloured
PROV: Bequeathed by Mrs C. C. Paterson,
1952

Although it was acquired as by John
Varley, this drawing appears to be a copy
of Plate I, 'Sunshine', in Varley's *Treatise
on the Principles of Landscape Design*. It is all
but identical in composition, differing only
slightly in the disposition of the trees and
in omitting some of the figures. A
comparison with the plate shows up the
watercolour as very inferior in points of
detail, such as the anchor on the shore and
the structure of the castle, and Varley's
authorship may be ruled out with some
confidence.

83

Abbreviations

BI British Institution
BM British Museum
Burl. Mag. Burlington Magazine
JWCI Journal of the Warburg and Courtauld Institutes
LV Claude Lorraine's *Liber Veritatis* (published by M. Kitson, BM, 1978)
NG National Gallery
OWCS Old Water-Colour Society: founded as the Society of Painters in Water-Colours, now the Royal Society of Painters in Water-Colours
RA Royal Academy
VAM, V & A, SKM Victoria & Albert Museum
Yale Yale Center for British Art

Bibliography

Manuscript sources

BARNES, J. Howard, Notes on the life of John Samuel Hayward and the Sketching Society; VAM, Dept of Prints and Drawings.

JENKINS, J.J., Papers relating to the history of the OWCS, in particular, reminiscences of J.P. Neale and Cornelius Varley, OWCS, Bankside Gallery.

LINNELL, John, *Journal*, 1811 and 1817 ff., copied by A.H. Palmer; *Autobiography*, 1863; Cash account books; Letters.

OWCS price books, 1805, 1807, 1808-12, in VAM Library; 1925-43, OWCS, Bankside Gallery (1814-23 annotated catalogues in OWCS).

Secondary sources

The books here listed are those repeatedly cited in the text. Further references are given in the notes to the introductory chapters. Place of publication is London unless otherwise stated.

BAYARD, J., *Works of Splendor and Imagination: The Exhibition Watercolour 1770-1870*, Yale Center for British Art, 1981.

BICKNELL, P., *Beauty, Horror and Immensity: Picturesque Landscape in Britain, 1750-1850*, Fitzwilliam Museum, Cambridge, 1981.

BINYON, L., *Catalogue of Drawings by British Artists in the British Museum*, IV, 1907.

BURY, A., 'The Varley Family', *The Connoisseur*, CXII, 1943, pp. 18-23.

BURY, A., *John Varley of the Old Society*, Leigh-on-Sea, 1946.

BUTLIN, M., *The Blake Varley Sketchbook of 1819 in the Collection of M.E.D. Clayton-Stamm*, 1969.

BUTLIN, M., 'Blake, the Varleys and the Patent Graphic Telescope', *William Blake: Essays in Honour of Sir Geoffrey Keynes*, ed. M.D. Paley and M. Phillips, 1973, p. 294.

BUTLIN, M., *The Paintings and Drawings of William Blake*, 1981.

CLARKE, Michael, *The Tempting Prospect: A Social History of English Watercolours*, 1981.

COLNAGHI, P. and D., *John Linnell and His Circle*, exhibition, 1973.

CROUAN, K., *John Linnell: A Centennial Exhibition*, Fitzwilliam Museum, Cambridge, 1982.

CUNNINGHAM, Allan, *Lives of the Most Eminent British Painters*, II, 1830.

DAVIES, Randall, 'John Varley', *OWCS Club Annual*, II, 1924-5, pp. 9-27, with list of OWCS exhibits compiled by B.S. Long.

DOBAI, J., *Die Kunstliteratur des Klassizismus und der Romantik in England*, III, 1790-1840, Bern, 1977.

FARINGTON, Joseph, *Diary*, vols. 1-6, ed. K. Garlick and A. Macintyre; vol. 7 ff., ed. K. Cave, Yale UP, 1978 ff.

FINCH, F.O., *Memorials of the Late F.O. Finch*, 1865.

GAGE, John, *A Decade of English Naturalism*, Norwich and VAM, 1969-70.

GAGE, John, *Colour in Turner: Poetry and Truth*, 1969.

GETTINGS, F., 'The divine principles: Blake, Varley and the spirits of the past', *The Hidden Art: A study of Occult Symbolism in Art*, 1978.

GILCHRIST, Alexander, *Life of William Blake*, 1863.

GILPIN, William, *Observations . . . on . . . Cambridge etc. . . . and Several Parts of North Wales, Relative Chiefly to Picturesque Beauty in Two Tours . . . 1769 and 1773*, 1809.

GIRTIN, T. and LOSHAK, D., *The Art of Thomas Girtin*, 1954.

GLEESON, L.A., *The Art of John Varley and his Pupils in the H.E. Huntington Art Gallery*, unpublished dissertation, University of California, Los Angeles, 1969.

HACKNEY, *John Varley: A Bicentenary Exhibition*, Hackney Library Services, 1978.

HAMILTON, J., *The Sketching Society 1799–1851*, VAM, 1971.

HARDIE, Martin, *Watercolour Painting in Britain, II: The Romantic Period*, 1967 (with earlier lit.).

HAWES, Louis, *Preserves of Nature: British Landscape 1780–1830*, Yale Center for British Art, 1982 (with full lit.).

HELENIAK, K.M., *William Mulready*, Yale UP, 1981.

HUTCHINSON, W., *A View of Northumberland*, 1778.

KITSON, S.D., 'Notes on a collection of portrait drawings formed by Dawson Turner', Walpole Society, XXI, 1932–3, pp. 67-104.

LYLES, A., *John Varley: A Catalogue of his Watercolours and Drawings in the British Museum*, M.A. Report, Courtauld Institute, 1980.

LYLES, A., 'John Varley's early work, 1800–04', *OWCS Club Annual*, 1984.

NEWCASTLE, *The Picturesque Tour in Northumberland and Durham c. 1720–1830* (catalogue by G. Hedley), Laing Art Gallery, Newcastle, 1982.

PENNANT, Thomas, *Journey to Snowdon*, 1781.

PIDGLEY, M., 'Cornelius Varley: Cotman and the graphic telescope', *Burlington Magazine*, CXIV, 1972, p. 781.

PIDGLEY, M., *Cornelius Varley*, P. and D. Colnaghi, 1973.

PIDGLEY, M., *J.S. Cotman's Patrons and the Romantic Subject Picture in the 1820s and 1830s*, unpublished dissertation, University of East Anglia, 1975.

RAJNAI, M., *John Sell Cotman*, VAM, 1982.

RAJNAI. M. and ALLTHORPE-GUYTON, M., *John Sell Cotman: Early Drawings, 1798–1812*, Norwich, 1979.

REDGRAVE, R. and S., *A Century of British Painters*, 1866.

RICH, A.W., *Water Colour Painting*, 1918.

ROETHLISBERGER, M., *Claude Lorrain: The Paintings*, 1961.

ROGET, J.L., *A History of the Old Water-Colour Society*, 1891.

SCRASE, D., *Peter de Wint*, Fitzwilliam Museum, Cambridge, 1979.

SMITH, Hammond, *Peter de Wint*, 1982.

SOLKIN, D.H., *Richard Wilson*, Tate Gallery, 1982.

STORY, A.T., *The Life of John Linnell*, 1892.

STORY, A.T., *James Holmes and John Varley*, 1894.

VARLEY, John, *Treatise on the Principles of Landscape Design*, 1816–17.

VARLEY, John, *A Treatise on Zodiacal Physiognomy*, 1828.

WHITE, Christopher, *English Landscape 1630–1850 . . . from the Paul Mellon Collection*, Yale, 1977.

WILDMAN, S., LOCKETT, R. and MURDOCH, J., *David Cox 1783–1859*, Birmingham Museums and Art Gallery, 1983.

WILLIAMS, Iolo, *Early English Watercolours*, 1952.

WILTON, Andrew, *The Life and Work of J.M.W. Turner*, 1979.

WILTON, Andrew, *Turner and the Sublime*, 1980.

WYNDHAM, Henry Penruddocke, *A Tour through Monmouthshire and Wales made in . . . 1774 . . . and 1777*, 2nd ed. 1781.

Note: Andrew Wilton, *Turner in Wales*, Mostyn Art Gallery, 1984, unfortunately appeared too late to be taken into account in this publication.

Index

Numerical index

Index of places and names